The A–Z of
CREATIVE DIGITAL
PHOTOGRAPHY

A DAVID & CHARLES BOOK
Copyright © David & Charles Limited 2006

David & Charles is an F+W Publications Inc. company
4700 East Galbraith Road
Cincinnati, OH 45236

First published in the UK in 2006

Text and illustrations copyright © Lee Frost 2006

Lee Frost has asserted his right to be identified as author
of this work in accordance with the Copyright, Designs
and Patents Act, 1988.

A catalogue record for this book is available from the British Library.

ISBN-13: 978-0-7153-2285-7 hardback
ISBN-10: 0-7153-2285-0 hardback

ISBN-13: 978-0-7153-2299-4 paperback
ISBN-10: 0-7153-2299-0 paperback

Printed in Singapore by Star Standard
for David & Charles
Brunel House Newton Abbot Devon

Commissioning Editor Neil Baber
Editor Ame Verso
Copy Editor Lara Maiklem
Proofreader Beverley Jollands
Art Editors Prudence Rogers & Sue Cleave
Design Assistant Sarah Clark
Production Controller Kelly Smith

Visit our website at www.davidandcharles.co.uk

David & Charles books are available from all good bookshops;
alternatively you can contact our Orderline on 0870 9908222 or
write to us at FREEPOST EX2 110, D&C Direct, Newton Abbot,
TQ12 4ZZ (no stamp required UK only); US customers call
800-289-0963 and Canadian customers call 800-840-5220.

The A–Z of
CREATIVE DIGITAL
PHOTOGRAPHY

Lee Frost

David and Charles

Contents

Introduction

When David & Charles first suggested that I write a book on creative digital techniques, I have to say I greeted the idea with a fair amount of trepidation. Compared to many photographers, my knowledge of digital imaging is limited to say the least. I do own a digital camera, but it's a modest compact by today's standards, used only for snapshots, and though I have been experimenting with Photoshop for a number of years, when the chips are down I'd much rather put film through my cameras and make prints in a darkened room, up to my elbows in smelly chemicals.

But then the more I thought about it, the more I realized that my lack of experience was probably a good thing, because it would allow me to write from the position of a beginner, assuming no prior knowledge and explaining things in a simple way. With digital imaging, perhaps more than any other area of photography, being able to do that is crucial, simply because there's so much to learn and it's so easy become baffled by this new science.

I've been there many times, listening to experienced 'Photoshoppers' discuss Layers, Curves, Blending Modes, Gradient Maps and Colour Profiles and trying pretend that I understood every word when they lost me halfway through the first sentence. It's like another language – and I was never any good at languages!

Six months on, however, I can say with confidence that it's not as scary as you might think. There's still a lot I don't understand, and probably never will, but what I realized very quickly when I sat down to write this book is that you don't actually need to know a huge amount about digital imaging to create successful images – a basic understanding of the main tools and controls is all that's required, because you will find yourself coming back to them time and time again, and adding new skills as you go.

The key is actually getting on with it. Just spend time at your computer trying things out. Experiment. Take risks. Open your mind and use your imagination. The great beauty of digital imaging is that you can try something and if it doesn't work, you can delete it and try again, safe in the knowledge that eventually it will

work, and you'll have mastered another skill that can be put to good use in a number of different ways.

The A–Z of Creative Digital Photography is here to make those first steps as pain-free as possible by covering a wide range of different techniques that beginners can try out.

You won't find advice on which digital camera to buy, or how to scan your photographs – there are plenty of books already available that do that far better than I can. Instead, I have written this one assuming that you already have the hardware, you have Adobe Photoshop in some form – Elements will be fine – and now you want to know what to do with those pictures you've scanned into your computer or downloaded from your digital camera.

Not surprisingly, black-and-white techniques feature heavily, because if there's one area where digital imaging excels, it's here. Darkrooms are a luxury in modern homes, and the spare time to make good use of them an even greater one. But don't let that put you off exploring the wonderful world of monochrome, because your computer can be every bit as effective as a traditional darkroom, and in no time at all you will be able not only to produce successful black-and-white images from colour originals, but also to experiment with creative techniques such as dodging and burning, lith printing, infrared, toning, hand-colouring, bas relief, solarization, liquid emulsion, adding texture to your pictures and fine-art printing – even re-creating old processes such as cyanotype and gum printing, which were invented long before computers had even been dreamt of.

All these techniques are covered in *The A–Z of Creative Digital Photography*. In addition, you will find helpful advice on how to add soft-focus filter effects to your digitized images, improve skies, add text, use colour creatively, rescue images, restore old photographs, create stunning panoramas and much more.

In describing each technique I have used step-by-step explanations to guide you through the stages involved, accompanied by screen images where

possible so that you know what you should be seeing on your own computer monitor, rather than just taking my word for it. In other words it's a recipe book, telling you what ingredients you need and the order in which they should be mixed together to get exactly the results you want.

I have no doubt that you won't always get it right first time – I certainly didn't – but I do hope that the confidence and inspiration you gain from reading *The A–Z of Creative Digital Photography*, and trying out some of the projects covered, will stand you in good stead for the rest of your photographic career – because, like it or not, digital is here to stay, so you might as well start making the most of it.

Lee Frost

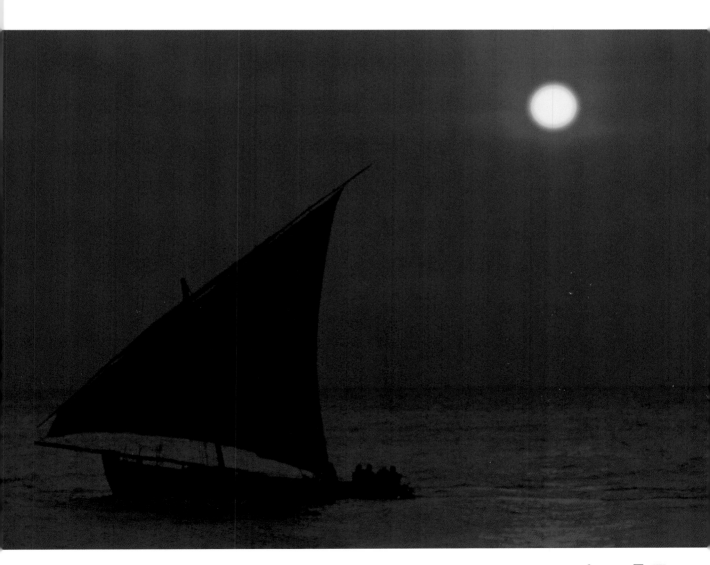

Adding Text

One of the most enjoyable aspects of photography is being able to share your pictures with others. Most of us like to send photographs to family and friends, and some people choose to display their work in frames. These days, with the advent of digital imaging and desktop publishing, you can even take things a step further and start designing and producing your own greetings cards, postcards, calendars and posters.

This is an idea that's far from new, however. For some time professional photographers have had photocards printed that feature one or more of their images along with their contact details. They use these as business cards or as notecards when they are submitting their work to magazines or book publishers. Every year I also receive Christmas cards from fellow photographers – most of them amateurs – who have had one of their favourite winter pictures turned into a Christmas card. It just adds that personal touch and is a great way to make use of good photographs.

Commercial printing is relatively expensive and print runs usually have to be high in order to keep the cost as reasonable as possible. With a basic digital workstation, however, you can make your own cards and other items quickly and easily, and for a fraction of the cost of commercial printing.

The key to producing professional-looking results is being able to add text to your images. Adding type or copy in Photoshop is actually quite easy, and once you know how to do it, you may not want to stop. To show how it's done, here is a step-by-step guide to producing your very own photocard.

HOW IT'S DONE

Step 1 Choose your photograph. You could use several images but I feel that using just one large image makes a bolder statement and keeps the look of the card simpler and more effective. I've chosen this cross-processed shot – the unusual perspective and vivid colours make it a real eye-opener so it's certainly going to attract attention.

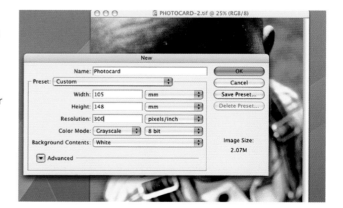

Step 2 To make life easy the card should be a standard size so that you can print it on to full sheets of inkjet paper. For this example, I'm using A6 (105 x 148mm/4⅛ x 5⅞in). This is big enough for a photocard and you can get four copies of the card on to a single sheet of A4 (210 x 297mm/8¼ x 11¾in).

To create a canvas for the card, open your selected image then go to File>New and enter the required size into the dialogue box, along with 300 for Resolution and RGB for Color Mode. Click OK and a blank canvas will appear.

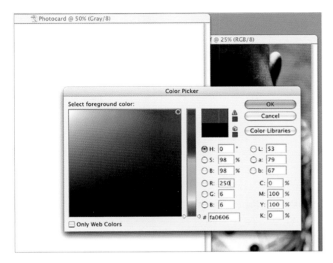

Step 3 I'm using white as the background colour of the card because the image is very colourful and white looks neat and professional. However, you can change the background colour to suit the image. All you do is click on the Set Foreground Color icon towards the bottom of the toolbox on the left of your screen, then use the Color Picker to select the new colour. For this example I have chosen red.

Step 4 To change the colour of the card, go to Edit>Fill, select Foreground Color in the dropdown menu of the Use window and click OK. The white canvas will then change to the selected colour.

Step 5 The dimensions of my photocard canvas are 105 x 148mm (4⅛ x 5⅞in). I want a 1cm (⅜in) border at the top and on both sides of the card and a 3cm/1¼in border at the bottom edge. This means that my image must fit into a box measuring 85 x 108mm (3⅜ x 4¼in), which is almost a square. The image size does not need to be reduced to fill the box, but I will need to crop it so that the proportions match.

Step 6 The image is now ready to be dropped on to the white background. To do this use the Move tool and drag the image over to the background image. As you can see, it is much larger than the canvas.

Adding Text

Step 7 To reduce the size of the image so that it fits its allocated space, go to Edit>Transform>Scale then reduce the image and reposition it. The card is now starting to take shape.

Step 10 I decided not to have the text in pure black. To change this click on the Color icon at the top of the screen and move the cursor into the grey area. After clicking OK to save the colour change, flatten the layers and make a final save.

Step 8 I have added a narrow black border around the portrait. To do this go to Select>All Layers then Edit>Stroke. In the dialogue box enter 5 pixels as the border width, choose black as the colour and click OK.

Step 9 Now it's time to add text. To do this use the Type tool. First, create a text box by dragging the cursor over the area where you want the text to be. Enter the text in the text box – in this case it is my name and contact details – then experiment with different fonts, type sizes and layouts until you are happy with the look of the card. The font I have used here is called Sand.

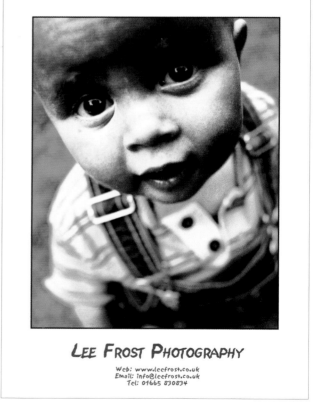

Ruis
And here is the final result – a simple, colourful and eye-catching photocard that can be printed and used to remind people of my contact details when I meet them in person or when I send off work by post.
Camera Nikon F90x **Lens** 28mm **Film** Cross-processed Agfachrome RSX100.

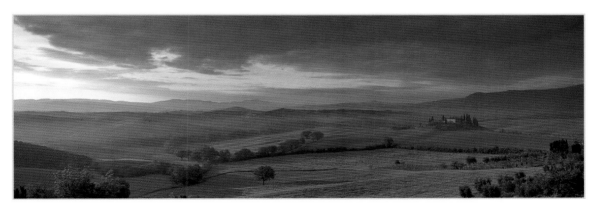

LEE FROST - TUSCAN DAWN

Belvedere, Tuscany, Italy
Given the high quality of modern inkjet printers, it is easy to turn your favourite images into stunning posters. My A3 (297 x 420mm/11¾ x 16½in)+ printer will accept a roll of paper 310mm (12¼in) wide, which means I can produce panoramic prints almost 1m (39in) long for less than it would cost to buy a poster by another photographer. These make great presents, especially when they are window-mounted and framed. For this image I created the white background simply by extending the canvas size. Text was then added along the bottom edge using the Type tool in Photoshop.
Camera Fuji GX617 **Lens** 90mm **Film** Fujichrome Velvia 50.

Old Forks
As well as using the Type tool you can also add handwritten text to an image so that it appears to have been hand-titled and signed. All you do is write the picture title and your signature on a piece of white paper, scan it at a high resolution, and then use the Move tool to drop in the scan of the text where you need it.
Camera Nikon F90x **Lens** 105mm macro **Film** Fuji Neopan 1600.

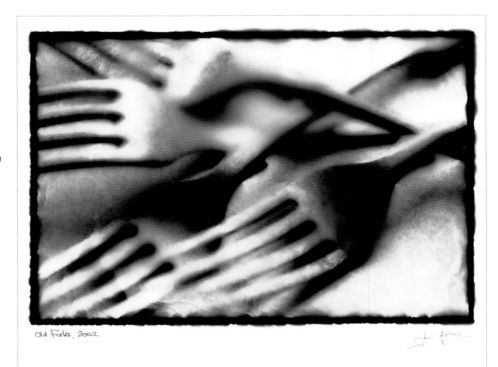

Old Forks, 2002

Bas Relief

Bas relief is a form of sculpture or etching that has a three-dimensional feel, despite being of low relief.

Creating this effect photographically involves sandwiching positive and negative copies of the same image together, slightly out of register. I used to do this by duplicating colour transparencies on to high-contrast black-and-white negative film, then sandwiching the two together – a fiddly and time-consuming affair. These days, however, you can use Photoshop to produce convincing bas relief effects at the click of a mouse.

I've shown two methods here, but I prefer the second method as you have more control over the final image and you can create colour bas relief effects, which often look striking.

WHAT YOU NEED

■ Colour or black-and-white images. Simple compositions that make use of bold shapes work best in this case.

HOW IT'S DONE: METHOD 1 – USING THE BAS RELIEF FILTER

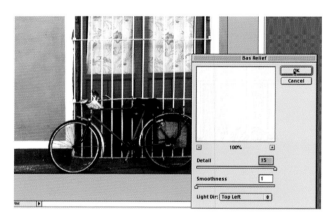

By far the quickest and easiest option is to use Filter>Sketch> Bas Relief. The dialogue box gives you three controls – Detail, Smoothness and Lighting Direction. I prefer to set the Lighting Direction to Top Left, but you don't have to. I also find that setting Detail to the maximum and Smoothness to the minimum gives the best results, though it's worth experimenting with this.

What you will find with most images is that when you click OK and the Bas Relief effect is applied, the image becomes very light in tone. This is easily remedied by adjusting Levels (see below left), and in many cases you will find that clicking Image>Adjustments>Auto Levels does the trick.

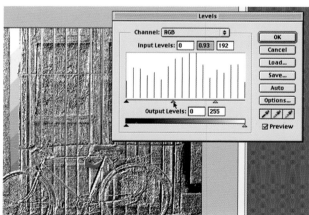

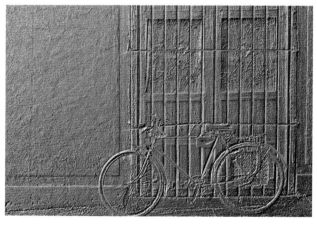

Bike, Trinidad, Cuba
This is the kind of effect you can expect, using the Bas Relief filter in Photoshop. It is quick and effective, but you don't have much control over the final image.
Camera Nikon F5 **Lens** 50mm **Film** Ilford HP5 Plus.

METHOD 2 – USING LAYERS

Step 4 Adjust the Opacity of the Background copy layer to around 50% so that you can see the other layers through it and get an idea of the effect achieved. Now click on the Move tool and move this layer slightly to one side, so it is out of register with the other layer. Flatten the image.

Step 1 Open your chosen image in Photoshop and select Window>Layers to open the layers palette. Next, select Layer>Duplicate Layer to make a copy of the original.

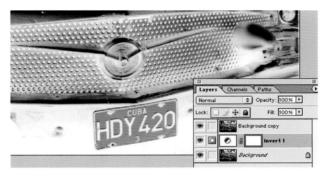

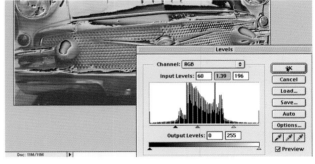

Step 2 Set the Opacity of the Background copy layer to 0% so that you can see what is happening to the image. Click on the icon for the original image then click on the New Adjustment Layer icon on the Layers palette and select Invert to make a negative copy of the original image.

Step 5 If you're not happy with the look of the image, select Image>Adjustments>Levels and tweak the levels to alter the tonal balance and create a more interesting effect.

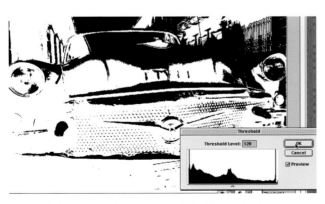

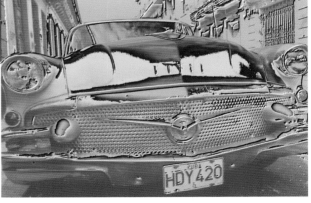

Old American Car, Havana, Cuba
Although true bas relief tends to be pure monotone, I like being able to introduce a few more tones into a photographic bas relief. In my opinion this method creates a more interesting image.
Camera Nikon F5 **Lens** 20mm **Film** Fujichrome Velvia 50.

Step 3 Click on the icon for the original image in the Layers palette then click on the New Adjustment Layer icon and select Threshold to make a high-contrast copy of the original image.

Border Effects

Creative borders are popular for black-and-white prints as they not only help to frame and set off the image, but they also add a pleasant fine-art feel.

The most popular method of creating a 'ragged' border in a traditional darkroom, and my personal favourite, is to file out the inside edges of the negative carrier or mask of the enlarger. This makes it slightly bigger than the film format it is intended for, and it also means that the edges are no longer straight and smooth. It exposes part

of the clear rebate around the edge of the negative so that it prints black and thus creates a border.

If you are using a computer there are plug-ins available, such as AutoFX Photo/Graphic Edges, that give you lots of border options, but you don't actually need such a wide choice as too many options can just make it harder to establish your own style. My advice is to save your money and create one or two simple border effects for yourself. Here are some ideas.

HOW IT'S DONE: METHOD 1 – BLACK REBATE BORDER

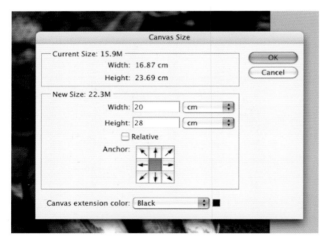

Step 1 To mimic the effect of the film rebate you need to add a thick black border to your image. To do this, go to Image>Canvas Size and extend the canvas by around 25.per cent of the height and width of the image. You also need to select Black as the Canvas extension colour.

Step 2 Select the Eraser tool from the toolbar. Click on Brush at the top of the screen then click on the small arrow in the top right of the window to reveal a list of brush styles. From this list, select Dry Media Brushes and click OK.

Step 3 Select the Pastel Medium Tip brush as shown then set the diameter of the brush to suit the thickness of the border. In this case, 70 pixels was the most suitable.

Step 4 Magnify the image on screen then, using the Eraser tool, start painting away the outer edge of the black border. This will create the film rebate effect of a sharp inner edge and a ragged outer edge. You may need to go over the same area two or three times to remove all traces of black. Slowly work your way around the image until the border is complete. If areas of the border are too ragged, you can always select a smaller brush size and go around the image again, erasing any smaller areas of black that you don't want.

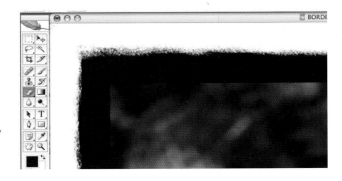

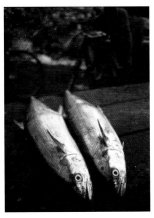

Kingfish, Stonetown, Zanzibar
Adding a ragged black border to this photograph really helps to make the two fish stand out, and also adds an extra element to the image. The border is just as striking as one created in a traditional darkroom, but it is infinitely more variable because every time you repeat it the border will be different. As a final touch, I gave the image a warm tone (see pages 148–53).
Camera Nikon F5 **Lens** 28mm **Film** Fujichrome Velvia 50.

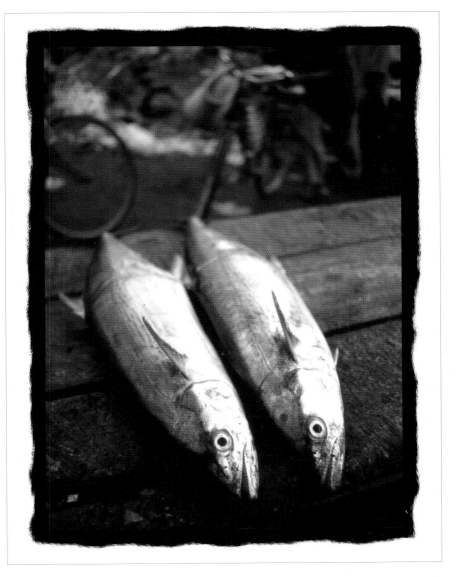

Border Effects

METHOD 2 – RAGGED BORDER

Instead of mimicking the effect of film rebates, another option is simply to make the edges of the image itself uneven. This is achieved using a technique similar to Method 1, though it involves a few more stages.

Step 1 Open your image and create a new layer on to which the border can be painted. Do this by selecting Layer>New Layer or clicking on the New Layer icon in the Layers palette. Name the new layer.

Step 2 Click on the Rectangular Marquee tool in the toolbox and make a selection on your image by clicking on the top left corner where you want the border to start. While holding down the mouse, drag the box to the bottom right of the image. The dotted line that is shown is where the border will be created.

Step 3 Go to Select>Inverse, so that the border area is highlighted by two sets of dotted lines.

Step 4 Go to Edit>Fill and in the dialogue box that appears select the fill colour as White. Click on OK. Your image will now have a white border with two sets of dotted lines surrounding it.

Step 5 Click on the Eraser tool in the toolbox and use the same brush as for Method 1, changing the size of it if necessary. Then start painting the edge of the image with the brush to create your ragged border.

Step 6 Work slowly all the way around the image until the border is complete then flatten the layers by selecting Layer>Flatten Image and save your changes.

Noah
And here's the final result. The border effect is just as good as anything you would get from a Photoshop plug-in, but costs nothing. You can vary the effect by using different brushes in different sizes.
Camera Nikon F90x **Lens** 80–200mm zoom **Film** Ilford HP5 Plus rated at ISO1600.

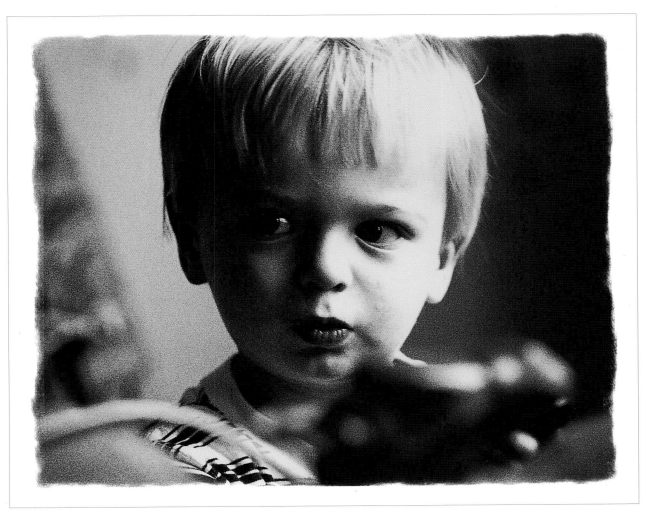

Border Effects

METHOD 3 – SCANNING A REAL FILM BORDER

Like many photographers, I love the border effect that is created by Polaroid Type 55 pos/neg black-and-white film. There are snags, however – the film is made only in 5 x 4in sheets for large-format cameras and it is also quite expensive and rather fiddly to use. Fortunately there is a solution. Scan a sheet of Type 55 film into your computer and drop your images on to it. This way you can put the characteristic border on to any photograph, taken in any format. Here's how it's done.

Step 1 Get hold of a processed sheet of Type 55 film. If you don't know a photographer who uses it, phone around some local professional studios and labs. I managed to obtain some rejected sheets from a photographer I know.

Step 2 You need to scan the sheet of film at high resolution. Large-format film scanners are costly, but a modest flatbed scanner will do the job well enough. My Microtek ScanMaker 8700 did a good job, I scanned the film to an output size of 40cm (16in) high at 300dpi.

Step 3 Open the image you want to add the border to, and make a copy using Layer>Duplicate Layer.

Step 4 Open the file containing the Type 55 scan and make sure both images are visible on your monitor.

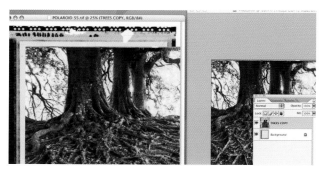

Step 5 Click on the image you're going to drop into the border then drag the copy layer of that image on to the border image.

Step 6 Go to Edit>Transform>Scale and resize the main image so that it fits neatly into the border image. There can be a slight overlap with the inner edges of the border as this creates a more convincing Type 55 effect.

Step 7 In the Layers palette change the blending mode to Multiply, then flatten the image and save.

Step 8 To finish off the image, I added a delicate warm tone using Image>Adjustments>Hue/Saturation, checking the Colorize box then adjusting the Hue and Saturation sliders. I also tweaked Levels to increase image contrast.

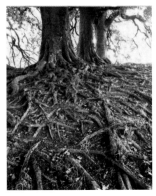

Avebury Trees
And here is the final result. Maybe not quite as delicate as a real Type 55 image – the film is renowned for its wonderful tones – but not bad considering the shot of the trees was taken on 35mm film and combined with a 5 x 4in negative.
Camera Nikon F5 **Lens** 20mm **Film** Ilford HP5 Plus.

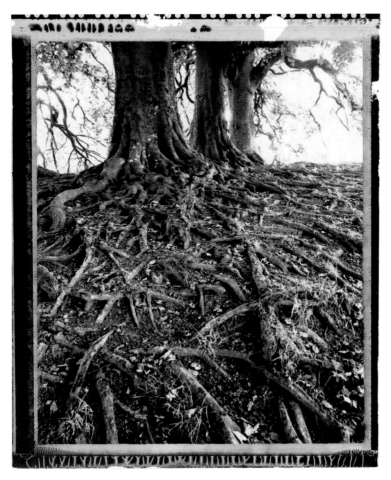

Building Pictures

One of the first creative techniques I explored when I installed Photoshop on my computer was building up my own pictures. By taking components from an original image and re-arranging and resizing them you can create a completely different picture.

I initially used this technique out of sheer desperation. I had taken part in a reader workshop for one of the magazines I write for and needed to come up with an inspiring image from the day. Unfortunately, the subject –

a huge suspension bridge – proved very difficult to photograph and the dull, grey weather just made matters worse. When I developed the films I had shot and examined the negatives, my heart sank.

However, I often find that in such situations a little imagination can go a long way, so instead of hiding away in my darkroom and attempting to perform magic on the dismal images, I scanned one of the negatives into my computer and decided to work on it digitally. The results were very pleasing.

HOW IT'S DONE

The key to this technique is making selections from the original image and pasting them on to a new canvas – a fairly straightforward process even if you are a Photoshop novice.

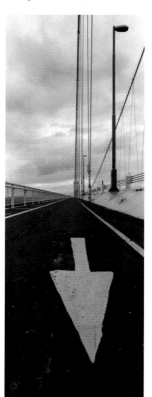

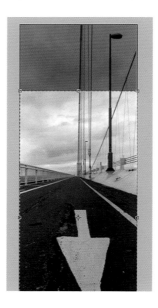

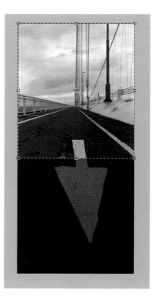

Step 1 Open the scanned image: as you can see this one is pretty drab and flat thanks to the awful weather on the day. An even bigger problem here is that the top left corner of the composition is empty because the photograph was taken on a pedestrian walkway that was outside the main framework of the bridge.

Step 2 I decided to crop the top 25 per cent off the image to place more emphasis on the foreground and make the composition more dynamic – in the original composition there was too much sky. I then copied the image.

Step 3 Next, I selected the top part of the copied image, down as far as where the converging white lines break out of the frame, and cropped the rest.

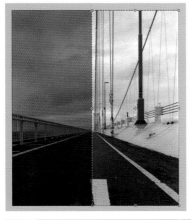

Step 4 I cropped the top part of the image again, so that only the top right corner containing the bridge framework was retained.

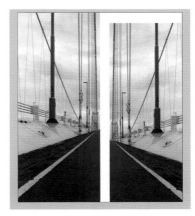

Step 7 I clicked on the original cropped section, from which the flipped copy was made, then, using the Move tool, I dragged it over and dropped it on to the extended canvas, using the direction arrow keys to move it into position.

Step 5 Next, I cleaned up the image using the Clone Stamp tool to drop pixels of the dark Tarmac over the areas of white road marking that were still visible in this cropped portion of the original image.

Step 8 Going back to the original image, I copied it again using File>Save As, then cropped out the big white arrow painted on the road in the foreground.

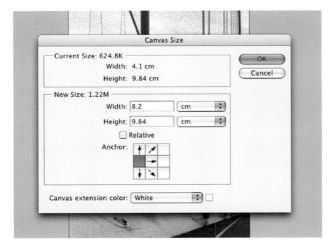

Step 6 I copied this part of the image by going to File>Save As and created a new image file. I flipped the new image – Image>Rotate Canvas>Flip horizontal – and extended the canvas so it was twice as wide using Image>Canvas Size. I then clicked on the left-hand anchor point so the canvas extension was added to the right of the image.

Step 9 The white road marking at the top right of this selection was removed using the Clone Stamp tool.

Building Pictures

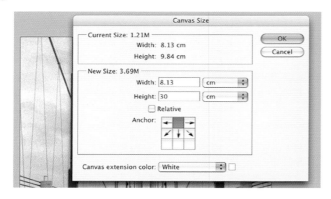

Step 10 Going back to the mirror-image of the bridge framework I finalized in step 7, I selected Image>Canvas Size then made the canvas much deeper, clicking on the top anchor point so the canvas extension was added below the existing image. I left the canvas width unchanged.

Step 13 There was also some overlap on the converging white lines on either side of the road. I corrected this by cloning parts of the white lines and covering up the black Tarmac overlapping them.

Step 11 With this image and the crop of the white arrow side by side on the desktop, I used the Move tool to drag the arrow on to the extended canvas. As you can see, it wasn't a perfect fit.

Step 12 (Below) Using the Move tool, directional arrow keys and Edit>Transform>Scale, I finalized the arrow's position and size. I then flattened the layers – Layer>Flatten Image – before cloning some areas of the black Tarmac and using them to fill any spaces and to blend the two new parts of the image.

Step 14 I was almost there. I could see where the Clone Stamp tool had been used in certain areas but I wasn't worried because the image still looked very grey and flat so it needed spicing up.

Step 15 (Below) Selecting Image>Adjustments>Levels, I adjusted the shadow slider to the right to darken the black, and the mid-tone and highlight sliders to the left to lighten the image and increase contrast. This gave a bold, graphic feel and hid the cloning scars.

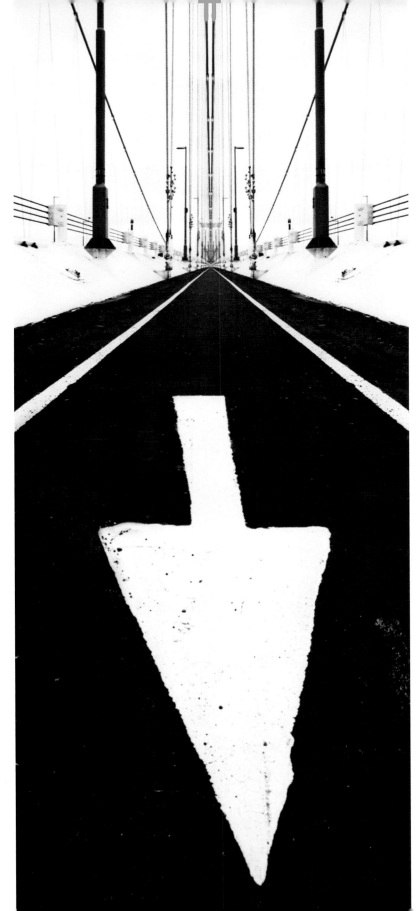

Building Pictures

Severn Bridge, Bristol, England
It was a leap of faith trying to make something interesting from the original, but I think I pulled it off. Despite the difficulties in photographing the original subject, and the dull weather, the enhanced end result is a striking and imaginative image that shows you really can make something out of nothing.
Camera Hasselblad XPan **Lens** 30mm **Film** Ilford HP5 Plus.

Changing the Background

One of the most useful things about Photoshop is the precision with which it allows you to make changes. If you don't like something, you can adjust it or even get rid of it altogether – and it is usually quicker, easier and more convincing than traditional techniques.

A good example to start with is changing the background. If you have shot a landscape and are disappointed with the sky, all you have to do is select a more interesting sky from a different photograph and use it to replace the one you are not happy with. Similarly, if you take a picture of a person against a boring background, that background can be stripped away and a more interesting one added.

Achieving this is simply a matter of combining two layers and stripping away areas of the main layer so that the second one can show through.

HOW IT'S DONE: METHOD 1 – REPLACING THE SKY

Let's start with a straightforward image. I'm happy with the sky in the original, but let's change it anyway to give you an idea of what is involved in this technique.

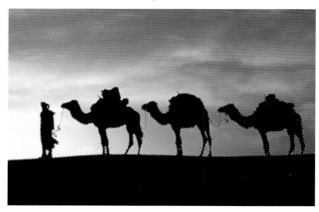

Step 1 Open the image and make a duplicate layer of it – Layer>Duplicate Layer. Next, click on the Magic Wand tool in the toolbox on the left of your screen, click on a part of the image you want to change and all the other areas in the image with a similar tone will automatically be selected. To add to the selection hold down the Shift key and click on another part of the image. Repeat this until all the areas you want to change have been selected. In this case, I did the opposite and selected the areas I wanted to keep – the silhouettes. I did this because it was quicker and easier than selecting the sky. The silhouettes are all the same tone so one click with the Magic Wand tool selected everything.

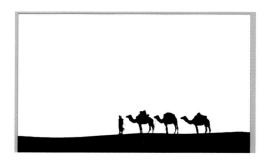

Step 2 If you select the areas you want to keep rather than change, as I did here, you need to reverse the selection so that Photoshop selects everything else. To do this go to Select>Inverse and the areas you want to change will be selected. When you've done that, press the Delete key on your keyboard and the selected areas will disappear.

Step 3 Open the image that contains the new background and make a selection from it. Here I used the Marquee tool to select an area of the orange sky including the setting sun.

Before doing this I checked the size of the sunset image to make sure that the selected area would be of similar pixel dimensions to the image I was adding it to. If the selection had been much smaller, pixelation would have occurred and ruined the effect. When you have made the selection go to Edit>Copy.

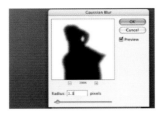

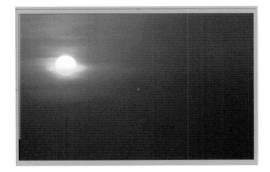

Step 4 Now click on the original image, minus the sky, and go to Edit>Paste. The selection of the new sky will be pasted on top of the original image and, if it's of similar pixel dimensions, will cover it. If the pasted selection is smaller or larger than the original, go to Edit>Transform>Scale and resize it accordingly. Save this change.

Step 5 In this example, because the part of the original image retained is in silhouette, all I had to do was change the blending mode of the sunset sky from Normal to Multiply – do this in the Layers palette – and the sunset filled the white areas where the original sky had been without showing through the silhouettes.

Step 6 The silhouettes appeared a little too sharp around the edges so I decided to soften them using Filter>Blur>Gaussian Blur, setting a low radius. You can use Preview Image to gauge the effect.

Sahara Desert, Morocco
Here is the final result after a final crop to tighten up the composition. It took no more then ten minutes to do, but the original image has been transformed.
Camera Nikon F90x **Lens** 80–200mm zoom **Film** Fujichrome Velvia 50.

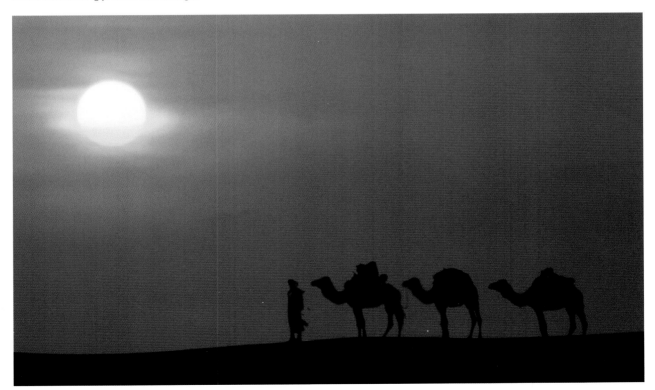

Changing the Background

METHOD 2 – CHANGING A BACKGROUND

Having seen what can be achieved with a simple silhouette, it's time to try something a little more complicated – adding a completely new background to a portrait. I used one I shot in the Cuban town of Trinidad.

Step 1 First, I selected the Polygonal Lasso tool from the Photoshop toolbox, enlarged the image on screen and started to make a selection around the man.

Step 2 After a few minutes the selection was complete and the man was surrounded by 'marching ants'. To help achieve a smooth blend with the new background I set feathering of the selection to 5 pixels.

Step 3 With the selection complete, I went to Edit>Copy and made a copy of the selection. This appeared in the Layers palette as a new layer with the background missing.

Step 4 I opened another image from Cuba and made a selection of the area I wanted to use as the new background using the Marquee tool. It is important to choose a new background that was taken in similar light to the image you are adding it to, otherwise the effect will look odd.

Step 5 With the selection made, I went to Edit>Copy to copy it, then clicked on the original portrait and went to Edit>Paste to drop the new background on to the image. Initially, all I saw was the new background.

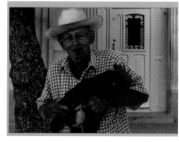

Step 6 To blend the two images properly, I went to the Layers palette and dragged the layer for the new background one place down, so it was beneath the layer for the selection from the original image. If necessary you can resize the new background using Edit>Transform>Scale and also use the Move tool to adjust it. In this case I wanted to make sure the man's head was between the tree and the door.

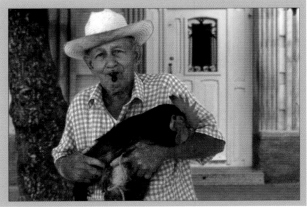

Step 7 The new image was starting to take shape, but I felt the background was too sharp so I threw it out of focus a little using Gaussian Blur – Image>Blur>Gaussian Blur.

Step 9 The transformation was complete and the effect was pretty convincing, but there was just one problem – the new image was too colourful for my liking. I therefore decided to convert it to black and white using the Channel Mixer method (see pages 34–5). I then added a warm tone using Image>Adjustments>Hue/Saturation, clicking on the Colorize box and adjusting the Hue and Saturation sliders.

Step 8 As predicted, my cutting-out left a lot to be desired and the blend between the man and the new background wasn't perfect. To remedy this, I selected the Clone Stamp tool, chose a soft brush, and smoothed the outline of the man so it was not so obvious that a new background had been added.

 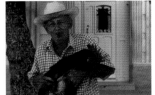

Man and his Cockerel, Trinidad, Cuba
You can see from this set of pictures how the original portrait was transformed. The man was initially photographed against a pale yellow wall; adding a more interesting background gave the portrait impact, but I felt that the colours were too bright. Converting to black and white, then toning, got rid of that problem and resulted in a much simpler image. Not bad for a first attempt.
Camera Nikon F5 **Lens** 50mm
Film Fujichrome Velvia 100F.

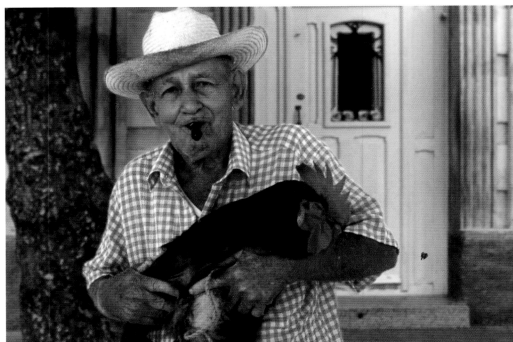

Colour Filter Effects

Filters have many applications in photography. More often than not, I use them to make sure that the film in my camera records the scene as my eyes see it – neutral density graduates balance the brightness of the sky with the landscape; the 81-series warm-up filters help to balance any coolness in the light that the film records; and the stronger 80-series blue filters cancel the warm cast that is created by tungsten lighting.

Sometimes, of course, I don't get it right. In my haste to take a shot I may forget to use a filter, decide that one isn't required, or select one that is either too strong or too weak. Nowadays, however, this doesn't matter. Once an image has been scanned into your computer, it is relatively easy to correct colour casts, or add one if you think an image would benefit from it.

Photoshop CS has even provided a Photo Filter option that allows the user to add effects from specific colour correction and conversion filters. This means that digital camera users no longer need to bother shooting with filters on their lenses – a process that reduces image quality, if only marginally.

The purpose of this section is to look at how colour filter effects can be added to your images digitally, for both technical and creative reasons.

HOW IT'S DONE: METHOD 1 – USING COLOUR BALANCE

Open an image in Photoshop then go to Image>Adjustments>Color Balance. A dialogue box will appear with three sliders that allow you to adjust the colour values in the photograph. This facility can be used in a number of ways. For example, long exposures on colour film can result in reciprocity failure, which creates unusual colour casts. I have seen examples of this where shadowy areas take on an unattractive green hue. Traditionally, there was little that could be done about it, but using digital methods it is much easier to remove colour casts from the shadows – just click on Shadows under Tone Balance in the Color Balance dialogue box and adjust the sliders to eliminate the cast.

Similarly, if you shoot in mixed lighting using a correction filter on your lens, to balance the colour cast created by one type of lighting, it will also add the colour of that filter to any other areas in the picture that are lit by a different source. In Photoshop, however, you can select individual areas in the photograph and adjust their colour balance.

You can also use Color Balance creatively, to add a colour cast intentionally to change the mood of the original photograph, as well as toning black-and-white photographs

(pages 152–3). Here are some examples of how Color Balance can be used, and the effect it has on the final image.

BALANCING A STRONG COLOUR CAST

I took the photograph opposite several years ago while leading a photographic tour in Morocco. The group and I camped in the Sahara Desert and our guides lit a fire after dinner. A few of us sat around, chatting and drinking mint tea and, as usual, I saw the potential for some interesting shots in the warm glow of the camp fire so I reached for my camera.

I knew that the low colour temperature of the flames would create a strong orange cast on daylight balanced film. A blue 80A colour correction filter would have solved this, but such a filter loses two stops of light and, given the fact that light levels were already very low and shutter speeds slow, I couldn't afford to do that. With this in mind I took a series of pictures, unfiltered. I actually quite like the orange cast that resulted, but maybe it is a little over the top, so by reducing the cyan levels and adding more blue and green I have managed to cool it down while still retaining that warm feeling. The image is now closer to how my eyes would have resolved the original scene.

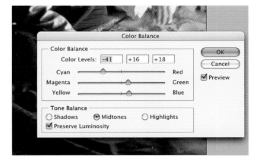

Sahara Desert, Morocco
You can see here that by cooling down the original image a little using Color Balance, it appears more natural without losing any of its mood.
Camera Nikon F90x **Lens** 50mm **Film** Fujichrome Sensia 400 rated at ISO1600 and push-processed two stops.

BALANCING A SUBTLE COLOUR CAST

Colour film is designed to give neutral rendition in light with a colour temperature of 5500°K – typically found in the middle of the day in bright, sunny weather. If you deviate far from this 'ideal' lighting condition then your colour photographs will take on a subtle colour cast.

When the colour temperature is low – early or late in the day – colour casts are usually welcome because they are warm. However, when the colour temperature is high, such as on sunny days with the sun overhead, the cool colour casts that are created generally look unattractive. The problem is that we don't see these cool casts because our eyes balance them automatically and the colours appear natural. Film can't adjust in the same way so it records the light as it actually looks.

For the photograph of Derwentwater (overleaf), taken around 1pm, I should really have used an 81A or 81B warm-up filter to balance the cool bias in the light, but because I wasn't aware of it I didn't. In addition, I used a polarizer, which made matters worse because in this kind of light polarizers can make an image even cooler than it would otherwise be.

The coolness was obvious so, having scanned the original 6 x 17cm transparency into my computer, I decided to get rid of it. To do that I used Color Balance, adding small amounts of yellow and red to warm up the image a little.

The difference isn't huge in the corrected image, but the greens look much better and there is an obvious difference in the colour of the fells (hills) beyond the lake and the partly submerged stone in the foreground.

Colour Filter Effects

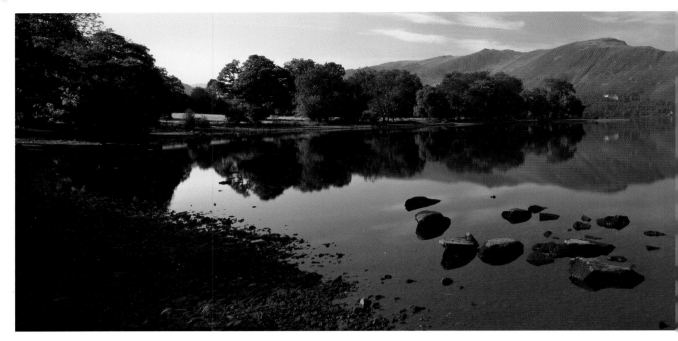

Derwentwater, Lake District, England
The cool cast in the original was easily eliminated using the controls in Color Balance. This has produced a far more attractive image.
Camera Fuji GX617 **Lens** 90mm **Filter** Polarizer
Film Fujichrome Velvia 50.

METHOD 2: USING PHOTO FILTERS

As I've already mentioned, users of Photoshop CS and CS2 have the additional advantage of being able to apply specific filter effects to images using Photo Filter. This option isn't quite as versatile as Color Balance when it comes to dealing with unusual colour casts that require the adjustment of more than one colour to eliminate them, but for general warming up and cooling down of a photograph it is very quick and easy to use.

If you go to Image>Adjustments>Photo Filter, a dialogue box opens that gives you two main controls. First, you can select the filter of your choice from the dropdown menu. Next, you can vary the level of colour applied by that filter using the Density slider. In both cases, Preview lets you gauge the effect.

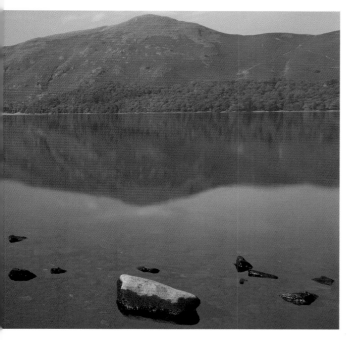

USING THE WARM-UP FILTERS

The 81-series of warm-up filters are an essential part of my regular filter collection. Warm-ups, neutral density graduates and polarizers are the only filters I use on a day-to-day basis. I carry a range of four densities – 81B, 81C, 81D and 81EF. The weaker filters are used to balance slight coolness in light, while the stronger ones are used to enhance pictures taken at dawn and dusk.

Using Photoshop's Photo Filter option you can mimic the effect of all these filters with ease. To demonstrate, I chose a photograph that was taken in very subdued lighting. A polarizer helped to improve the sky and increase colour saturation a little, but it's still rather muted. Below, you can see the difference Photo Filter can make – I used the 81 filter in each case and applied it in different densities to mimic the effects of different warm-up filters.

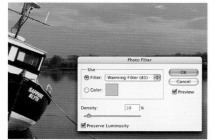

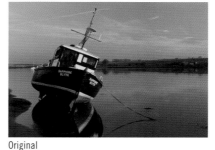

Original

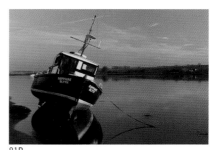

81B

81C

81D

81EF

Alnmouth, Northumberland, England
This comparison shows how Photo Filter in Photoshop CS and CS2 can be used to recreate the effects of popular warm-up filters.
Camera Pentax 67 **Lens** 105mm Filter Polarizer **Film** Fujichrome Velvia 50.

Colour to Black and White

My very first experiments with digital imaging involved converting colour images to black and white then outputting them as inkjet prints. These early results were not exactly works of art, but they certainly gave me a pretty good idea of what was possible with this technique and inspired me to delve more deeply into the different methods that can be used to create fine-art black-and-white prints from colour originals.

Many photographers are of the frame of mind that if you want to produce a black-and-white print you should shoot in on a black-and-white film in the first place. Personally, I don't happen to think that it matters, providing that the image you end up with is both pleasing and inspiring.

There can also be a great benefit to converting colour photographs digitally to black and white. You can retrieve some colour shots that you perhaps took years ago and breathe new life into them. Sometimes, you may even discover that they actually work better in black and white.

WHAT YOU NEED

- A selection of colour photographs. These can either be original colour negatives or slides (transparencies), colour prints, or image files captured using a digital camera. If you're scanning a film original, do so at high resolution and in RGB mode so all colour information is retained.

HOW IT'S DONE: METHODS 1–3

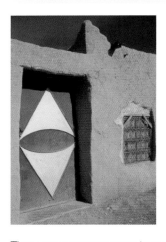

Painted Door, Hassi Labiad, Morocco
Here's what the original photograph looked like in full colour. Note how the different colours in the image translate to grey tones when converted to black and white using the various different techniques.
Camera Nikon F90x **Lens** 28mm **Filter** Polarizer **Film** Fujichrome Velvia 50.

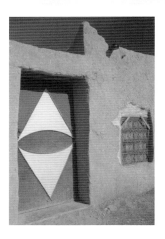

This is the result of simply converting to greyscale, with no additional work on the image. Though the different colours contrast strongly in the original, here they record as similar grey tones.

There are numerous ways to convert a colour photograph to black and white. The quickest and easiest produce reasonable results, but if you want to have greater control over the tonal balance of the final image, it is worth mastering the more time-consuming and complicated techniques.

1 CONVERTING TO GREYSCALE

By far the easiest way to convert an image from colour to black and white is simply by choosing Image>Mode>Grayscale so that all the colour information is removed from the image. This reduces the file size, but the image is changed forever and a straight conversion usually tends to result in a rather flat black-and-white photograph. You can improve things in Photoshop using Levels – Image>Adjustments>Levels – to adjust the tonal balance and contrast. The less destructive methods give better results, but if you do convert a colour image to greyscale, remember to copy the original first, otherwise it will be lost forever.

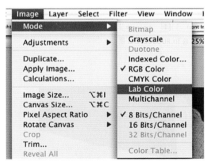

Desaturating the image gives a similar result to converting to greyscale.

2 DESATURATING THE IMAGE

If you open the colour image in Photoshop then choose Image>Adjustments> Desaturate, the photograph will be converted to black and white, but all colour information will be retained so you can use it for techniques such as toning (see pages 148–53). This is a much better option than converting to greyscale, though the black-and-white image you end up with will still need work to give it more impact. Selecting Image>Adjustments>Hue/Saturation then dragging the Saturation slider all the way to the left will desaturate the image in the same way.

3 USING LAB MODE

Although it is still a relatively quick and easy method, converting a colour image to black and white using Lab mode tends to produce much better quality results from scratch and the image you end up with will need less work to make it acceptable.

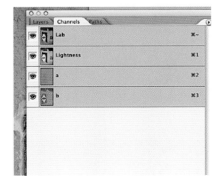

Step 1 Select Image>Mode>Lab Color. Nothing changes on the colour image, but it is now in Lab mode rather than RGB mode.

Step 2 Next, select Window>Layers to open the Layers palette then click on Channels. You will see that you have four layers – Lab, Lightness, a and b.

Step 3 You now need to get rid of either the a channel or the b channel – it doesn't matter which one, so click on one of them and drag it to the trash icon. Doing this will leave you with a high-quality black-and-white image that has better highlights and shadows than the images that are produced using the Grayscale or Desaturate commands.

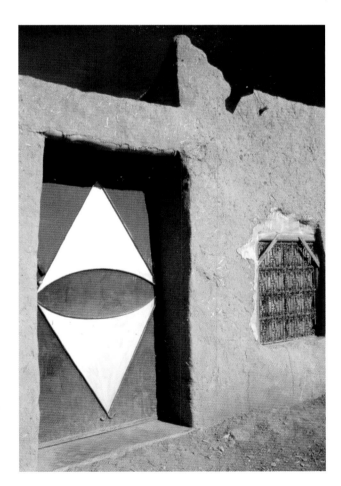

Converting to Lab mode produces a better quality black-and-white image – note the improved highlights and shadows.

Colour to Black and White

METHOD 4 – USING CHANNEL MIXER

A much more sophisticated way to convert colour images to black and white is by using Channel Mixer in Photoshop. This allows you to change the tonal balance of the image by tweaking each colour channel individually. This will achieve a similar effect to using colour filters on your lens when taking black-and white photographs on film, but you have greater control when working in Photoshop because you can achieve the effects of more than one filter on a single image. Apart from giving you greater control over the black-and-white image, using Channel Mixer does not destroy any of the original image's colour information.

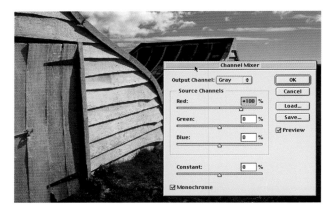

Step 1 First create an adjustment layer from the original colour image by selecting Image>Layer>New Adjustment Layer>Channel Mixer and ticking the Monochrome window in the Channel Mixer dialogue box. In default setting, the Red channel is always set at 100% and the other channels at 0%, as shown. This gives a similar effect to using a red filter on the lens when taking a black-and-white shot.

Step 2 Experiment by moving the sliders for each channel into different positions and see what happens to the image. If you set the Green channel to 100% and the others to 0%, for example, the effect is similar to shooting through a green filter.

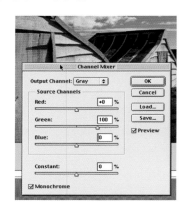

Step 3 You will probably find that the best results are obtained by changing the position of the slider for each colour channel, so experiment and see what happens.

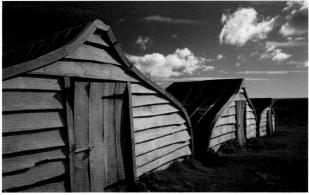

Fishermen's Huts, Holy Island, Northumberland, England
This is the original colour image used to demonstrate the use of Channel Mixer when converting to black and white.
Camera Mamiya 7II **Lens** 43mm **Filter** Polarizer **Film** Fujichrome Velvia 50.

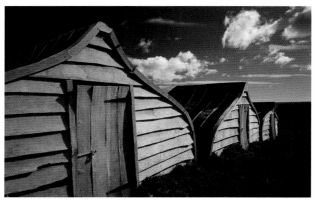

Using Channel Mixer allows you to adjust the tones of the image in the same way that using coloured filters on the lens does when taking a photograph – except that you have much more control.

METHOD 5 – INCREASING COLOUR SATURATION

A handy addition to the Channel Mixer method is to boost the colour saturation of the original image before converting to black and white. Select Image>Adjustments>Hue/Saturation, then in the edit window of the dialogue box select the colour you want to adjust. If you choose Blue and move the Saturation slider to the right, the blue sky will become darker and more intensely coloured. Don't worry that the colour looks awful: when you convert the image to black and white that will disappear. Try repeating this process with other colours, then convert to black and white using Image>Adjustments>Channel Mixer and checking the Monochrome window in the Channel Mixer dialogue box. This should give you a black-and-white image with bolder tones, though you can always make further adjustments in Channel Mixer using the previous method.

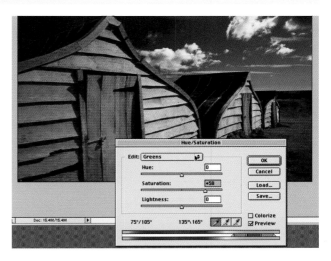

Increasing the saturation of individual colours, and also lightening certain colours, can improve the quality of your black-and-white photograph even more. In this case, the saturation of the sky was increased so it came out as a darker tone, while the green grass was lightened.

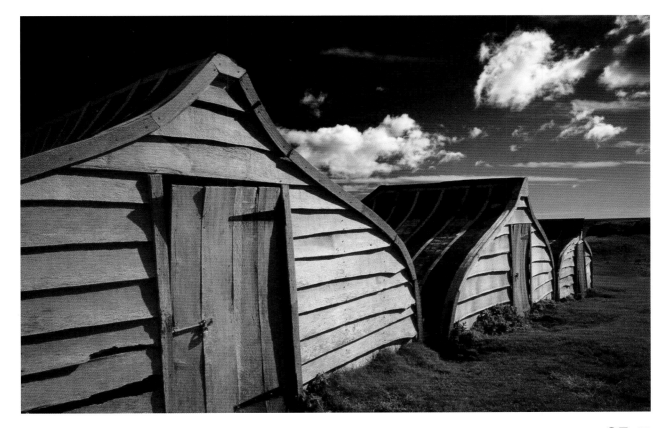

Colour to Black and White

METHOD 6 – THE FILM AND FILTER METHOD

The most versatile technique we are going to explore is one that involves working with two Hue/Saturation adjustment layers. One layer is desaturated and treated like a piece of black-and-white film. The second mimics the effects of using contrast-controlling colour filters on a camera lens. By making adjustments to the Hue and Saturation of the filter layer, it is possible to change the mood of the image completely. Although it takes a little more time to master than the other options discussed in this chapter, it is my favourite by far and I am confident that once you have tried it you will feel the same.

Step 1 First make an adjustment layer from the original. Open the Layers palette – Window>Layers – then click and hold the New Adjustment Layer command and select Hue/Saturation. Click OK to get rid of the Hue/Saturation dialogue box then change the blending mode of this layer to Color. This is your filter layer so double-click the icon and rename it 'Filter'.

Step 2 You now need to create your 'Film' layer. To do this, click and hold the New Adjustment Layer command in the Layers menu and select Hue/Saturation again. In the Hue/

Saturation dialogue box, move the Saturation slider to –100 so all colour is removed from the image, then click OK. Double-click the layer icon for this layer and rename it 'Film'.

Step 3 Click on the Filter layer then double-click to open the Hue/Saturation dialogue box. All you need to do now is move the Hue and Saturation sliders around and note how changing the position of each one affects the tonal balance, mood and impact of your image. In this case I found that moving the Hue slider to the left and the Saturation slider to the right gave the best results, but each image will be different.

Step 4 Taking things one step further, you can control the Hue and Saturation of each colour individually. To do this, open the Hue/Saturation box for the Filter layer by double-clicking its icon in the Layers palette, then click on the Edit window at the top of the box. Select one colour, such as Blue, and adjust the Hue and Saturation sliders so that the tones in the image that were blue in the colour original are changed. Repeat this with another colour, such as Green or Red, and continue until you are happy with the tonal balance of the image.

Lindisfarne Castle, Holy Island, Northumberland, England

You can see from this comparison how effective the film and filter method is for converting a colour image to black and white. The version on the far right was converted simply by desaturating the colour original and the tones are rather flat. For the final version (below) I used the film and filter technique and adjusted the Hue and Saturation of each colour individually to create a much more powerful black-and-white image.

Camera Mamiya 7II **Lens** 43mm **Filter** Polarizer **Film** Fujichrome Velvia 50.

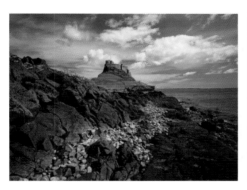

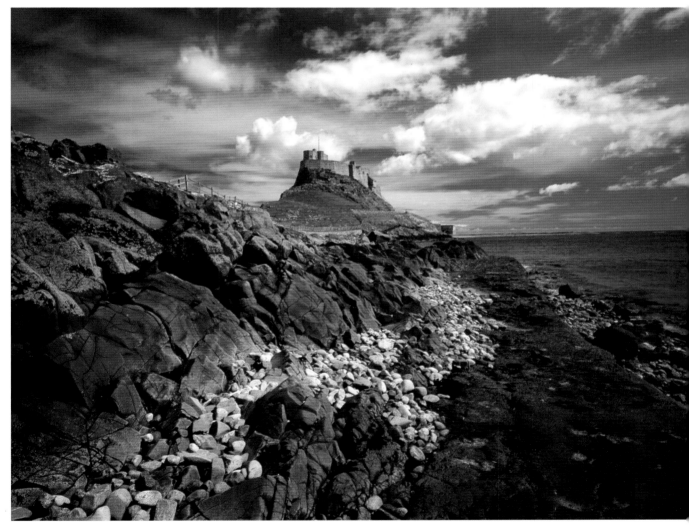

Crazy Colours

When I first became interested in photography, long before digital imaging was accessible and affordable, producing surreal colour images was a time-consuming process that involved using complicated techniques such as lith masking and pin registration. The chance of producing a successful result was slim, and even if you did its quality was dubious, to say the least.

All that has changed, however, and wacky, original images can now be produced at the mere click of a mouse. Mundane photographs can be transformed in seconds, and no matter how vivid your imagination, bringing your wildest photo fantasies to life is no longer a problem.

This is the part of digital imaging that I enjoy the most – taking an image, experimenting with it, and seeing what happens. If nothing else, it is certainly fun, and a great way to occupy a dull winter afternoon.

For the examples on these pages, I first scanned a 35mm colour transparency of a bright yellow flower against a rich red background. I then played around with the Hue/Saturation controls in Photoshop. Within minutes I had created over a dozen different variations derived from the original image. It is amazing how quickly and simply this can be done.

Of course, there is little point in creating images if you have no end use for them, but this dilemma was quickly resolved when I flicked through one of my art books and caught a glimpse of Andy Warhol's famous Marilyn Monroe print. I decided to try and use my flower images in a similar way to this.

The end result was an eye-catching image that I have not only printed at poster size but have also used as a blank message card for sending notes to family and friends.

HOW IT'S DONE

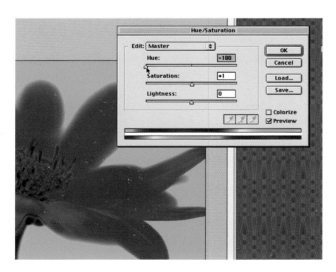

Step 1 Open your chosen image in Photoshop, make a copy, then select Image>Adjustments>Hue/Saturation. Now adjust the Hue slider slowly to the left or right and watch how the colours of the image change. When you are happy with the look you have created, save the changes.

Repeat this process several times until you have a selection of variations of the same image, each one boasting different vivid colours. I made about a dozen versions, but you can make as many as you like. To increase the possibilities, make copies of the manipulated images and adjust them rather than always copying the original.

Once you have a suitable set of images, it is time to create your Warhol-style poster.

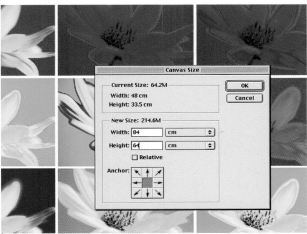

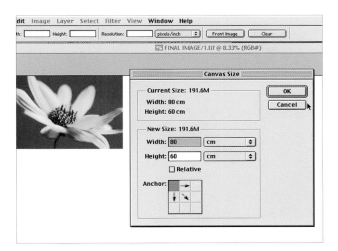

Step 2 To start creating your poster, open and copy one of the variations, rename it, then increase the canvas size (Image>Canvas Size) so it is big enough to take all the other images. I always oversize the canvas – it's better for it to be too big than too small – then crop any excess at the end. In this case I made the canvas 80cm (32in) wide and 60cm (23¼in) deep and selected the top-right anchor point so the first image would remain in the top left corner of the canvas.

Step 3 Open the next image that you want to add to the composite, and use the Move tool to drag it on to the canvas and carefully position it. I decided to leave a narrow gap between each image for effect. Repeat this process with the rest of the images until the composite is complete.

Step 4 Once all the images are in place crop any excess canvas – this will be along the bottom and right edges. Next, select Image>Canvas Size again. Leave the anchor point in its default central position and increase the canvas size by the same amount for the width and height, as shown – this will create a neat white border around the composite.

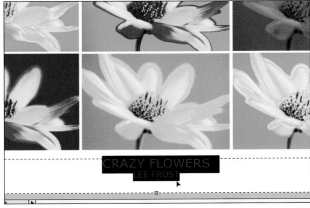

Step 5 Next, select Image>Canvas Size again. Click on the top centre anchor point then increase the canvas height a little so that the border along the bottom edge of the canvas is a little deeper than at the top and sides The reason for doing this is so that you can add a title and your name to make the finished product look like a proper poster.

To add the text, select the Type tool in Photoshop and create a text box within the bottom border of your poster. You can now type in the title of the poster. When you have done that, hit return on the keyboard and type your name on the next line.

Crazy Colours

Experiment with different fonts and type sizes. You will find a dropdown menu at the top of the screen containing all the different fonts you can use – I used Times. You will also find an option to justify the text on the left or right, or to centre it. I opted to centre the title as it looks neater. I also reduced the font size for my name. Once I was happy, I went to Layer>Flatten Image and saved all the changes.

Step 6 The final stage was to create a narrow black keyline around the edge of the canvas, mainly so that the white borders are more obvious on the printed version.

To add a keyline, choose Select>All then go to Edit>Stroke and a dialogue box will appear on screen as shown below. This allows you to choose the thickness (in pixels) of the keyline, its colour, opacity and position (on the inside or outside edge of the canvas, or central). I chose a black keyline on the outside of the canvas, 5 pixels thick with 100% Opacity.

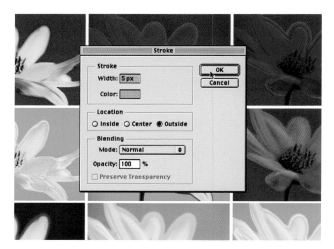

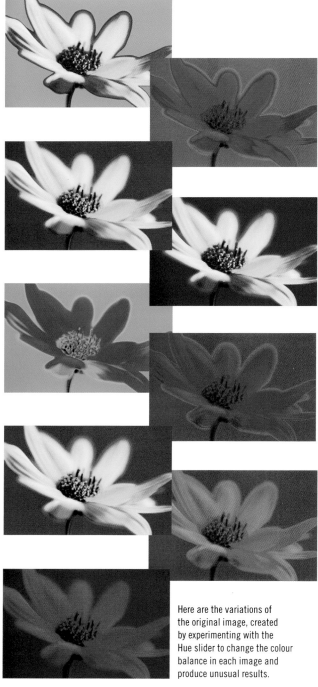

Here are the variations of the original image, created by experimenting with the Hue slider to change the colour balance in each image and produce unusual results.

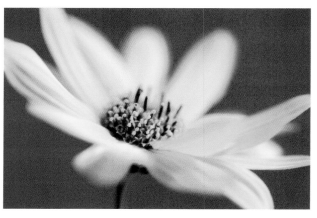

Flower
This is the original image, shot using windowlight with the flower positioned in front of a sheet of red card – the type you can buy from art shops. A reflector was placed opposite the window to fill in the shadows. The original 35mm colour slide was then scanned at high resolution using a flatbed scanner.
Camera Nikon F90x **Lens** 105mm macro **Film** Fujichrome Sensia II 100.

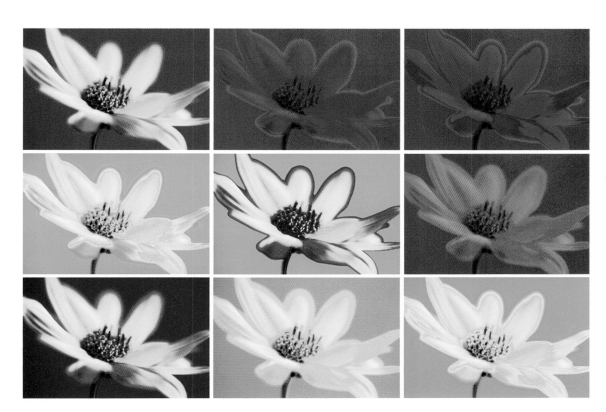

CRAZY FLOWERS
LEE FROST

Here is the final article, an eye-catching poster consisting of nine manipulated copies of the original image arranged in a neat grid pattern, complete with title and keyline. This kind of project offers endless potential for creative experimentation, allowing you to produce fine-art posters that are as good as any you will find in an art shop or gallery. Andy Warhol, eat your heart out!

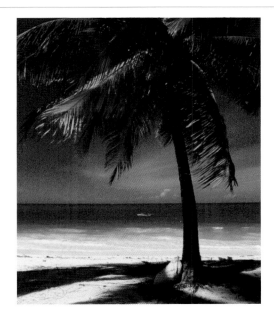

Jambiani, Zanzibar
Who says palm trees have to be green — why not blue? And what's wrong with a shocking pink sky? With Photoshop anything is possible, so use your imagination. **Camera** Nikon F5 **Lens** 28mm **Filter** Polarizer **Film** Fujichrome Velvia 50.

Cross-Processing

Developing colour film in the wrong chemicals has been a popular technique among professional photographers since the late 1980s. The effects vary widely from film to film, and some of the best films are no longer in production.

My favourite films for use with the cross-processing technique are the Agfa RSX range of colour transparency materials. Fujichrome Velvia, Provia and Sensia also respond well.

I prefer cross-processing colour slide film in negative (C-41) chemistry as the results are contrasty, grainy prints with vivid colours and an obvious warming of neutral tones. Negative film through transparency (E6) chemistry produces thinner, high-key images with casts in the highlights and shadows and loss of highlight details.

Here is how to achieve the cross-processing effect digitally.

HOW IT'S DONE: METHOD 1 – CROSS-PROCESSED SLIDE FILM

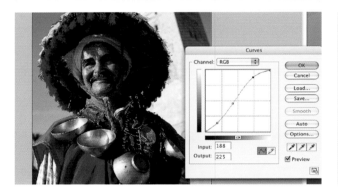

Step 1 Select Image>Curves and change the values on the RGB channel. I selected Input 188 and Output 225.

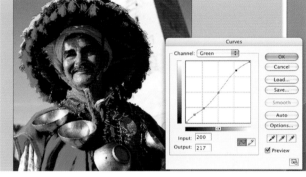

Step 3 In the Green channel, I adjusted the curve to give Input and Output values of 200 and 217 respectively.

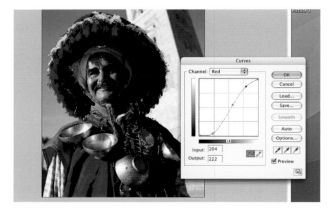

Step 2 Click on the Red channel. I changed Input to 204 and Output to 222, but instead of typing in numbers, try adjusting the curve itself – you may come up with a better effect.

Step 4 I adjusted the curve in the Blue channel to give Input and Output values of 255 and 255. You can make each adjustment by manipulating the curve or inserting values.

Step 5 Next, I added Noise at 7% to mimic the grain of cross-processed slide film.

Step 6 Finally, I tweaked Levels then Hue/Saturation to get the effect I wanted.

Waterseller, Marrakech
This kind of image is ideal for cross-processing, being bold and highly colourful. Having shot many rolls of slide film then had them cross-processed, I am pretty happy with the effect here – neutral tones tend to go yellow, other colours stay reasonably realistic, but saturation and contrast increase, and the grain is much more obvious.
Camera Nikon F90x **Lens** 50mm **Film** Fujichrome Sensia II 100.

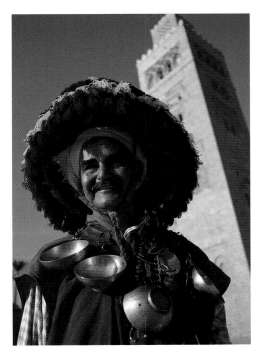

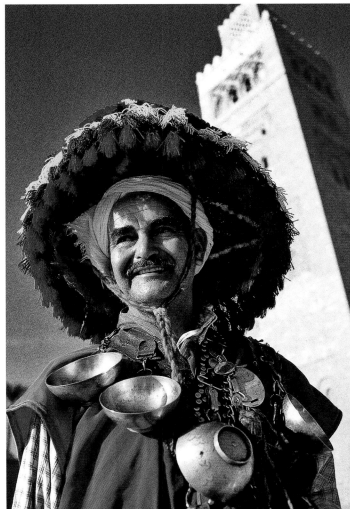

Cross-Processing

METHOD 2 – CROSS-PROCESSED NEGATIVE FILM

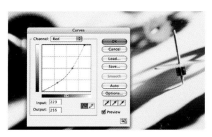

Step 1 Open the image then go to Image>Adjustments >Curves and click on the Red channel. Change the Input to 223 and Output to 255 or simply pull the curve around to form a similar shape to the one shown. Note the position of the highlight points for the red channel – this helps to produce the coloured highlights.

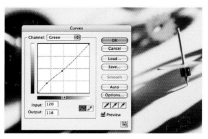

Step 2 In the Green channel adjust the curve to give Input and Output values of 120 and 116 respectively.

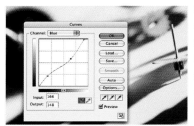

Step 3 In the Blue channel adjust the curve to give Input and Output values of 166 and 148 – or pull it into a shape like that shown on this screengrab.

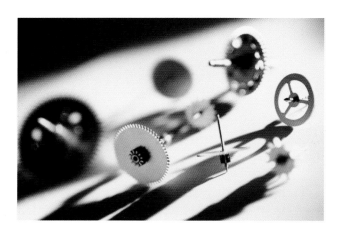

Watch Cogs
These cogs were placed on white paper and shot unfiltered, with a slide projector as the only light source – hence the warm cast on the original image. To mimic the effect of cross-processing negative film in slide (E6) chemistry, which colours the highlights and shadows and suppresses highlight detail, I adjusted Curves then brightened the highlights in Levels.
Camera Nikon F90x
Lens 105mm macro
Film Fujichrome Velvia 50.

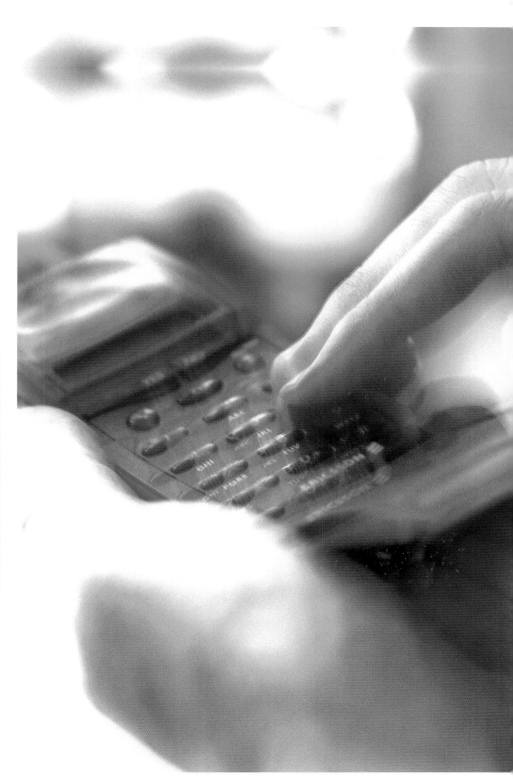

Mobile Phone
I shot this image for one of the picture libraries I supply, to capture the hustle and bustle and stress of business life. I was happy enough with the original, shot on colour slide film, but creating a cross-process effect digitally has given it a more unusual twist. I used the same curve settings for this image as I did for the image of the watch cogs. **Camera** Nikon F90x **Lens** 105mm macro **Film** Fujichrome Velvia 50.

Depth-of-Field Effects

A popular photographic technique is to use a telephoto or telezoom lens at its widest aperture so that depth of field is minimized and only a small part of the scene is recorded in sharp focus.

Differential focusing, as it's commonly known, is a great way of isolating your main subject from distracting surroundings or directing the eye to a specific part of the frame. It also adds a strong three-dimensional feel to a photograph. It's often used when shooting portraits, to make sure the background is nicely blurred and

doesn't compete for attention with the subject, but it works well on all manner of subjects, from landscape and architecture to close-ups and wildlife.

Achieving similar effects in Photoshop is quick and easy, and as usual, gives you far more control over the final result than a camera and lens, because you can select exactly which areas you want to keep sharp, which you want to blur, and how much you want to blur them. This is done using Gaussian Blur or, even better, the Lens Blur Filter in Photoshop CS.

HOW IT'S DONE: METHOD 1 – USING GAUSSIAN BLUR

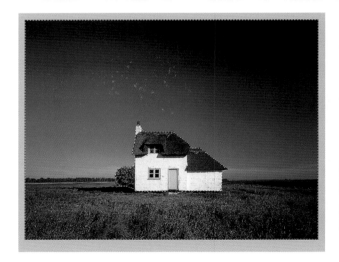

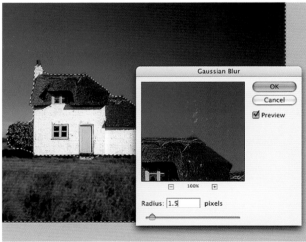

Step 1 Open your selected image, then use the Lasso tool to select the outline of the main subject so that it can be isolated. Go to Select>Inverse. You will now see 'marching ants', not only around the area you selected but also around the edge of the image. This means that you can now work on everything except the original selection.

Step 2 Go to Filter>Blur>Gaussian Blur and adjust the slider. Here, I set the Radius slider to 1.5 pixels to blur everything but the cottage. Don't overdo it at this stage.

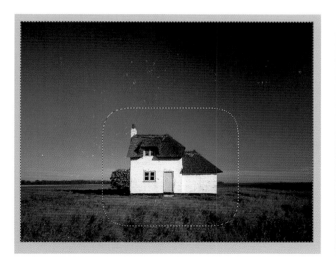

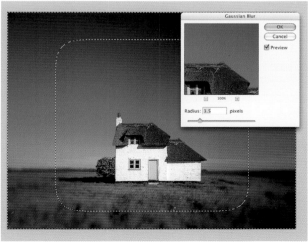

Step 3 Make a larger selection around the main subject using the Marquee tool and set the feather to 50 pixels to produce a soft edge. Now go to Select>Inverse again and apply more Gaussian Blur.

Step 4 Repeat step 3, but make the initial selection larger than the last. The reason for doing this is that you want the level of blur to increase the further you get from the main subject – as it would if you were shooting at a wide aperture to minimize depth of field. Here, I set the Radius to 3.5 pixels. You can see the effect the Gaussian Blur has had by looking at the preview image. If you overdo it, just pull the slider to the left a little and the blur will be reduced.

Canary Cottage, Thorney, Cambridgeshire, England
I used to live just a short distance from this tiny thatched cottage and one day, after years of thinking about it, I finally decided to take a photograph of it, which I did on a clear, sunny morning. I've always liked the photograph for its simplicity and bold colours, but by isolating the cottage and throwing the rest of the scene out of focus I think it works even better, and also looks more creative.
Camera Walker Titan 5 x 4in **Lens** 65mm
Filter Polarizer **Film** Fujichrome Velvia 50.

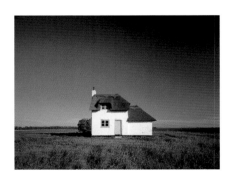

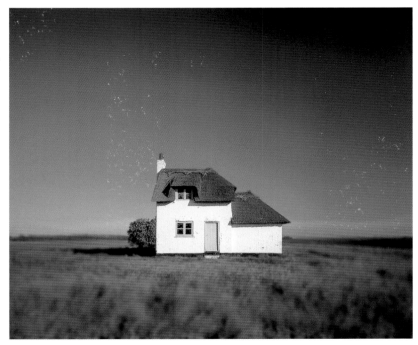

Depth-of-Field Effects

METHOD 2 – USING THE LENS BLUR FILTER

Another option for users of Photoshop CS is the Lens Blur filter – Filter>Blur>Lens Blur. This allows you to blur certain parts of the image so that they appear out of focus. A dialogue box gives you different controls to vary the effect. For the best results you need to create a layer then paint out the areas you want to keep in sharp focus using the Brush tool – the rest of the image can then be blurred. It is more sophisticated than simply using Gaussian Blur, but it is also more involved.

Step 1 Open your image then open the Layers palette – Window>Layers. Next, drag the image icon in the Layers palette down to the Create a New Layer icon at the bottom of the palette.

Step 2 Now drag the icon for the Background copy down to the Add Layer Mask icon at the bottom of the Layers palette. A white box should appear next to the Background copy icon. Before moving on to step 3, click on the eye icon next to the Background layer icon so that the layer for the original image is switched off.

Step 3 In the Layers palette, click on the Layer Mask icon (the white box next to the icon for the Background copy) then click on the Brush tool in the toolbox on the left of the screen – use it to start painting away the areas you want to keep sharp. Use a large brush to begin with, then reduce the size and type to mask off smaller areas.

Step 4 Enlarge the screen image when you are painting away small details – in this case I reduced the brush size to just 3 pixels to mask the man's hand. If you use a brush that is too big, tracing the outline of smaller details will be tricky and this could affect the success of the final image.

Step 5 After a few minutes your masking will be complete. Here, I masked off the two men in the foreground, who were engaged in an argument, so that I could blur the rest of the image to make them stand out.

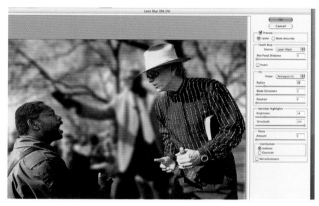

Step 6 Click on the icon for the Background copy in the Layers palette then go to Filter>Blur>Lens Blur. A rather daunting dialogue box will appear along with a large preview image. In Depth Map, click on the Source window and select Layer Mask from the options that appear. You should now be able to see which areas will be affected by the filter, and also the sharp areas that you masked off. The only change I made to the default settings in the Lens Blur dialogue was to reduce the Radius setting under Iris to 18 so that the background wasn't quite so blurred. When you are happy with the effect, click OK then save your changes.

Speaker's Corner, London, England
I photographed these two men from close range with a 20mm wide-angle lens and, even at a modest aperture setting, it still gave me quite a lot of depth of field so the background came out sharply focused. Using the Lens Blur filter I was able to isolate the men from the background to make them stand out – in the same way that a telephoto or telezoom lens would when set to its widest aperture.
Camera Nikon F5 **Lens** 20mm **Film** Ilford HP5 Plus.

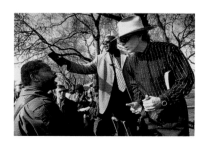

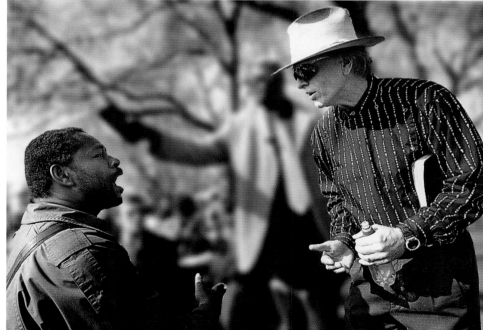

Digital to Film

You may not realize it, but digital images do not have to remain as tiny dots whizzing around in cyberspace. Thanks to modern technology, it is possible to copy or 'write' digital files back to conventional film. Therefore, an image that started life as a piece of film, and was later scanned and manipulated, can end up as a piece of film again, as can images that were captured using a digital camera.

So, why bother? Well, like many photographers, I still love working with film, but I am also happy to embrace the endless benefits of digital imaging. If I take a photograph on film that is not perfect I can scan it, manipulate it, and then have it written back to film. I can also create effects digitally that would be impossible to do in-camera, and still end up with a colour transparency.

Writing back to film also offers huge benefits in black-and-white photography. You can convert a colour image to black and white very effectively in Photoshop (see pages 30–7) then have the file written to black-and-white film and make traditional prints on fibre-based paper, a technique that digital still cannot match in terms of image quality. How's that for old and new technology working in harmony?

WHAT YOU NEED

- A selection of colour and black-and-white images and a lab that offers a film-writing service. Most pro labs offer this nowadays, so check your local directories or do an online search.

HOW IT'S DONE: METHODS 1 & 2

The actual technique of turning digital images into film is one that you and I won't ever see to completion ourselves – unless you want to invest a lot of money and buy your own film writer, which I would not advise.

Fortunately there are plenty of experts out there who can help. I found local labs offering a film-writing service where the digital file could be output on transparency or negative film in formats from 35mm to 10 x 8in.

Here are two case studies to illustrate the benefits of going from film to digital, then back to film.

1 REMOVING UNWANTED ELEMENTS

I shot this landscape (opposite, above) several years ago. The scene was perfect and the light stunning, but there was one problem – vapour trails slicing through the sky. I knew this one thing alone would prevent me from ever selling the image, but I exposed one sheet of film anyway because I loved the view and had to have something to show for my long hike.

Fast-forward a few years – I had a decent flatbed scanner, Adobe Photoshop and a new computer. One of the first jobs I tackled with my new toys was to scan the original transparency and get rid of those horrible vapour trails, which took just a few minutes but made a huge difference.

I also tweaked the colours and had a general tidy-up then sent the image away on CD, as a 50MB TIFF file, to have it written back to film.

As I still shoot exclusively with film, and almost all of my photographic submissions are film-only, this image now forms part of my portfolio and has already been published a couple of times.

2 IMPROVING THE ORIGINAL

I made a trip to the Maldives, back in 1995, to shoot stock images. During my stay I spent a day island-hopping with a group of tourists and around lunchtime found myself looking out on the scene opposite. It was a potentially great seller, but the light was awful, with hazy overhead sun and a wishy-washy sky. Even my trusty polarizer made little difference.

Several years later, I unearthed the image and decided to scan it to see if I could improve it in Photoshop. As you can see the answer was yes, significantly. As well as boosting colour saturation to make the sky and sea more attractive, I also tidied up the clouds using the Clone tool and cleaned up the sand-covered jetty to make the scene appear more idyllic. The difference is clear to see, and the new version is far more likely to sell than the original.

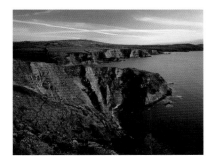

View From Dinas Head, Pembrokeshire, Wales
Camera Walker Titan 5 x 4in **Lens** 90mm **Filter**
Polarizer **Film** Fujichrome Velvia 50.

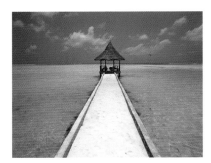

Kanifinolhu Island, Maldives
Camera Pentax 67 **Lens** 45mm **Filter** Polarizer
Film Fujichrome Velvia 50.

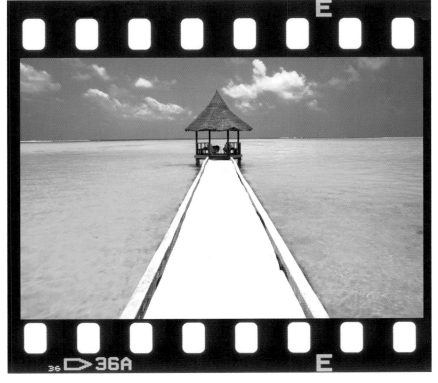

51

Dodging and Burning

When black-and-white negatives are printed in a traditional wet darkroom it is rare to come up with a perfect result simply by printing the image 'straight'. More often than not, the initial proof print will reveal areas that are too light or too dark. In order to rectify this and to make a print with balanced tones, techniques known as 'dodging' and 'burning' are used.

Dodging involves shielding dark areas of the print so they receive less exposure and come out lighter. Small pieces of card, cut into discs and other shapes then attached to lengths of fine wire, are the preferred tools for dodging small areas. A hand or a sheet of card can be used to shield larger areas during exposure.

The opposite method applies to burning. Areas of the print that are too light need more exposure to darken them. To do this, sheets of card with holes of various shapes cut out of them are used to give more exposure to specific areas, while shielding the rest of the image.

In Photoshop we can make the same selective adjustments using the Dodge and Burn tools. As with most digital tasks, they can also be performed with much greater precision and without any risk of wasting expensive paper.

To demonstrate the power of these tools, I selected an image from my collection and intentionally made certain areas even lighter and darker than they were on the unmanipulated original.

WHAT YOU NEED

- A colour or black-and-white image that requires work to lighten and darken certain areas.

HOW IT'S DONE

Both the Dodge and Burn tools are located in Photoshop's toolbox. Depending on the version of Photoshop you are using, you may see both tools in the default toolbox. In Photoshop CS2, the version used for this demonstration, the Dodge tool is visible in the default toolbox but not the Burn tool. To use the Burn tool, Alt-click the Dodge tool icon in the toolbox and the Burn tool icon will appear.

Both the tools work on the same principle – you can select different brush types from the Brushes menu and vary the size to deal with large or small areas. You can also vary the exposure, using a slider that appears at the top of your screen. The default setting is 50% but I reduced it to 30% – the lower the setting, the less effect a single application of the brush has so you can lighten or darken slowly and carefully.

Obviously, if you over-lighten an area with the Dodge tool, you can always darken it a little with the Burn tool. Beware though: both tools are destructive so never work on the original image – always make a copy and ideally work in layers.

Step 1 In this example, to speed up the job, I first made a selection of everything below the horizon using the Marquee tool, set feathering at 50 pixels to produce a seamless join and lightened the whole selection using Levels. This has saved time lightening some of the landscape, but the Bushman is still too dark and requires closer attention.

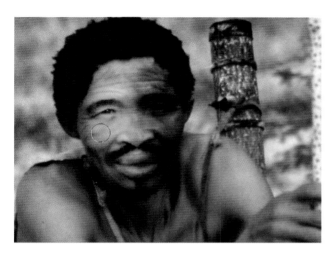

Step 2 Starting with his face, I chose the Dodge tool and selected a soft-edged brush with a diameter of 40 pixels. To burn in the area it was simply a case of painting over it gradually – the lower the Exposure setting, the more sweeps you will need to make. Another option is to select a larger brush and use mouse clicks to apply the tool, but the way you work really depends on the shape and size of the area you're working on.

Step 4 With the dodging complete, it was time to burn in the sky. This can be done using the Gradient tool, which works a bit like a neutral density graduated filter, but I also like using the Burn tool. I selected the Burn tool and a suitable brush and started painting the sky to darken it. As the sky was very bright when the picture was originally taken I didn't expect to reveal detail in all of it. Be careful – if you burn in too much the effect looks unnatural.

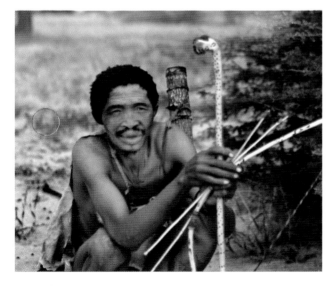

Step 3 Having achieved a satisfying result on the man, I then started lightening areas of the landscape using the same brush, but set to a bigger diameter. Patience is key. If you rush, you won't be happy with the results and as you can be more precise doing this job digitally, you might as well make the most of it.

Step 5 I used a large brush on the sky to cover a lot of ground quickly. It is actually quite therapeutic to see the effect of each stroke and the image starting to take shape. The beauty of dodging and burning digitally is that you can see results immediately, whereas in a traditional wet darkroom you have to develop and fix the print before checking to see if you have got it right, by which time it's too late to rectify your mistakes. In this example, I added duotone to enhance the mood of the picture.

Dodging and Burning

Bushman, Kalahari Desert, Namibia
Comparing the original image with the final version, you can see just how effective the Dodge and Burn tools are. Admittedly, I had made the original a little worse than it really was so you can see more of an improvement, but having had years of experience of dodging and burning prints in a darkroom, I can honestly say that doing the job digitally is infinitely easier and less prone to error. That said, it does help if you have experience of 'real' dodging and burning so that you can understand why the techniques need to be applied and what the limitations are.
Camera Nikon F5 **Lens** 50mm **Film** Ilford HP5 Plus.

PAINTING WITH LIGHT

A less conventional way to use the Dodge tool, but one that is very effective, is to treat it as a flashlight and use it to paint a subject or scene with light. I have tried this technique many times before, on everything from a bunch of flowers to the outside of a church. What is so appealing is the dappled lighting effects that are created by shining the torch on areas for different periods of time, so some come out lighter and others darker. There are no hard edges, just a gentle merging of the highlights and shadows to create surreal images.

The key to success is choosing the right image. Painting with light can only be done for real in darkness or semi-darkness, as you need low ambient light levels, so choose a low-light or night shot for your digital painting with light. This twilight shot of windmills was perfect.

Dodging and Burning

Step 1 Achieving a good result is simply down to trial and error. I selected the Dodge tool and used a soft-edged brush set to a decent size. After setting the Exposure slide to 10% I just started painting over the windmills, starting with the one nearest the camera. The key is not to make too many strokes before releasing the mouse, otherwise, if you make a mistake and want to backtrack, you could undo good work.

Step 2 From the windmill, I moved on to the low walls and gate. Painting with light creates a dappled effect so there is no need to try to get a perfect result. In fact, if the effect is too even it won't look right. By making lots of individual strokes you can gauge the effect and build it up gradually. Don't go too far though, otherwise you will produce burned-out areas and you can't put detail back.

Step 3 Having done all the painting with light that I wanted, the last stage was to tweak Levels to get the balance between the twilight sky and the windmills as I wanted it. I also realized that I had gone a bit too far with the gate, so I made a selection around it using the Marquee tool and darkened it down in Levels.

Mykonos Town, Mykonos, Greek Islands
I discovered this technique by accident, while experimenting with an image that I had intentionally darkened down so that I could lighten selected areas with the Dodge tool. I didn't realize it would produce such an interesting effect, but that is part of the fun of photography — experimentation. You can see how well the effect works on this shot. It would have been quite feasible to paint the windmills with light using a handheld flashlight, so creating the effect digitally isn't stretching the truth too far.
Camera Nikon F90x **Lens** 28mm **Film** Fujichrome Velvia 50.

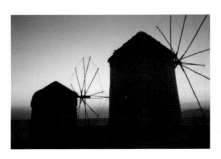

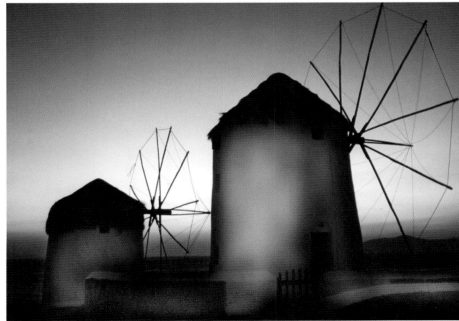

Double Exposures

Creating double exposures on film has always been a tricky technique. If you do it in-camera by exposing the same frame of film twice you either need a camera with a multiple exposure facility, or you have to rewind the film, reload it and advance to the frame where the first exposure has already been made. This tends to be a hit-and-miss affair, but since the arrival of the digital age that has all changed – even Photoshop novices can now combine images with ease.

HOW IT'S DONE: METHOD 1 – ADDING THE MOON TO A NIGHT SCENE

Step 1 Open your picture of the moon, enlarge it on screen and make a selection around it using the Lasso tool. Select just inside the outer edge of the moon and set feathering at 10 pixels to give a soft edge that will blend easily with the sky. When your selection is ready, go to Edit>Copy to copy it.

Step 2 Open your night shot and make a circular selection with the Lasso tool in the area of the sky where you want the moon to go. This selection should be bigger than you want the moon to be. Again, set feathering at 10 pixels. Go to Levels and adjust the mid-tones slider to make the sky selection a little lighter – this will help to mimic the glowing effect you get in the sky around the moon.

Step 3 With your night scene still active, go to Edit>Paste and the moon selection will appear. Use the Move tool to position it. If you want to change the size of the moon, go too Edit>Transform>Scale.

Step 4 If the moon appears too sharp, add a little grain using Filter>Noise>Add Noise and also some Gaussian Blur. This will make the moon look more realistic.

Big Ben, London, England
Here is what the final image looks like. Lightening the sky around the moon definitely makes a difference, not only by creating a more realistic effect but also by adding an eerie glow.
Camera Nikon F5 **Lens** 20mm **Film** Fujichrome Velvia 50.

METHOD 2 – DOING A DOUBLE-TAKE

Step 1 Choose a setting for your photograph that will make it easy to join together two halves of two pictures in order to create a single image. Mount your camera on a tripod, get your subject in position and make the first exposure.

Step 2 Without moving the camera, direct your subject into the second position, then make another exposure.

Step 3 Download the two images into your computer. Open the first one, make a copy of it, then crop out the half that doesn't contain your subject, as shown here.

Step 4 Go to Image>Canvas Size and extend the canvas so it is at least twice as wide, but the same height, as the cropped image.

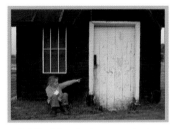

Step 5 Open your second image and use the Marquee tool to make a selection of the right side containing your subject. This selected image should start at the same point that the first one ended, so you can join them easily. Now go to Edit>Copy to copy the selection.

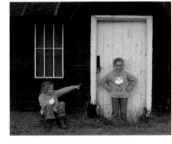

Step 6 Go back to your extended canvas, click on it, then go to Edit>Paste and the copied selection will appear. Use the Move tool to move it into position and create a seamless join.

Kitty Doing a Double-Take
Can you see the joins? Neither can I. Achieving an effect like this in-camera is tricky, but in Photoshop it's a five-minute job.
Camera Nikon Coolpix 4300 digital compact with integral zoom.

Duotone

Duotone printing involves printing in two colours rather than one. It means that, instead of reproducing images in pure black and white, subtle tones can be added. The duotone mode in Photoshop allows you to achieve the same effects digitally with your own black-and-white photographs.

You can use this method to mimic the effects of any standard toner. Also, if you give your images a delicate duotone finish, you are more likely to be happy with the prints you can produce on your inkjet printer, because achieving pure black and white is difficult unless you use special ink sets.

HOW IT'S DONE

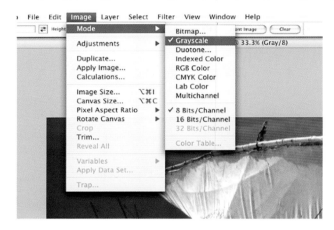

Step 1 Open your image, make a copy and convert it to greyscale using Image>Mode>Greyscale. When the dialogue box appears, click OK to discard all colour information – this reduces the image to a single channel. (In RGB mode the images use three channels so duotone can't be achieved.)

Step 2 Now go back to Image>Mode and select Duotone. A dialogue box will appear with four windows. If this is the first time you have used duotone settings, only the first window will be coloured and the default colour will be set to black. To create a duotone effect, click on the colour box for the second ink and a Pantone box will appear.

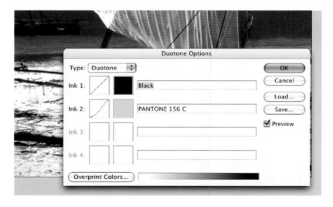

Step 3 Scroll down the list of Pantone colours – of which there are hundreds – and select one you like. In this case I went for 156C, which gives the image a sepia-like colour. You can see the effect your chosen colour has had by looking at the preview images. If you don't like it, choose another colour.

Step 4 Once you are happy with your chosen colour, you may want to tweak it. This is done by clicking on the small box next to the colour box in the duotone window so the curve for the image is opened. By adjusting the curve or entering numbers into the boxes to the right of the curve you can adjust the level of colour in different parts of the image. Entering 0 means that none of the colour will be added, while entering 100 means 100 per cent of the ink colour will be added. This may allow you to reduce the colour in the highlights while increasing it in the shadows, to achieve split-tone effects.

Step 5 Once you are happy with the duotone colour, you can save it so that exactly the same effect can be used on other images. To do this, click on Save in the duotone dialogue box, give the setting a name and save it in the duotones folder. To re-use it on another image, open your selected image, convert to greyscale, go to Image>Mode>Duotone, click on Load, click on the named duotone setting from the list, click on Load again and the pre-saved duotone settings will be applied to the new image.

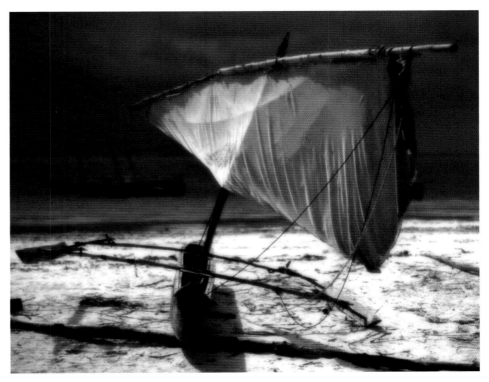

Outrigger, Nungwi, Zanzibar
Here is the final result of following steps 1–5. The image started out as full colour, it was converted to black and white in Channel Mixer and ended up as a high-quality duotone. To enhance the mood of the final image I also added a soft focus effect using Gaussian Blur (see pages 136–9).
Camera Nikon f5 **Lens** 50mm
Film Fujichrome Velvia 50.

Duotone

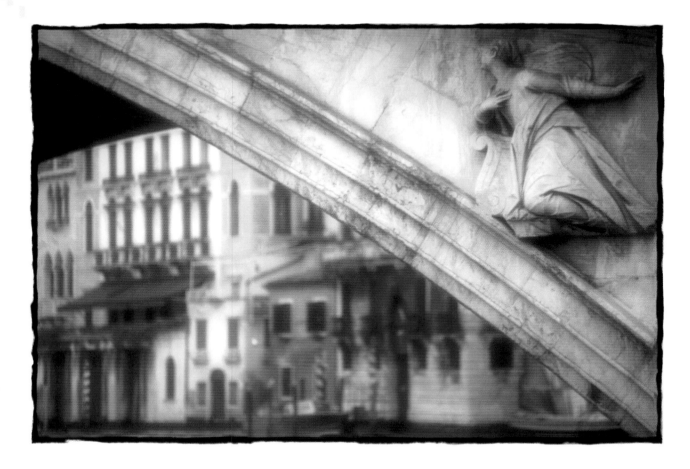

Rialto Bridge, Venice, Italy

I have always liked this shot of Venice – the soft light and muted colours are so characteristic of the city in winter. However, I felt that it would work even better as a toned monochrome image so I converted to greyscale and created a duotone setting (as shown below) to add a soft blue tone. Finally, I created a ragged border by extending the canvas in black then painting away the edges of the border with the Brush tool (see pages 14–15).

Camera Nikon F90x **Lens** 80–200mm zoom **Filter** Soft focus
Film Fujichrome RHP400.

TRITONES AND QUADTONES

Once you have mastered the art of using duotones, why not experiment with three or four different tones? This is achieved in the same way as duotone, but once you have chosen your second ink colour you can then select a third and, if you wish, a fourth.

Using tritones and quadtones gives you more subtle control over the final image colour. By combining different Pantone colours and adjusting the curve for each, you can achieve an endless range of effects by placing different colours in different parts of the tonal range, as with split toning in a wet darkroom. The key is to experiment. If you have experience of working in a traditional wet darkroom you may have a fondness for a particular type of printing paper, for example, so you can look at ways of re-creating the subtle effects of your favourite paper.

Here, I created a quadtone setting that gave a look I liked, then used it on a selection of panoramic images from my trip to Cuba to achieve a uniform look and feel. All the images were shot on colour transparency film.

Havana and Trinidad, Cuba
These panoramics were all originally shot in colour, but I felt that they would work equally well in black and white so I scanned a selection into my computer. Having applied a quadtone to the interior, I decided to use the same setting (shown above) on the other images in the set to unite them all with a common feel, as well as a common format.
Camera Hasselblad XPan **Lenses** 30mm, 45mm and 90mm **Film** Fujichrome Velvia 50.

Emulsion Lifting

Although Polaroid instant films were initially created for convenience, over the years they have become the basis of a range of fascinating, fine-art photographic techniques.

One such technique involves soaking a Polaroid print in water so that the emulsion containing the image comes away from the paper backing. The emulsion is then gathered up and transferred to another base material, usually white paper, where it is laid out again. Being so thin and delicate, however, the emulsion ends up

creased and the image is distorted, wherein lies its appeal.

Practising this technique for real is fairly straightforward if you own a Polaroid instant camera or have a Polaroid back for a large- or medium-format camera. I much prefer the digital alternative, however, because it allows you to work with existing images and you have much more control over the look of the final image.

It will help if you have seen real emulsion lifts, so you might search on the Internet for some real examples.

HOW IT'S DONE

The process of creating a Polaroid emulsion lift is quite involved, so take your time and if necessary copy your image at crucial stages. If you make a mistake that can't be rectified, or if you move on to a different stage and decide that you don't like something that you have already done, you can easily revert to an earlier saved version.

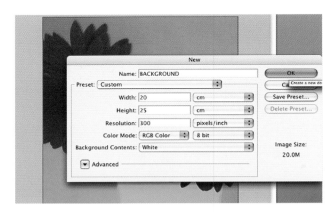

Step 1 Open your image then go to File>New and create a new canvas that is about 20 per cent taller and wider than your image. In the dialogue box that appears, enter the dimensions for the canvas, make sure the resolution is the same as that of the main image (in this case 300ppi) and set the Background Contents to White. Click OK.

Step 2 Click on the Move tool then drag the main image on to the new canvas, align it centrally and save.

Step 3 Create a Displacement Map for later distortion. To do this, click on the image you are working on then go to File>New. The settings should be the same as for the previous canvas so click OK. Next, go to Filter>Render>Clouds. The image that is created may be quite faint. If so hold down the Alt/Option key and re-apply the effect. Re-apply several times

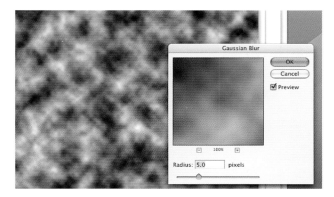

if necessary so that the image is quite dark, as shown. Now go to Filter>Blur>Gaussian Blur and enter a Radius of 5.0 pixels. Save this image as a Photoshop (PSD) file to your desktop and close it.

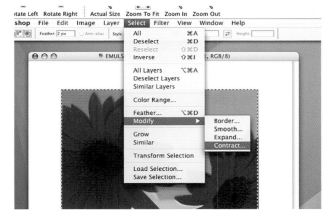

Step 4 Click on the image you want to distort then use the Rectangular Marquee tool to select the photograph itself. When you have done that go to Select>Modify>Contract. Enter a value of 2 pixels.

Step 5 Now go to Select>Inverse, then Edit>Copy, then Edit>Paste. The results of these actions will be that a thin frame is created from the outer edge of your image and saved

as a new layer. This layer will be copied several times later and used to create the folds at the edge of the emulsion lift. Set the blending mode for this layer to Multiply.

Step 6 To start the distortion, click on the layer for the main image then go to Filter>Distort>Displace. The parameters you enter will determine the level of displacement. I started with values of 3 and 3 but found the effect was too subtle so I increased them to 25 and 20, as shown. In the dialogue box you also need to select Stretch To Fit and Wrap Around.

Step 7 When you click OK a window will appear asking you to choose an image for your Displacement Map. Click on the Clouds image you created earlier then click Open. The distortion will be applied and you should see an obvious change to the image.

Emulsion Lifting

Step 8 Apply the Displacement again. If you go to the Filter dropdown menu at the top of the screen, the first option in it should be Displacement, as that is the last filter you used, so go to Filter>Displacement and the effect will be repeated. Do this several times until you are happy with the look of the image, remembering that more distortion will be added later. I came up with this after re-applying the filter a total of four times.

Step 9 Click on the layer for the thin border in the Layers palette and go to Layer>Duplicate Layer. Do this four or five times to create copy layers. Now go to Filter>Displace, and distort the first duplicate layer several times.

Do the same for the other copy layers and each time apply different levels of displacement (see step 6) to create a number of folds at the edge of the image.

Step 10 Click on the eye icon next to the layer for the white background to switch it off then go to Layer>Merge Visible so the main image layer and thin border layers are merged.

Step 11 You now need to add some texture to the image. You may have a suitable image in your library for this, but I didn't so I created one by photographing a sheet of greaseproof paper that had been screwed up then flattened out, so it contained lots of creases. I used a digital compact to take the shot then downloaded the image to my computer. The image was a little flat so I went to Image>Adjustments>Brightness/Contrast and increased the contrast.

Step 12 With the main image and the texture image both open on the desktop, use the Move tool to drag and drop the texture image over the main image. If you need to resize it, go to Edit>Transform>Scale.

Step 13 Set the blending mode of the texture image to Multiply then adjust the Opacity slider in the Layers palette until you are happy with it – 40–50% should be enough.

Step 14 Go to Filter>Liquify. In the dialogue box select quite a large brush size – I went for just over 400 pixels – then use it to push, stretch and distort parts of the image so it looks more like a very fine emulsion that has been laid down on a sheet of paper and moved around.

Step 15 Once you are happy with the overall look of the distorted image, adjust Levels if necessary (the emulsion lift won't be as dense as the original), then merge all the remaining layers using Layer>Merge Layers and save your handiwork.

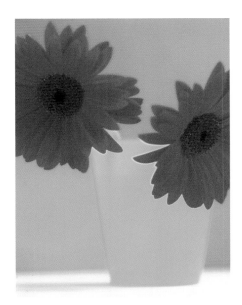

Two Red Flowers
This is my first attempt at an emulsion lift, so I am really pleased with the effect. I did bin my efforts and start again several times, gradually fine-tuning the technique, but it was worth the time and effort. Hopefully by learning from my own mistakes I can help prevent you from making the same ones. But there is no right or wrong. Just experiment – it's great fun.
Camera Nikon F90x **Lens** 105mm macro
Film Fujichrome Sensia II 100.

Faking Infrared

Infrared film is an exciting and very versatile material but many photographers are put off using it. This is because, as well as being expensive and sometimes difficult to get hold of, it requires very careful use to achieve successful results, both at the taking and, in the case of mono infrared film, printing stages.

As digital cameras become more popular and film sales decline, more specialized film is also being discontinued due to a lack of demand. Unfortunately infrared film falls into that category and is already suffering.

At the time of writing (July 2005) Konica has announced that its wonderful 750 Infrared film will no longer be made in 120 format, while Ilford has also ceased production of SFX in 120 format. Both films exist in 35mm format, as does the legendary Kodak High Speed mono infrared film, but for how long is anyone's guess.

Luckily, you no longer need to load a camera with infrared film to produce striking infrared images. The effects can now be mimicked quickly and easily in Photoshop using conventional photographs.

WHAT YOU NEED

- ■ A colour photograph, ideally shot in bright, sunny weather. Blue sky, white clouds and foliage help to show the infrared effect. The image you work with can either be shot on film and scanned or captured with a digital camera.

HOW IT'S DONE: METHOD 1 – MONO INFRARED

This is probably the quickest and easiest option, so if you're feeling lazy or want to achieve a good effect in a hurry, give this a try.

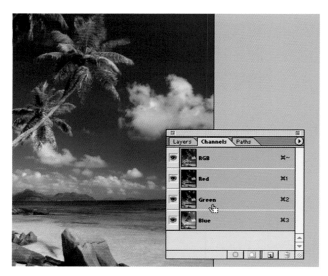

Step 1 Open the image in Photoshop, select Window>Channels and click on the Green channel.

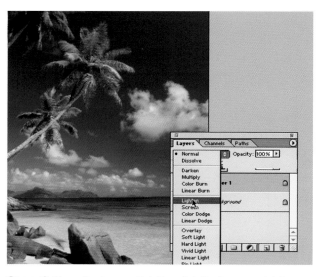

Step 2 Open the Layers Palette, click the layer containing your image and make a copy of just the Green channel using Layer>New>Layer Via Copy. Change this layer's blending mode to Lighten.

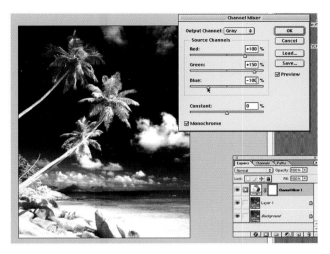

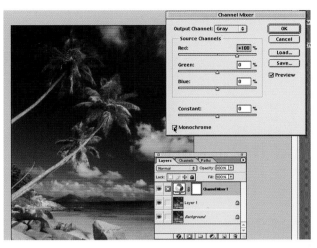

Step 3 Create a new Channel Mixer layer by clicking and holding the New Adjustment Layer command in the Layers menu and selecting Channel Mixer. In the Channel Mixer dialogue box, click on Monochrome.

Step 4 Adjust the Green and Blue sliders. A negative value for Blue will darken the sky while a positive value for Green will lighten the foliage. Try the sliders in different positions until you are happy with the effect.

La Digue, Seychelles
The dark sky, white clouds and ghostly foliage in the final image are just what you would expect from mono infrared film. Keeping the grain fine mimics the effect of Konica 750 Infrared – a wonderful film for landscape photography.
Camera Pentax 67 **Lens** 55mm **Filter** Polarizer **Film** Fujichrome Velvia 50.

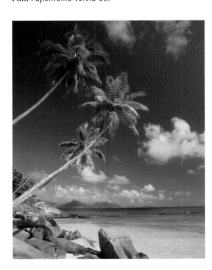

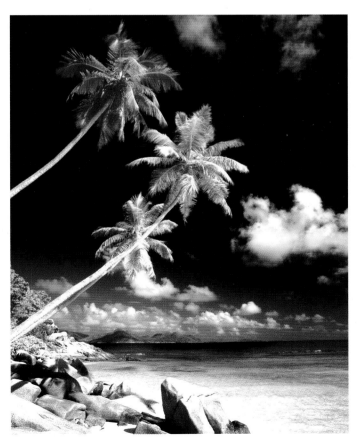

Faking Infrared

METHOD 2 – MONO INFRARED

Step 1 Open the image in Photoshop and select Image>Adjustments>Replace Color. Using the + Eyedropper tool, select an area of blue sky then drag the Fuzziness slider to the right so only the sky is selected. Here I used a value of 178.

Step 2 Drag the Lightness slider to the left so it shows –100. This darkens the sky and removes much of its colour. Already you can see the infrared effect beginning to emerge.

Step 3 Select Image>Adjustments>Hue/Saturation, choose Yellow and adjust the Lightness slider to +100. Do the same for Green. This lightens both the yellows and greens.

Step 4 Desaturate the image to remove all colour then go to Image>Adjustments>Levels and select the Green channel. Next, set the highlight slider to a value around 190, the mid-tone slider to around 1.8 and the shadow slider to around 7.

Step 5 A characteristic of infrared film is that foliage, grass and unripened crops come out very light. To recreate this effect, select the required areas and lighten them in Levels. I used the Polygonal Lasso tool to select the field and feathered by 20 pixels.

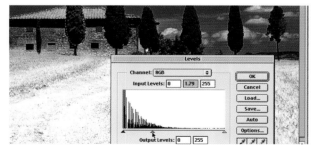

Step 6 The next stage here was to select each cypress tree in turn and lighten it using Levels. Further selections were made and the tones adjusted to give a balanced image.

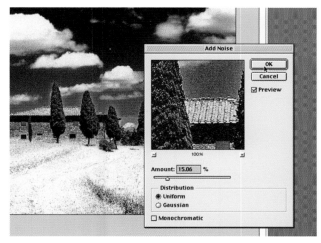

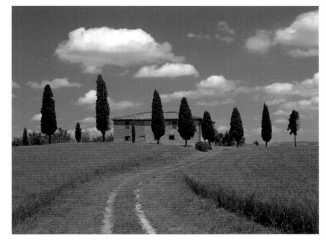

Step 7 The final step in this case was to crop the composition slightly and add coarse grain to mimic the effect of Kodak High Speed mono infrared – my favourite infrared film. You can add grain by selecting Filter>Noise>Add Noise and tweaking the Amount slider in the dialogue box until you are happy with the effect.

Near Pienza, Tuscany, Italy
And here is the final result, every bit as convincing as a photograph taken on infrared film, but without the hassle.
Camera Pentax 67 **Lens** 105mm **Filter** Polarizer **Film** Fujichrome Velvia 50.

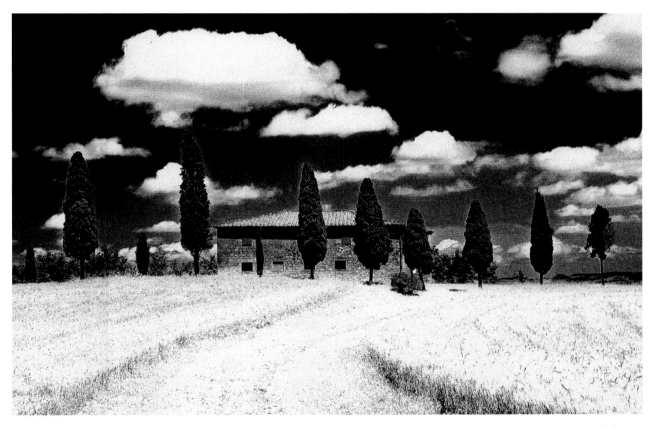

Faking Infrared

METHOD 3 – COLOUR INFRARED

Mono infrared is possibly easier to mimic because the effects of the film are very pronounced and you are also working in black and white, so less precision is required. That said, colour infrared film can produce some really eye-catching results, complete with bizarre colours. Foliage comes out crimson, for example, so if you fancy experimenting, it is well worth trying to fake the effects of colour infrared digitally.

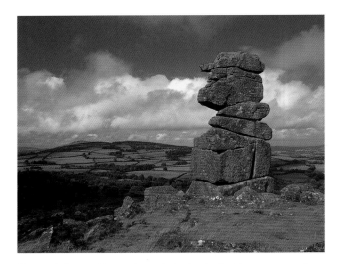

Step 1 Start with a colour photograph shot in sunny weather, ideally one that has a good sky, as this one has.

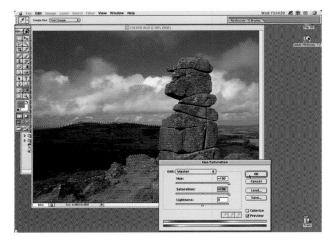

Step 2 The idea is to select different areas of the image using the Lasso tool, then make shifts to colour and saturation in Image>Adjustments>Hue/Saturation.

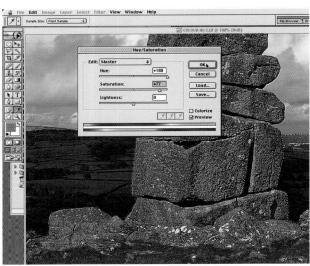

Step 3 Select each area in turn. The crimson/blue colouring I applied here is typical of infrared film exposed through a deep yellow filter. I feathered each selection by 5 pixels to get a neat edge.

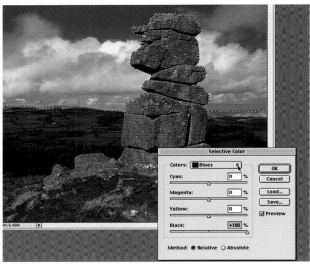

Step 4 Now it is the turn of the sky. On infrared film white clouds still tend to look white, while blue sky comes out a more intense blue. I mimicked this effect using Image> Adjustments>Selective Color, choosing Blue and tweaking the sliders, then choosing White and adjusting the Black slider to make the clouds nice and crisp.

Bowerman's Nose, Dartmoor, Devon, England

The final stage was to select the rocks and the tor and to boost their colours a little. Stone doesn't reflect a lot of infrared radiation so it tends to look fairly natural when shot on infrared film. To stay true to that effect, I selected the required areas using the Lasso tool then in Image>Adjustments>Selective Color I selected Green and tweaked the sliders until I was happy with the result.
Camera Pentax 67 **Lens** 55mm **Filter** Polarizer **Film** Fujichrome Velvia 50.

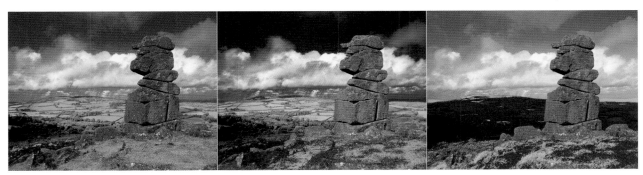

And here are some variations on the main image, created by adjusting the colours in Image>Adjustments>Hue/Saturation.

Filters for Black and White

An important part of black-and-white photography is knowing how different colours will relate to each other when they are recorded as shades of grey. A common example is red and green. As colours, one stands out clearly against the other. When captured in or converted to black and white, however, they form similar grey tones and are no longer so clearly discernible.

To get around this issue when shooting black-and-white film, photographers use coloured filters on their lens to alter the way certain colours record as grey tones. If you are shooting digitally, everything is recorded in colour, then you have the option of converting to black and white later. However, when you do this the same tonal problems will apply, so you need to be able to mimic the effects of coloured filters digitally.

The easiest way of doing this is using Channel Mixer. By making a Channel Mixer adjustment layer from the original you can work on the Red, Green and Blue channels individually to change their tonal balance.

WHAT YOU NEED

■ A selection of images containing a range of colours. If you want to try this technique merely to see how it works, choose a photograph that contains obvious reds, greens and blues.

HOW IT'S DONE

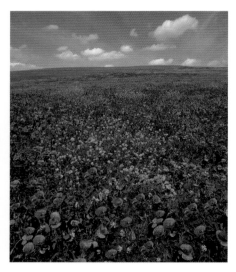

Spring Flowers, Near Pienza, Tuscany, Italy
Here is the original colour image – note the different colours in the scene and how they relate as grey tones.
Camera Pentax 67 **Lens** 45mm **Filter** Polarizer
Film Fujichrome Velvia 50.

Simply desaturating the colour image shows how it would have recorded on black-and-white film without the use of any contrast-controlling filters.

Step 1 Open your chosen colour image then open the Layers palette – Window>Layers. Next, click on the New Adjustment Layer icon at the bottom of the Layers palette and create a Channel Mixer adjustment layer. Click OK in the Channel Mixer Dialogue box, then in the Layers palette change the blending mode of this adjustment layer from Normal to Color.

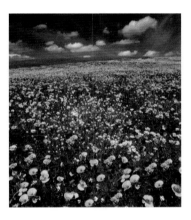

Step 2 Double-click the layer thumbnail of the adjustment layer to open the Channel Mixer dialogue box again. The default settings show Red at 100% and Green and Blue at 0%. This gives the same effects as if you had photographed the original scene through a red filter – the red poppies are light in tone while the blue sky and the greens are very dark, making the clouds stand out strongly. This effect is very dramatic, though it works well with this image.

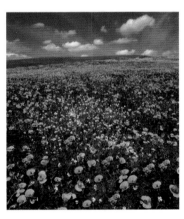

Step 3 Red filters produce a dramatic effect, but with many subjects the results look too over-the-top. Instead, an orange filter is more popular with many photographers using black and white because it does a similar job, but more subtly. There isn't an Orange channel to work on, but I find that setting Red to 70%, Green to 10% and Blue to 20% produces a similar effect to using an orange filter.

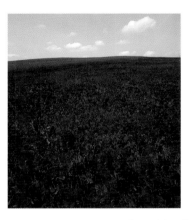

Step 4 To see what would happen if you used a blue filter, enter 0% for the Red channel (the preview image will go black) then enter 100% for the Blue channel. Here, the blue sky has been lightened so the clouds hardly stand out, while the foreground has merged horribly. It's little wonder that a blue filter is hardly ever used for black-and-white landscape photography.

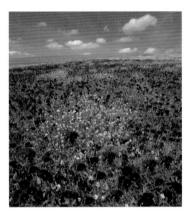

Step 5 To mimic the effects of a green filter, set the Blue and Red channels to 0% and the Green channel to 100%. The most obvious effect here is that it has lightened the greens and darkened the reds. The poppies appear almost black, the yellow flowers are lighter, while the sky is hardly affected. Green filters are used by some landscape photographers because they give a good separation of greens, but I prefer an orange filter for general use.

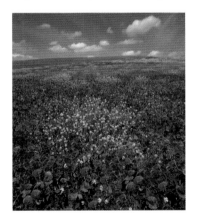

Step 6 One other filter favoured by some is yellow. Using this will darken blue sky slightly so that clouds are emphasized and give a slight increase in the overall contrast. There is no Yellow channel in Channel Mixer, but I have found that setting Red to 25%, Blue to 45% and Green to 30% comes close to mimicking the effects of a yellow filter.

Fine-Art Printing

Making prints from digital files using an inkjet printer always struck me as clinical compared to the 'art' of making handprints in a traditional darkroom. The experience of wet printing is a joy – the smell of the chemicals, the glow of the safelight, the primitiveness of using your hands and bits of card to dodge and burn, and the anticipation of pulling a perfect print from the fixer. In the digital darkroom, however, prints are generated by a machine at the click of a mouse. As time goes by, though, I move more and more in favour of inkjet printing.

In the last few years, the technology has moved on dramatically. Not only do you get much better printers for your money, but archival permanence has improved to the point where prints made using pigment inks are now as stable as conventional prints, so they won't fade after a year or so. The choice of inkjet printing papers has also increased.

I have just taken delivery of a new Epson 4800 professional printer, which uses Epson's latest Ultrachrome ink sets and produces prints up to 45cm (18in) wide – and up to 43cm (17in) wide on paper rolls, which means I can now produce prints up to 43 x 122cm (17 x 48in) from 6 x 17cm transparencies.

I never took my old printer, an Epson Photo Stylus 1290, very seriously and it showed in the quality of my prints. The new printer is bigger and better and I've realized that to get the most from it I need to do more than just load a sheet of paper and click 'Print' (see panel on calibration and profiling, pages 76–7).

WHAT YOU NEED

- An inkjet printer. There are dozens of models available. A good compromise in terms of cost/quality/size is an A3+ printer that will produce prints up to 33 x 48cm (13 x 19in) and also accept paper rolls up to 33cm (13in) wide for panoramics.

- Inks. The latest inks are far more archivally stable than the ink sets of a few years ago. Most photographers go with the printer's own inks for colour work, but for black and white printing there are independents, such as Lyson, who produce special inks.

- Papers. I prefer matt-finish papers for both colour and black-and-white images. Hahnemuhle is the first choice of many fine-art printers and, though a little expensive, produces exquisite results.

- Images. This is really down to you. I print photographs that I want to frame and hang on the wall, or to give to friends as gifts.

HOW IT'S DONE: METHOD 1 – MAKING THE PERFECT PRINT

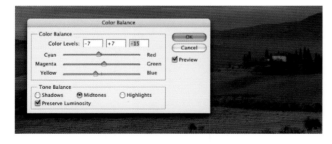

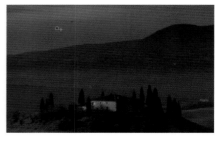

Step 1 Open your chosen image. Check that you are happy with the colour balance and make any corrections or adjustments you feel are necessary. In this case there was a slight red bias in the image, probably because I originally scanned it before my monitor had been calibrated, so I adjusted it using Image>Adjustment>Color Balance.

Step 2 Now make sure the image is 'clean' by enlarging it on screen and checking for hairs, dust spots, scratches and any other blemishes that may show up. Get rid of them using the Clone Stamp tool. Select a soft brush, Alt-click on an area next to the blemish to copy some pixels, then click on the blemish to cover it.

Image>Rotate Canvas and selected 90°CW. This rotated the image on to its side, in the direction it would be printed.

Step 3 If there are any distracting or offending elements in the picture, these can also be removed using the Clone Stamp tool or by making a selection with the Marquee tool and using Copy and Paste. In this case I decided to remove the telegraph pole and blue telegraph wire.

Step 6 Go to File>Print with Preview and a dialogue box will open. I wanted to print a panoramic image so I needed to set up the printer to do that. First I went to Page Setup and selected Stylus Photo 1290 (Roll Paper) from the Format For dropdown menu, then 210mm Paper Roll in the Paper Size dropdown menu. This is a custom paper size I created for printing panoramics on a 210mm roll of paper. I created a paper size of 21 x 65cm (8½ x 26in), which is ideal for printing panoramics like this one. Creating non-standard paper sizes can vary for different printers so check with your manual.

Step 4 Go to Image>Image Size and check the size of the file. The resolution should be a minimum of 200ppi but most photographers save their work at 300ppi. You will be outputting at 300dpi or similar so the dimensions you see in the Image Size window are the maximum dimensions you can output to. If you go much bigger the image quality will suffer, unless the file is interpolated. In this case, the image dimensions at 300ppi are approximately 62 x19.5cm (25 x 8in).

Step 5 If the orientation of the image needs changing before you print, do this now. I was printing a panoramic so I went to

Step 7 Next, go to File>Print and check other settings such as Media Type. If you've had a custom profile made for the ink/paper combination you're using then you'll know what these settings are and how they must be used – for example, Media Type Water Colour Paper Radiant White, Resolution 1440, Colour Mode Photo Realistic, Gamma 2.2. Now you just need to make sure the paper's loaded and tell the printer to print.

Fine-Art Printing

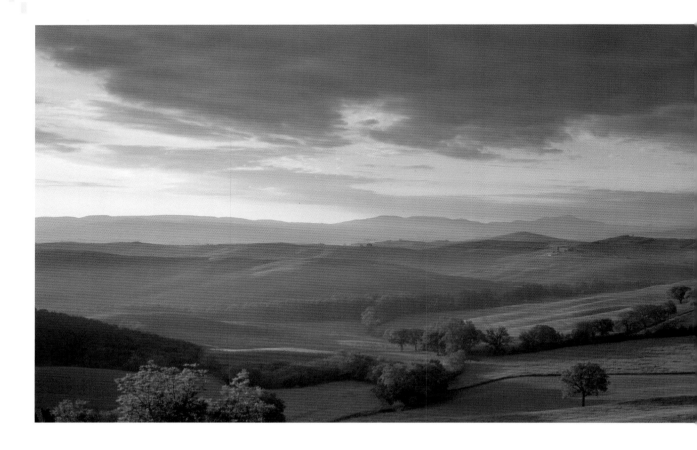

CALIBRATION AND PROFILING

One of the most important things I have discovered, to my cost, is that if you want to produce high-quality prints that are a close match to the original image, you need to do two things:

1. Calibrate your monitor.
2. Profile your printer.

Calibrating the monitor is necessary so that you can see on the screen what the image really looks like and how it is going to print. If your monitor has a slight colour cast, for example, then the colours in your photographs are not going to look right. This can be confusing if you shoot film and scan the slides or negatives, because when you compare the original to the on-screen image there will be a difference. However, if you shoot digitally the situation is even worse as you don't have an original to compare the image to. Therefore, what you see on your computer monitor is how you think the image really looks, so if you then start correcting it using image-editing software you are effectively introducing imbalance. The problems get even worse when you then proceed to make a print of the image and it looks nothing like the image you can see on the screen. Which one is correct? And where does the problem lie – with the scanner, with

The Colorview Spyder II is one of the easiest monitor calibrators to use.

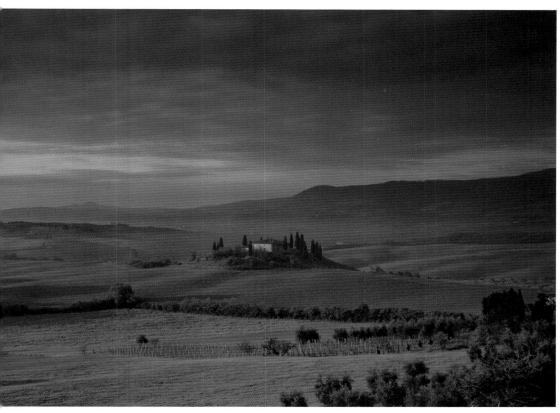

Val d'Orcia, Tuscany, Italy
It's difficult to show here just how impressive an image like this looks when printed on high-quality paper to a large size. I've seen it printed to over 1m/39in long and the image quality was still superb. **Camera** Fuji GX617 **Lens** 90mm **Filter** 0.6ND grad **Film** Fujichrome Velvia 50.

the monitor or with the printer? At least calibrating your monitor removes one variable from the equation.

For several years I avoided doing this because I assumed it would be complicated. However, when I eventually purchased a calibration kit (the Colorview Spyder II), I realized immediately that calibration is easy. You just follow the on-screen instructions you are given and within minutes it's done.

The next step towards perfect prints is profiling your printer. If you use inks and papers from the same manufacturer as the printer you own, profiling may not be necessary. However, if you use, for example, an Epson printer with Permajet inks and Hahnemuhle paper, it may be necessary to profile your printer. A printer profile is basically a piece of software that optimizes your printer driver settings to achieve optimum tone separation and ink delivery. You can usually download profiles for specific papers and inks from the manufacturers' websites, but another option is to have a custom profile made for you.

Custom profiles are made for specific ink/paper combinations and require you to carry out a number of tests with your printer at different settings so that the profile can be created. You may find, for example, that when using gloss paper you get better results when Inkjet Backlight Film is selected in the printer's media setting, rather than Premium Gloss Photo Paper. The same applies to printer resolution, colour adjustment and so on. By doing these tests and having a custom profile made, you know that, with a specific ink and paper combination, you will achieve optimum quality. At the moment I am having a profile made for my Epson 4800 printer for Epson K3 Ultrachrome inks with Hahnemuhle Photo Rag paper – this is the combination I will be using to produce my limited edition fine-art prints.

Custom profiles are not expensive, compared to the cost of printers and the amount you will spend on papers and inks over the months and years, so I highly recommend that you have them made in order to get the best from your printer.

Fine-Art Printing

METHOD 2 – PRINTING ON UNCOATED MEDIA

Of course, you don't have to use coated inkjet papers – one of the more exciting aspects of digital printing is that you can experiment with uncoated materials such as litho paper, handmade paper, textured art paper and even fabrics. I have also seen some wonderful examples where the photographer has purchased old artists' sketchbooks, in which the paper had started to discolour with age, removed the stitching from the binding, fed the pages through an inkjet printer to print images on to them, then re-assembled the books to create one-off portfolios. You could do the same thing using both new and old books to create unique, fine-art photo albums.

The main drawback to bear in mind is that image quality is never the same when you print on uncoated paper. A lack of coating means that more ink may be absorbed into the paper so that colours and tones appear weaker, or the image may print much darker. The highlight colour in the final image will also be influenced by the base colour of the medium you are printing on, so if it is old, yellowing paper, you can't expect to have crisp white highlights or perfect colour balance. However, this is all part of the fun, and if you make a copy of your selected image, you can then apply changes using Levels, Curves, Color Balance and other Photoshop settings so that it prints more satisfactorily.

Because uncoated papers are more absorbent than coated ones, ink droplets tend to merge. This means that fine detail won't be resolved as well, so you should initially work with images that don't rely on fine detail for their appeal.

I printed on old parchment-type paper that had started to go yellow. I set Page Size to A5 (148 x 210mm/5⅞ x 8¼in), as I didn't want to commit to a larger size until the image was printing well, and I set Plain Paper as the Media Type.

Step 2 The first test print looked pretty good, but I adjusted Levels to make the shadows and mid-tones lighter to give a more delicate feel. I also added a warmer, sepia-like tone and ran off a final test. Happy with that, I made the final print on an A4 (210 x 297mm/8¼ x 11¾in) sheet of the same paper.

Step 1 Open the image and check the printer settings. I did a test print first to see how the image would come out.

SCANNING

If you want high-quality prints you need to work from high-quality digital files and if you are a film user that means scanning. There are many scanners available, with prices to suit all budgets. I use a Microtek flatbed scanner as it handles all the different film formats I shoot, from 35mm to 5 x 4in and 6 x 17cm, for a fraction of the cost of a film scanner that would handle the same formats.

In reality, you get what you pay for, so if you want the very best prints, you need the very best scans. With that in mind, I have selected some shots and had them professionally scanned by someone who has years of experience and a scanner worth more than my car. The files from 6 x 17cm originals are 180MB and I can produce prints over 1m (39in) long from them.

Nude Study
Here is what the image looked like when it was printed on to a sheet of old, discoloured paper. The markings on the paper add to the feel of the final image, which is what fine-art printing is all about.
Camera Nikon F90x **Lens** 50mm **Film** Fuji Neopan 400.

Jambiani, Zanzibar
This simple, graphic composition started life as a colour transparency that I scanned and converted to black and white using Channel Mixer. I then converted it to greyscale, then duotone to add the warm tone. The first print was too dark, so I copied the image and adjusted Levels to make it lighter. The prints were made on uncoated Bockingford paper – a heavyweight, textured art paper. You can see where the ink has 'missed' the paper in places due to its coarse surface texture, a look that I am happy with.
Camera Nikon F5 **Lens** 20mm **Filter** Polarizer **Film** Fujichrome Velvia 50.

Grain

When it comes to the rather thorny subject of grain, photographers tend to fall into two distinct camps – those who love it and those who hate it.

I am happy to say that I fall into the former camp – I love grain, and the coarser it is, the better. Ever since I picked up a camera for the first time, over two decades ago, I've been experimenting with different ways of emphasizing grain, from uprating and push-processing fast film (ISO25,000 is the fastest I've managed so far) to selective enlargement and duplication.

Unfortunately, because the majority of photographers want their pictures to be as grain-free as possible, over the years film manufacturers have been going to great lengths to reduce the amount of grain. Even the fastest films available today offer surprisingly fine grain for their speed, which is why we grain fans have to resort to extreme measures to get the effect we want.

Fortunately, yet again, Photoshop has come to the rescue. It is quick and easy to add as much or as little grain as you like to existing images using various digital techniques.

This is good news if you are a digital camera user because increasing the chip speed to a higher ISO does not work in quite the same way as using ultra-fast film when you want really obvious grain. It also means that you can add grain to existing photographs that were shot on slow film, to create your own impressionistic masterpieces.

WHAT YOU NEED

- A selection of colour or black and white photographs. If they are film originals or prints, scan at high resolution. If you start with a colour image and want to convert it to black and white, do so using one of the methods explained on pages 32–7.

HOW IT'S DONE: METHODS 1–4

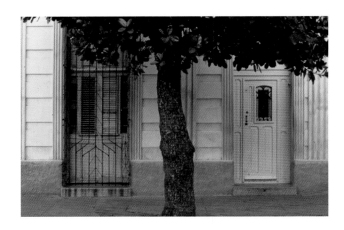
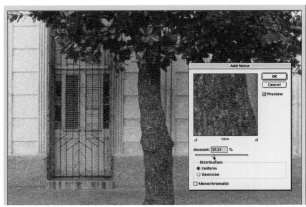

1 ADDING NOISE

Photoshop gives you various ways to add grain, each offering different levels of control and producing subtly different results. The quickest option is simply to add Noise. Open the image, select Filter>Noise>Add Noise, then adjust the Amount slider. The effect it has on the main image can be seen instantly, so you can experiment until you are happy with the result.

Cienfuegos, Cuba
This is the kind of effect you can achieve by adding Noise to an image. I set the Amount slider to around 37% and checked the Uniform option in the Distribution window. The grain is a little coarser than I would normally go for, but I wanted the effect to be obvious. As well as adding Noise, I also adjusted Levels a little and reduced Color Saturation to improve the overall mood of the image.
Camera Nikon F90x **Lens** 50mm
Film Fujichrome Velvia 50.

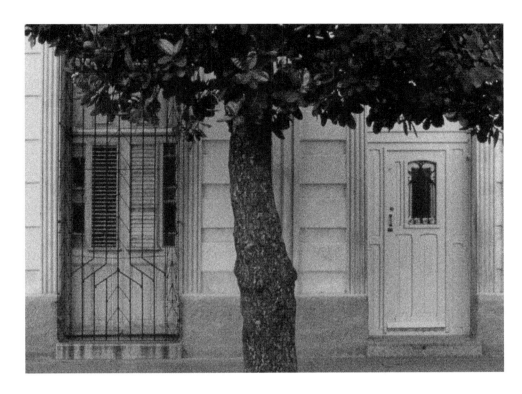

2 USING THE GRAIN FILTER

The next method is using the Grain Filter, which offers more variables to help you control the final result.

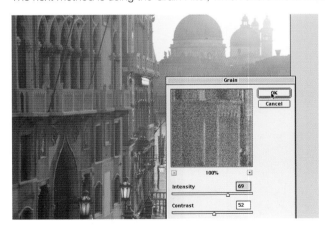

Step 1 As before, open your image in Photoshop, then select Image>Filter>Texture>Grain and a dialogue box will appear. A pulldown menu next to Grain Type gives you various options, though I find that the only two worth bothering with are Regular and Soft. Choose Soft when you want the grain to be less crisp, as I did here. To vary the effect, experiment with the Intensity and Contrast sliders.

Step 2 In order to give yourself further control it is worth making a duplicate layer of the original image. Do that by selecting the Layers palette – Window>Layers – then dragging the image down to the New Layers icon. That way, once you have applied the grain you can vary its effect by adjusting the Opacity slider. For example, if the grain is too coarse you can lessen its impact on the image by reducing Opacity to 70–80%.

Grain

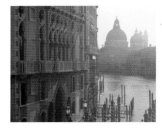

Grand Canal, Venice, Italy
At the time I took this photograph
my camera was loaded with ISO50
Fujichrome Velvia – the finest-grained
slide film on the market. I was happy
with the result (above), but I feel
that adding grain in Photoshop
using the Grain filter has enhanced
its mood significantly.
Camera Pentax 67 **Lens** 165mm
Filter 81D warm-up
Film Fujichrome Velvia 50.

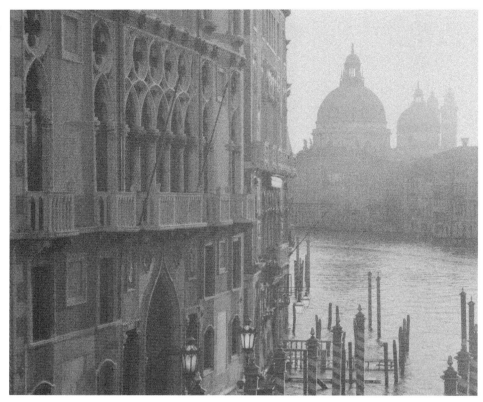

3 RETICULATION

In the good old days of photography,
when film was fragile, if you subjected it to
changes in temperature during development
– for example making the wash water much
colder than the fixer bath – the emulsion
would crack and create an unusual pattern
across the image. This is known as
reticulation. Some photographers latched
on to this 'mistake' and used it as a creative
darkroom process. Unfortunately, these
days film is much less fragile and reticulation
is almost impossible to achieve.

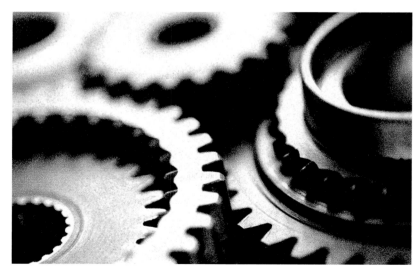

Old Gears
This image started life as a colour transparency. After scanning, I converted the original to black and white
using the Channel Mixer method discussed on page 34. I applied Reticulation then adjusted Levels to
increase contrast and make the final image more dramatic. Finally, I checked the Colorize box in the Hue/
Saturation window and adjusted the Hue and Saturation sliders to add a subtle image tone.
Camera Nikon F90x **Lens** 105mm macro **Film** Fujichrome Sensia II 100.

Luckily, Photoshop has a Reticulation filter, which also happens to be ideal for adding grain to photographs. To use it, select Filter>Sketch>Reticulation then experiment with the three sliders until you are happy with the effect. What you will find when reticulation is applied is that the image goes rather dark and flat. However, this can be remedied by adjusting Levels and using Channel Mixer with the Monochrome box checked to bring the image tones back to life.

4 USING THE FILM GRAIN FILTER

This filter adds an even grain pattern to the image in the same way that using fast film produces coarser grain evenly across the image area. The grain in film is created by clumps of the silver halides that form the light-sensitive emulsion.

Step 1 Open your image and select Filter>Artistic>Film Grain. The dialogue box will show a preview area of the image and three sliders – Grain, Highlight Area and Intensity. Move the image around in the preview box until a well-defined part of it is visible and you can use it to judge the effect of the grain

– in this case I used one of my subject's eyes. The size of the image in the preview box can be enlarged or reduced. I find that 100% usually works fine, but sometimes a setting of 75% or 50% is more suitable. You can vary the size of the preview area simply by clicking on the + or – icons below the preview box.

Step 2 It's worth making a duplicate layer of your image so that if you make a mistake you will still have the original intact. Open the Layers palette – Windows>Layers – then drag the Background layer down to the New Layer icon in the dialogue box. Double-click the duplicate layer icon and rename it 'Film Grain', or whatever seems appropriate.

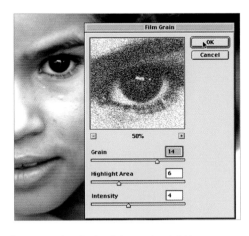

Step 3 Moving the Grain slider to the right increases grain size. Here I used a setting of 14, which is quite high, because I wanted the image to have a gritty, reportage feel. Also, I knew that if the effect was too harsh I could lessen it by reducing the opacity of the layer to something like 80 per cent.

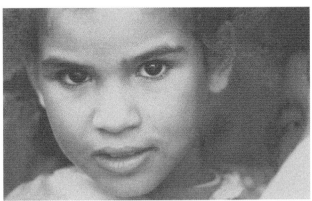

Step 4 Applying the grain made the image look rather flat and dull. This was soon remedied by adjusting Levels – darkening the shadows first then lightening the mid-tones and highlights to increase contrast and emphasize the grain even more.

Grain

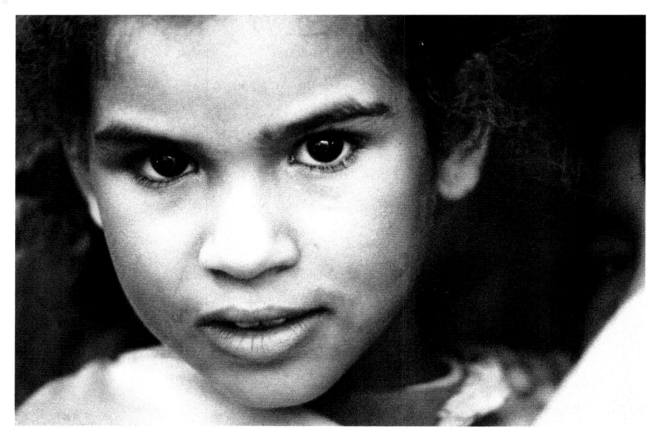

Desert Girl, Hassi Labiad, Morocco
I liked the original fine-grained portrait of this girl, but felt that the image would be stronger if I added a coarser grain. There was no way this could be done conventionally because the film used was only ISO100 and its grain was exceptionally fine. However, the Film Grain filter in Photoshop solved the problem quite easily. Once I was happy with the image contrast, I added a gentle warm tone in Curves (see pages 148–9).
Camera Nikon F5 **Lens** 80–200mm zoom **Film** Fujichrome Provia 100F.

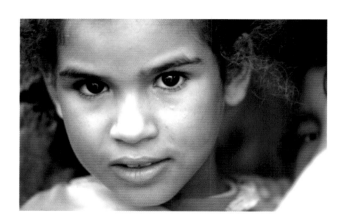

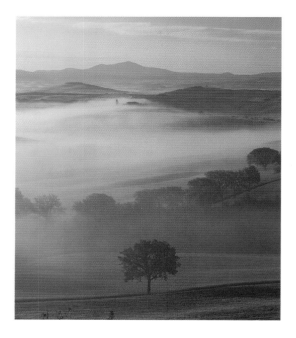

Val d'Orcia, Tuscany, Italy
It Is hard to believe that this gritty, stark black-and-white landscape started life as a tranquil colour photograph (below left),
but that is the power of Photoshop! After converting the image to black and white, I applied grain using the Film Grain filter,
then adjusted the tones in Channel Mixer until the desired effect was achieved.
Camera Pentax 67 **Lens** 165mm **Filter** 81c warm-up **Film** Fujichrome Velvia 50.

Graduated Filter Effects

A common problem with landscape photography is that the sky is usually quite a lot brighter than the landscape itself. Therefore, if you correctly expose the landscape, the sky is overexposed and comes out too bright.

The traditional way around this is to use neutral density (ND) graduate filters that have a grey top half and clear bottom half. By carefully positioning the filter on your lens you can cover the sky with the grey part of the filter so that it is toned down and records as you remember seeing it.

If you shoot digitally, there is an easier option. Instead of using a graduated filter on the lens, you can take a shot that correctly exposes the sky then use Photoshop to lighten the foreground.

This method is preferable to correctly exposing the foreground then darkening the sky in Photoshop because if the sky is really bright you risk burning out the highlights so no detail is recorded, whereas underexposure is unlikely to destroy detail so you can reveal it by lightening the area concerned.

HOW IT'S DONE

Step 1 Open your original image then make a Levels adjustment layer by going to Layer>New Adjustment Layer>Levels or clicking on the New Adjustment Layer icon in the Layers palette and selecting Levels. With this layer active, pull the highlight and mid-tones sliders to the left until the dark foreground looks correct.

Step 2 You will now notice that the sky is too bright, because Levels will have adjusted it as well as the foreground. To put that right, click on the Gradient tool in the Photoshop

toolbox, go to the tool presets in the top left corner of your screen and set Foreground to Transparent. If you are not sure which preset that is, move the cursor over each icon and their names will appear.

Step 3 Make sure the Levels Adjustment layer is active by clicking on its icon in the Layers palette then, using the mouse, take the cursor to the top of the image and draw a line straight down from the top to the horizon. This will create a black-to-transparent gradient, just like an ND grad filter. Where there is black, the effect of the Levels adjustment layer will be cancelled.

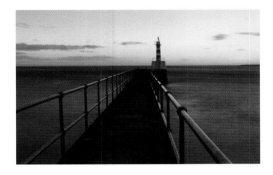

Step 4 Repeat the process of drawing lines in the sky and gradually it will be brought back to how you want it. Experimentation is the name of the game here, so as well as vertical lines, also trace them diagonally across the sky.

GRAD FILTER PLUG-INS

Plug-ins are available, such as DRI Pro Plugin v1.1 by Fred Miranda (see www.fredmiranda.com), that allow you to take two identical shots of the same scene. One will correctly expose the sky and the second will correctly expose the foreground, then at the click of a mouse the two images are combined so you get a perfect exposure across the whole image area. Not only is this quick and easy, but the precision that is achieved automatically is far greater than you could ever expect from an ND grad filter – especially if there are important elements breaking the skyline, such as buildings or trees.

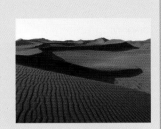

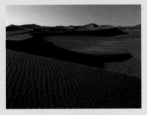

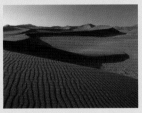

Namib Desert, Namibia
In this comparison you can see how one exposure was made for the sky and a second for the dunes. The two images were then combined to give a single image that is perfectly exposed.
Camera Nikon Coolpix 4300 with integral zoom lens.

Amble Pier, Northumberland, England
This is the kind of result you can expect from exposing the sky then using a Levels Adjustment layer to lighten the foreground and the Gradient tool to balance the sky.
Camera Pentax 67 **Lens** 55mm **Film** Fujichrome Velvia 50.

Hand-Colouring

I have always had great admiration for photographers who possess the patience to spend hours, sometimes days, painstakingly hand-colouring black-and-white prints. It is a long, laborious process of applying inks or paints in weak layers, allowing them to dry, and gradually building up the depth of colour until the final goal is achieved.

To do the job well you need to be nimble-fingered and it's easy to make mistakes. If you're not very careful, all that hard work can be in vain. Weighing up the effort that is required against the chance of producing something worthwhile, I have always taken the easy option.

With Photoshop, it is a different ball game altogether. Although it is still a relatively slow process and there are no real short cuts to success, mistakes can easily be corrected and you can work with great precision without having to be a master craftsman. In fact, it is possible to produce stunning results on your very first attempt.

If you start off with a colour image, desaturate it rather than converting to greyscale mode, as you will need the colour information. In some cases it is also a good idea to give the image a weak sepia tone, which acts as a useful background colour. The quickest way to do this is to go to Image>Adjustment>Hue/Saturation, click on the Colorize box then tweak the Hue and Saturation sliders until you are happy with the tone.

WHAT YOU NEED

■ A selection of colour or black-and-white images.

HOW IT'S DONE

Digital hand-colouring involves selecting the area you want to colour then using Hue/Saturation adjustment layers to apply each colour.

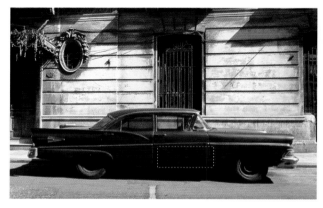

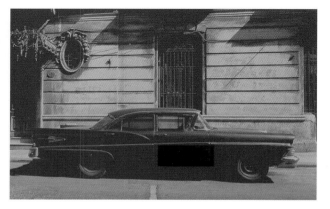

Step 1 Select as much as you can of the first area you want to colour using the Marquee tool or Lasso tool. In this case the plan was to colour only the car, so I selected part of one door, as shown by the dotted lines.

Step 2 Click on the Quick Mask icon towards the bottom of the toolbox so that everything, apart from the area that you have selected, turns red.

Step 3 Change the foreground colour to white by clicking on the large white square in the toolbox and moving the marker in the Color Picker that appears to the top left corner. Click OK.

Step 4 Select the Brush Tool icon from the toolbox and choose a soft brush. Enlarge the image and start painting away the red mask from the area you want to colour.

Step 5 Don't worry if you are a little heavy-handed and paint away areas that you don't want to colour – mistakes can be rectified using the Eraser tool to paint back the red mask.

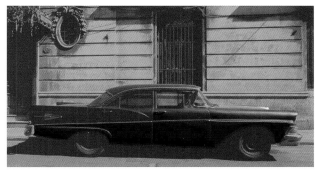

Step 6 If the area you are painting is large, as it is here, it is a good idea to reduce the image size every few minutes to check your progress. In this case I wanted to colour all of the car bodywork that was coloured in real life, and this meant painting away the mask from each body panel in turn.

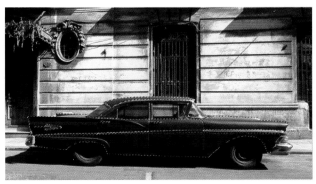

Step 7 When you have revealed the whole area, switch off the Quick Mask. The areas selected will be bordered by dotted lines of 'marching ants'.

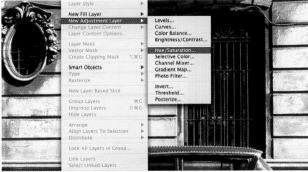

Step 8 Go to Layer>New Adjustment Layer>Hue/Saturation then, when the pop-up window appears, adjust the Hue and Saturation sliders until you are happy with the colour.

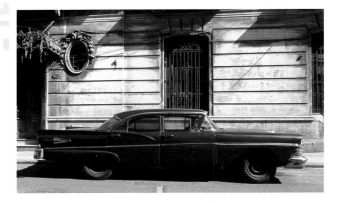

Step 9 What you choose to do is up to you. It can be subtle, vivid, realistic or completely out of this world – just use your imagination. Here are two variations.

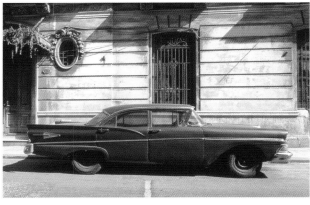

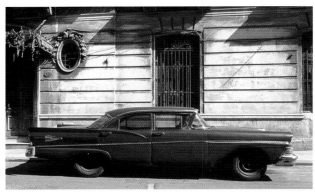

Old American Car, Havana, Cuba
I finally settled on green for the car, simply because it was green in real life. I did consider adding small splashes of colour elsewhere, such as in the plant overhanging the door to the left, but I decided to keep it simple. The whole job took around 30 minutes from start to finish – not bad for my very first attempt at hand-colouring.
Camera Nikon F5 **Lens** 28mm **Film** Ilford FP4 Plus.

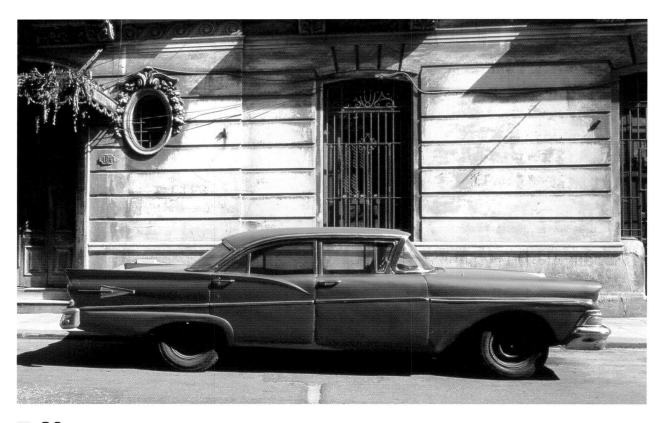

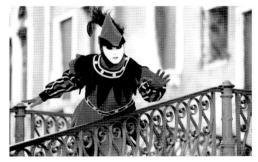

Venice Carnival, Italy
Fresh from the success of my first attempt, I decided to try something a little more ambitious with this shot. First, the black-and-white image was sepia-toned to add a background colour. Next, I carefully selected each area of the costume that I wanted to be red and added the colour using a Hue/Saturation adjustment layer. After that I selected and coloured the woman's lips. I could have left it at that, but I decided too put some colour in the background — first the pale blue of the shutters on the windows, then the pastel yellow tone on the walls. All the white areas were left untouched, as was the railing in the foreground, which shows the sepia tone I added initially. Producing this image was great fun and took around one hour.
Camera Nikon F5 **Lens** 80-200mm zoom **Film** Ilford FP4 Plus.

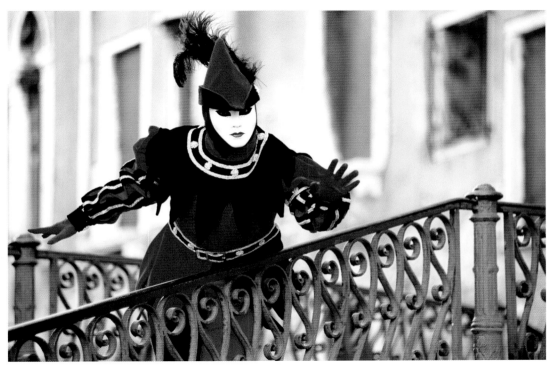

Shop Front, Trinidad, Cuba
You don't always have to add colour to black-and-white images, you can also take colour away from colour ones to achieve similar results. Here I used Quick Mask to select everything apart from the door and the bicycle. Then I desaturated the adjustment layer so that the wall and pavement were converted to black and white. I then went to Image>Adjustments>Hue/Saturation and increased saturation in the rest of the image to make the bike, door and curtain more vivid.
Camera Nikon F5 **Lens** 28mm
Film Fujichrome Velvia 50.

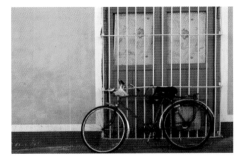 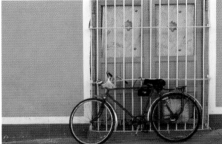

Image Transfer

My favourite Polaroid technique has always been image transfer. This involves taking a photograph with, or copying an existing picture on to, Polaroid instant film, then, instead of allowing the instant print to develop fully, the film is peeled apart and the 'negative' part containing the dyes is contacted with another material so that the image is transferred on to it.

I have followed this procedure many times in the past, creating image transfers mainly on textured art paper, and the results can look amazing. However, the materials are costly and the technique can be hit-and-miss – for every successful transfer you may throw two or three in the bin.

The obvious solution is to re-create the effect digitally, so I set about finding ways of doing it. Most of the published tutorials I discovered seemed far too complicated and were clearly designed for experienced digital artists so I decided to ignore them all and came up with a much simpler procedure.

WHAT YOU NEED

■ A selection of colour photographs. Colour saturation tends to be reduced by image transfer and colour shifts may occur, so bear this in mind when deciding which shots to work on. I prefer simple, bold images – portraits, still-life and architecture are ideal subjects. You will also need a real Polaroid image transfer or the negative half of a Polaroid instant print so that you can scan it and use the border – creating an image transfer border from scratch would be very tricky. If you scan the negative half of a Polaroid instant print, you will need to invert the scan so it becomes a positive image using Image>Adjustments>Invert.

HOW IT'S DONE

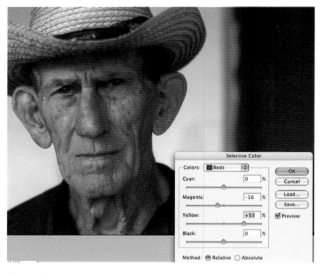

Step 1 Open your chosen image and crop it down to almost square in order to match the typical image proportions of a Polaroid print. Next, start tweaking the colours, using Image>Adjustments>Selective Color. Selecting each colour in turn, reduce Magenta and increase Yellow to make the image warmer.

Step 2 One of the main characteristics of an image transfer is the texture that is created by the material on to which the dyes are transferred. To add texture, you could scan a sheet of textured paper then combine it with the main image as a layer and adjust the opacity to get the right effect, but to save time here I used Filter>Texture>Texturizer, selected Sandstone as the texture and set Scaling at 80% and Relief at 8.

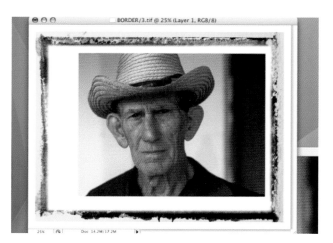

Step 3 To prevent the texture looking too sharp, you can apply Gaussian Blur – Filter>Blur>Gaussian Blur – but don't overdo it. Here, I set Radius to just 0.8 pixels to take the edge off the sharpness without making the image appear soft.

Step 6 If you need to resize the image, which you probably will, go to Edit>Transform>Scale and adjust accordingly until the image fills the white area. It doesn't matter if it overlaps the Polaroid border image a little.

Step 4 Open your real image transfer then, using the Marquee tool, select the central area of the image you want to get rid of so that only the Polaroid border remains and set Feathering to 10 pixels for a soft edge. When you have selected the required area, go to Edit>Fill and choose White as the colour in the Contents window. Click OK and the selected area will turn white.

Step 5 (top right) Open the image you want to turn into an image transfer so you can see it and the Polaroid border image on your desktop. Select the Move tool from the toolbox on the left of your screen, then drag and drop the image on to the border image.

Step 7 In the Layers palette, change the blending mode of the main image to Multiply then flatten the layers – Layer>Flatten Image.

Image Transfer

Step 8 The edge of the main image will be too sharp and straight and will need to be merged with the Polaroid border so that it looks natural. There are complicated ways to do this, but I find the quickest and easiest is to use the Clone Stamp tool. Select a soft brush from the Basic Brushes menu, set Opacity to 60% then overlay the sharp edge of the image with pixels from the Polaroid border. Do this bit by bit and work your way around the image until you are happy with the effect.

Step 10 The final stage for this image was to give Hue and Saturation a tweak. I also adjusted Levels to get the overall feel of the image closer to how I felt it should look. There isn't a perfect 'model' to aim for here as every image transfer looks different, so just go with your instinct.

Step 9 Once you are happy with the texture of the image you are almost there. However, in this case I decided to make the texture even coarser so I again used Filter>Texture> Texturizer, chose Burlap as the texture and set Scaling to 124% and Relief to 3. There is no right or wrong way here, so just go with what you like.

Farmer, Vinales, Cuba
Compare this original photograph to the image transfer to see the difference.
Camera Nikon F5 **Lens** 50mm **Film** Fujichrome Velvia 100F.

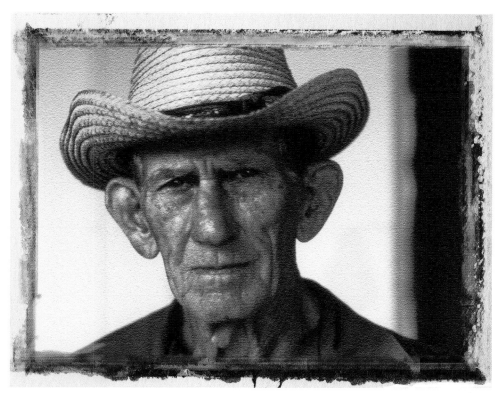

By following the stages outlined, this is the kind of result you can expect. Having created many authentic Polaroid image transfers over the years, I reckon this is a pretty good match for the real thing. I purposely adjusted Hue and Saturation as colour shifts occur during image transfer. I also made sure there was plenty of texture, which made it look as if the image had been transferred on to an art paper such as Bockingford.

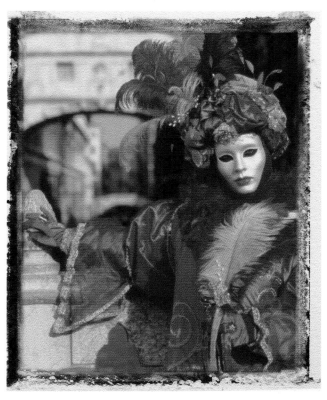

Venice Carnival, Italy
For this image transfer I decided to introduce a blue/green colour shift by adjusting the Hue slider in Image>Adjustments>Hue/Saturation and also tweaking the blue channel in Image>Adjustments>Curves. There is no right or wrong, so just experiment — if you like the result, that is all that matters.
Camera Nikon F90x **Lens** 50mm **Film** Fujichrome Velvia 100F.

Joiners

Soon after I became interested in photography in the early 1980s, the British artist David Hockney created a stir with his 'joiners'. These were huge photographic artworks that he made by taking dozens, sometimes hundreds, of individual photographs then putting them together as a kind of jigsaw. The pieces, however, were not fitted together in perfect order and some elements were repeated several times to give the final image a third dimension. It didn't take long for other photographers to follow suit, and for a time everyone was having a go.

Today, you can create joiners digitally. All you do is take lots of pictures with a digital camera, using the zoom lens to home in on small areas, so you capture your chosen subject or scene bit by bit. It doesn't matter if some areas are photographed more than once, or if areas overlap – that's all part of the fun.

Once the images are transferred to the computer, the joiner is created by dropping the individual images on to an oversized canvas and moving them around until the desired effect is achieved.

Another option, and the one I have used here, is to take a single image then copy small parts of it one at a time to build up your joiner. The advantage of this method is that you can decide exactly which areas you want to copy. This helps a great deal as the joiner starts to take shape, because you can make creative decisions as you go.

WHAT YOU NEED

- Either one large image file or a selection of individual photographs of the same subject.

HOW IT'S DONE

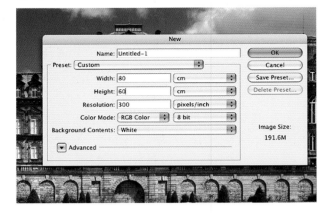

Step 1 Open the image you are going to work from then go to File>New. In the dialogue box that opens, enter the dimensions of the new canvas. It needs to be at least 25 per cent larger than the image you are working from, but if you don't make it quite large enough at this stage you can always extend it later using Image>Canvas Size. Enter the image resolution you want (here I used 300ppi), set white as the Background Contents and RGB as the Color Mode.

Step 2 Go back to your original image and make a selection around a key area using the Marquee tool. The size you select depends on how many individual images you want to use in the final joiner – the smaller the selection, the more of them you will have to make in order to copy the entire image. The size of selection should be similar for each one to give the impression that the joiner was created using a pile of prints. So, whatever the size of your first selection, stick to it (roughly) for the rest.

Step 3 When you have made your first selection by clicking on an area then dragging the Marquee tool over it with your mouse, copy it by going to Edit>Copy. Next, click on the new canvas and go to Edit>Paste and the selection will be copied on to the new canvas. To position it where you want, use the Move tool.

Step 4 Click on the original image and repeat Step 3. When you paste the new selection on to the canvas it will need to be re-positioned. Keep repeating Step 3 and slowly your joiner will start to take shape. Work on a specific area and use the original image as a guide. Keep both images side by side on the desktop so that you can see one while manipulating the other. To keep your selection size the same, instead of making a new selection each time with the Marquee tool just move the selection you have already made to the next area, then Copy and Paste it on to the new canvas.

Step 5 Each time you paste a new selection to the canvas it creates a new layer and the file size will increase, so periodically flatten the layers using Layer>Flatten Image. Remember, once you have done that you can't make any changes to the image that was created prior to flattening the

layer, so don't be too hasty. If you don't flatten the layers you can always open the Layers palette – Window>Layers – select a layer and delete the selection in it or move the selection to a different position, though you shouldn't need to do this.

Step 6 Keep copying and pasting selections. This process can take a long time, so have a break if you start to feel tired or bored and come back to it later. To make the joiner more interesting, you can position some of the selections at angles. To do this, paste the selection on to the canvas then go to Edit>Transform>Rotate and drag the selection round by one corner.

Step 7 The key to creating a successful joiner is finding a compromise between retaining a sense of reality in the image while also positioning the pieces of the jigsaw in such a way that they are not too regimented. Try overlapping or rotating some of them, or putting them out of line.

Step 8 For areas where there is a degree of repetition, you can paste the same selection in different areas – in this case, the gravel drive and sky were good examples. Instead of making each selection different, I copied and pasted the same selection several times and moved it around so it wasn't obvious – this saved time. To make the final image more unusual I also revisited certain areas, especially at the edges, and made further selections to break up any evenness.

Joiners

Bowes Museum, Barnard Castle, County Durham, England
I decided to use this image as the basis of a joiner because the building has
repeated architectural features, such as the windows and balustrades, that
I knew would provide me with plenty of room to experiment and would make
mistakes less obvious. It took around two hours to complete and involved
more than 100 different selections from the original image, pasted on to
the new canvas.
Camera Calumet Cadet 5 x 4in Monorail **Lens** 150mm **Filter** Polarizer
Film Fujichrome Provia 100.

Liquid Emulsion

Liquid photographic emulsions have been used by fine-art photographers for many years to produce one-off images with a wonderful textured feel. This is achieved by painting the light-sensitive liquid on to a suitable substrate under darkroom conditions, then exposing and developing it like a normal black-and-white print. Handmade paper is the most common material used for this process, but glass, wood, metal, fabric, and even objects such as pebbles are suitable.

The only downside of using liquid emulsion is that it takes time, it is expensive and it can be a rather hit-and-miss affair. Luckily, a similar effect can be easily achieved using digital techniques, and at a fraction of the investment in both time and money.

Another great thing about reproducing this process digitally is that there is hardly any mess involved, and you don't have to fumble around in the dark – the whole thing can be done from the comfort of your kitchen table and computer desk. You can also work on existing images in both colour and black and white, and have complete control over the final result.

WHAT YOU NEED

- I used a sheet of handmade paper – the same type I have coated with real liquid emulsion in the past – to create a mask. You can use tissue paper, wood, or anything that you can scan. You will also need black acrylic paint (or an indelible black marker pen), a paint brush and a flatbed scanner.

HOW IT'S DONE

Step 1 First you need to create your mask. In this case, I painted a sheet of handmade art paper with black acrylic paint using rough brush strokes. Apply the paint first in vertical strokes, then in horizontal strokes to ensure even coverage and give a nice ragged edge.

Step 2 Once the paint or ink is fully dried, scan your mask at high resolution. The mask created here measured around 20 x 16cm (8 x 6½in) and was scanned using an A4 (210 x 297mm/8¼ x 11¾in) flatbed scanner to give an output size up to 40 x 32cm (16 x 13in) at 300dpi. Increase the contrast on the pre-scan to make sure the black is jet black, and tweak Levels on the high-res scan for the same reason.

Step 3 You now need to combine both images. To do this in Photoshop, choose Select>All, then Edit>Copy. Next, double-click the photographic image you want to combine with the mask, choose Select>All, then Edit>Paste.

Step 5 With the photograph now visible through the mask, save what you have done so far, then select Edit>Transform>Scale so you can drag the edges of the mask out as far as necessary to achieve the desired effect.

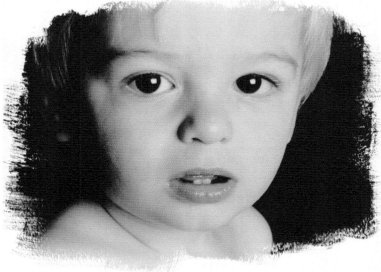

Step 4 The mask is now over the photograph. To show the photograph through the mask, go to Layer>Layer Style>Blending Options>Lighten.

Noah

This method creates a convincing liquid emulsion effect in minutes. The same mask can be used again and again, though it is worth creating and scanning a range of different masks in one go so you can vary the effect. The technique suits colour images as well as black and white.
Camera Nikon F90x **Lens** 105mm Nikkor Macro **Film** Ilford FP4 Plus **Lighting** Single studio flash and softbox.

Lith Effects

Lith printing is a popular technique among fine art black-and-white photographers, thanks to its versatility and the wide range of effects that are possible. The basic idea is that a sheet of printing paper is heavily overexposed under the enlarger then developed in dilute lith developer until the required image density is reached. The end result is (ideally) a print with delicate fine-grained highlights, hard grainy shadows, and an attractive image colour.

Achieving success can be highly hit-and-miss because development starts off slowly then suddenly accelerates out of control, giving you just a second or two to snatch the print. However, it is possible to mimic lith effects in the digital darkroom, where mistakes can easily be rectified, which is not an option when lith printing for real.

WHAT YOU NEED

- A selection of colour or black-and-white images. If you start off with colour images, convert them to black and white (see pages 30–7), but save them in RGB mode rather than greyscale as colour information is required.

HOW IT'S DONE

Step 1 Open up the Layer's palette using the Window dropdown menu. Double-click the Background layer and rename it 'Shadows', then duplicate this layer and name it 'Highlights'.

Step 2 To recreate the light highlights and mid-tones that are characteristic of lith prints, select the Highlights layer then go to Image>Adjustments>Curves and drag the bottom left marker upwards. The best output level will depend on the contrast of the original image – here I used a level of 70.

Step 3 Lith prints also typically have dark, dense shadows. To mimic this, select the Shadows layer then go to Image>Adjustments>Curves and drag the top right marker to the left. Experiment with different input levels, but don't overdo it – here a level of 100 was fine.

Step 4 The shadows of lith prints have a coarse grain. To create this, select the Shadows layer then Filter>Artistic>Film Grain and experiment with different levels of grain.

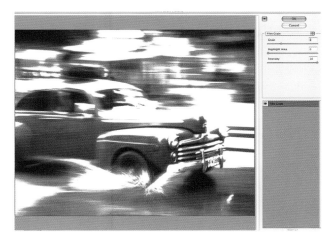

Step 5 Once you are happy with the grain, select the Highlight layer then Image>Adjustments>Hue/Saturation and add some colour to the highlights and mid-tones. Click the Colorize window and set different Hue and Saturation values until you are happy. Lith prints tend to have a yellow/brown colour, though some papers are more rusty/peachy in colour.

Step 6 Select the Highlight layer and change its blending mode to Multiply in the Layers palette. This reveals the grain in the shadows and gives you a clearer idea of how the final image is going to look.

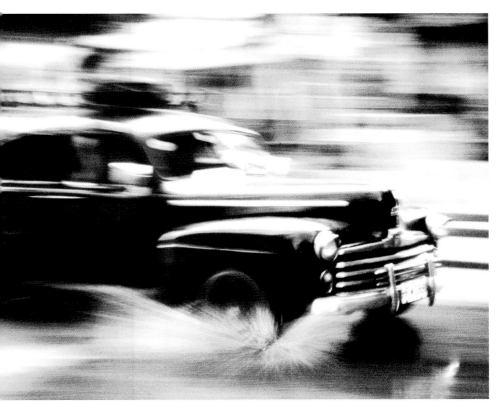

Havana, Cuba
After flattening the layers and saving changes I tweaked Levels to make the image density a little darker. I also reduced colour saturation by a small amount. The final effect is close to how I expect a real lith print to look – and not a single sheet of printing paper was wasted.
Camera Nikon F5 **Lens** 50mm
Film Fujichrome Velvia 100.

Merging Images

Image-editing software, such as Adobe Photoshop, offers endless ways to combine images, and as your skills grow you will begin to experiment with more ambitious projects. Until you get used to working with Photoshop, it is probably best to begin with images that are easy to merge, so there is less chance of any joins showing.

For this example, I chose two photographs that were taken at the same time using the same props, lighting and, most importantly, against the same black velvet background. These factors all make achieving a seamless finish fairly straightforward.

I didn't actually shoot the individual images with any digital manipulation in mind and am quite happy with them as separate photographs. However, it was while looking at them side by side on a lightbox one day that I realized I could create a much more interesting photograph by combining the two images, so I turned on my computer and set to work.

WHAT YOU NEED

- Two or more images that will work well together when merged. If you're new to image manipulation, choose or shoot images that will merge easily. Black or white backgrounds are ideal as you don't have to worry about achieving perfect alignment.

HOW IT'S DONE

Step 1 Scan your images at high resolution, making sure the scanner settings are identical for each so that the images have the same density and contrast and will merge convincingly. It also makes sense to scan to a similar size, though this isn't essential.

Step 2 Open the first image in Photoshop then select Image>Canvas Size. Use the controls in the dialogue box to increase the canvas size so there is sufficient space for the other images you want to merge. In this example I am adding only one more upright image so the canvas width is increased to 62cm (25in), which is just over double the width of the first image. You also need to select the required anchor point so that the first image is correctly positioned in the new canvas. In this case I chose the centre-left anchor point so that the image of the bottle and glass remained on the left side of the canvas.

Step 3 Open the second image to be added to the composite then, using the Move tool in Photoshop, drag the second image on to the extended canvas and carefully position it next to the first image as required. Because the background of both images is black in this example, careful alignment was not necessary and I simply moved the second image into the desired position.

Step 4 Once you are happy with the final composite, select Layer>Flatten Image, then Save. In this case, I decided to make the colours a little more intense so I selected Image> Adjustments>Hue/Saturation and increased Saturation by 10%. I then selected Levels and moved the highlight slider to the left to brighten the highlights on the glass.

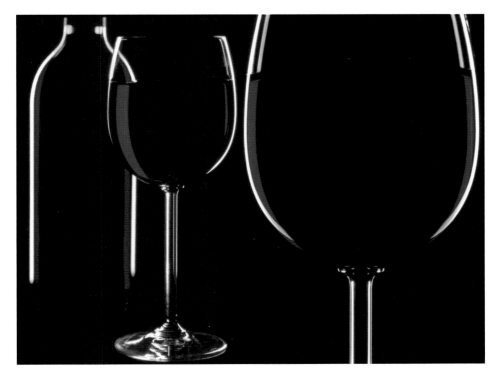

Wine Bottle and Glasses
The final image is complete, and I think it looks pretty good. Although the two images work well together, combining them makes a big difference because the perspective of the final image couldn't have been achieved in a single exposure. It also shows how you can use simple Photoshop techniques to breath a new lease of life into existing photographs – so have a look through your files and see what you can come up with.
Camera Nikon F90x **Lens** 105mm macro **Lighting** Studio flash and softbox **Film** Fujichrome Velvia 50.

Mirror Images

Can you remember how, as a child, you would paint an image on one half of a sheet of paper then, while the paint was still wet, fold the paper in half and press down on it to create a mirror image of your picture on the blank side?

Even though the end result always resembled a mutant butterfly, it inspired me to experiment with symmetry years later when I discovered photography.

I spent hours making prints with the negative first the right way round, then flipped so that the image was inverted, before cutting and sticking half of each print side by side to create a surreal composite image.

Nowadays, this can be achieved digitally in a matter of minutes, but it is well worth trying because it can open up a whole new avenue of creativity.

WHAT YOU NEED

- A selection of colour of black-and-white images. Portraits are ideal, but you can work with any subject providing that it is reasonably symmetrical.

HOW IT'S DONE

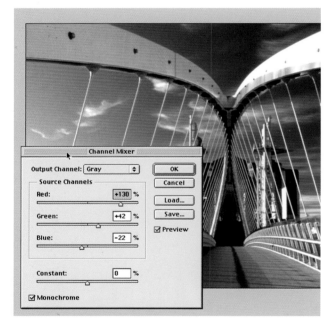

Step 1 The original colour image was converted to black and white in Channel Mixer by choosing Image> Adjustments>Channel Mixer and checking the Monochrome window in the Channel Mixer dialogue box. I played with the sliders until I was happy with the appearance of the image. I could have left it in colour, but felt that it would be more graphic in black and white.

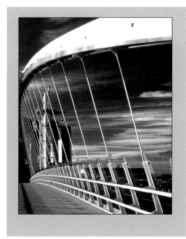

Step 2 The image was cropped so only the well-lit, right-hand half of the original composition remained.

Step 3 Using Select>All, then Edit>Copy, I made a copy of the image. Next, the image was flipped – Image> Rotate Canvas>Flip Horizontal – and the canvas size increased so it was a little more than double the width of the image, but the same height. I also checked the left-hand anchor point so the canvas would extend to the right of the image.

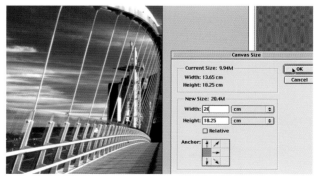

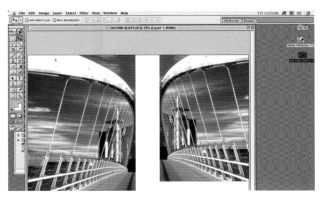

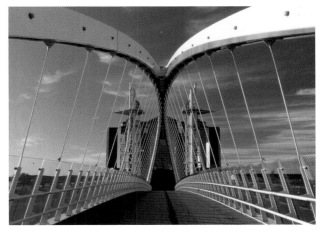

Step 4 Using Edit>Paste, the copied half of the image was dropped on to the canvas. With the Move tool it was then carefully dragged into position and merged with the other half of the image. Once in position, the canvas was cropped, the layers flattened and the image saved.

Salford Quays, Manchester, England
I was initially attracted to this pedestrian suspension bridge by the symmetry of its design. However, the sun was off to one side of the bridge, so it wasn't evenly lit and the symmetrical effect was spoiled. To remedy this, I decided to take the well-lit half of the bridge, copy it, flip it and merge the two halves together.
Camera Nikon F90X **Lens** 28mm **Filter** Polarizer **Film** Fujichrome Velvia 50.

Movement

Action photography has never been one of my strong points. I don't have the reflexes that are needed to capture fast-moving subjects so they are perfectly positioned in the frame. Although I am not afraid to take the occasional panning shot, I never expect the results to be great.

Action photography requires great skill and those who are good at it are generally the ones who have had years of practice. I have accompanied professional car photographers on

commissions for magazines and watched them work. It is a delight to see the level of control and precision they apply. There is no hit-and-miss involved – they instinctively know exactly when they have got the shot, even though their subject flashed by in the blink of an eye.

Thanks to Photoshop, however, we can all be action heroes. With a couple of simple blur filters it is possible to make static subjects look as if they are moving at the speed of sound.

HOW IT'S DONE: METHOD 1 – USING MOTION AND RADIAL BLUR FILTERS

To show how effective Motion and Radial Blur can be, I used them to make this static portrait of a sports car I used to own look like an action-packed panned shot.

Step 1 If the car had really been moving there would be a small amount of blur on it, so I first applied motion blur to the whole image on a low setting. To do this go to Filter>Blur>Motion Blur. In the dialogue box that appears there are two main controls – Angle and Distance. Distance determines the amount of blur. Here I entered 3 as I wanted only a tiny amount to take the edge off the car's sharpness.

Step 2 To achieve a realistic panning effect the car needed to remain unchanged, so I selected it using the Lasso tool and set feathering to 5 pixels to give a relatively smooth edge. I went around the wheels as well as the body, then used Select>Inverse to reverse the selection so that the filter effect was applied to everything but the car.

Step 3 Next I added some serious blur. Using Filter>Blur>Motion Blur I moved the Distance slider slowly to the right and watched the preview image to see what happened. The further to the right the slider is moved, the more blur you get – I stoped at 66. I also set Angle to 4. This tilted the angle of blur to the right, which suited the angle of the car.

Step 4 I wanted to add more blur to the top and bottom of the image so I made a selection at the top using the Marquee tool then applied Motion Blur with Distance set to 28 pixels. I did the same with the bottom part of the image. This created enough background blur.

Step 5 The wheels looked sharp, while in a real panned shot they would be blurred in a circular motion because they were spinning at high speed. To mimic this I made a roughly circular selection around the front wheel and tyre. Then I went to Filter>Blur>Radial Blur, clicked on the Spin option, set Quality to Best and moved the Amount slider to the right until I was happy with the effect on the wheel.

Step 6 I repeated this for the back wheel. As I was using the same setting in Radial Blur as before I didn't need to open the filter's dialogue box, I just went to Filter>. The first item in the Filter dropdown menu was the last filter used (Radial Blur), so I highlighted Radial Blur and the effect was automatically applied to the back wheel.

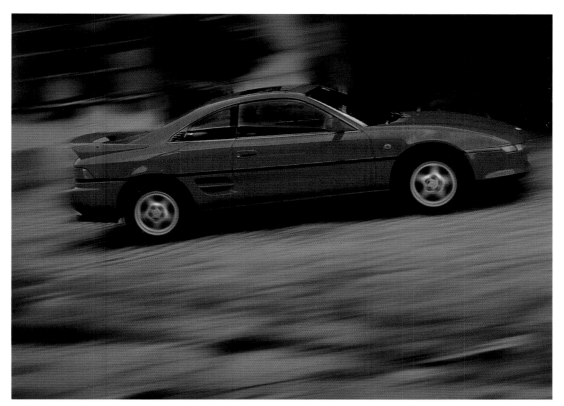

Toyota MR2, Yorkshire, England
Once I was happy with the level of blur, I changed the angle of the car to make it look more dynamic using Image>Rotate Canvas>Arbitrary and setting an anticlockwise adjustment. I also realized that if the car had really been moving there would have been someone driving it. It was obvious that there was no one behind the wheel, so to play this down I selected the car windows using the Lasso tool and darkened them in Levels. I also copied and pasted the dark shape of the headrest on the driver's seat as it looked something like a head in semi-silhouette.
Camera Pentax 67 **Lens** 165mm **Film** Fujichrome Velvia 50.

Movement

METHOD 2 – RADIAL BLUR

I used Radial Blur in the image of the red sports car to make the wheels appear to be spinning, and it did the job brilliantly. I then went in search of an image that would suit the effect on a grander scale. You have to pick your image carefully when applying Photoshop filters such as this because if you make a bad choice, the effect will look unnatural.

I soon found this shot of a young boy doing a handstand on a beach in Zanzibar. Unprompted gymnastics seem to be the norm in Zanzibar and everywhere you turn there are boys cartwheeling or doing somersaults. I asked this young athlete if he would do a cartwheel while I took his photograph, but all he could manage was a handstand. Not to worry, Radial Blur should be able to sort it out.

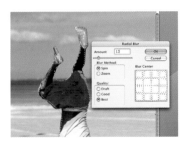

Step 3
Filter>Blur>Radial Blur brought up the filter's dialogue box, where I clicked on Spin and Best quality, and dragged the Amount slider to the right until I was happy with the level of blur. To see what effect this filter has when you select Zoom instead of Spin, see pages 154–5.

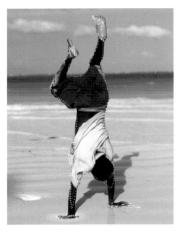

Step 1 Having opened the image and copied it, I made a rough selection around the boy using the Lasso tool with feathering set to 50 pixels. A perfect cut-out would have looked odd so I made sure parts of the boy's hands and feet were outside the selection, so that they too would be affected by the filter.

Step 2 To reverse the selection I used Select>Inverse. This made sure that everything except the initial selection (the boy) was affected by the filter.

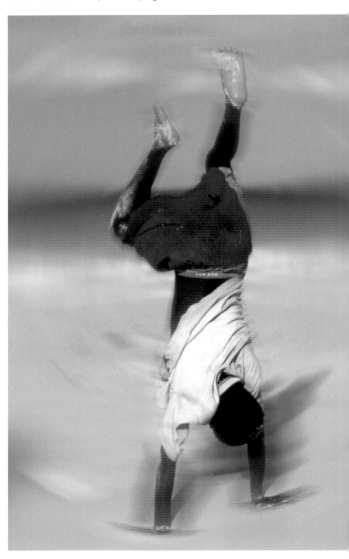

Gymnast, Jambiani, Zanzibar
It took a matter of seconds to transform the original image, giving it a real sense of movement. Note the blur around the boy's hands and feet, which makes it look as if he is flipping over and was photographed using a slow shutter speed rather than a fast one.
Camera Nikon F5 **Lens** 50mm **Film** Fujichrome Velvia 50.

Havana, Cuba

Car photographers often work from a moving car that is being driven by someone else, with their subject car following them at close quarters and at the same speed. This is known as 'tracking' and it allows the photographer to keep his subject car sharp, while blurring the background. Here I tried to mimic the effect using a photograph of a car that was completely static. The low viewpoint and use of a wide-angle lens give the original plenty of impact, but adding some blur makes it appear to be racing down the street at high speed. To achieve the effect I added a very small amount (5.0) of Radial Blur to the whole image. I then selected the front of the car with the Marquee tool, inversed the selection, then added more blur to the background. Finally, I selected just the central part of the car's front end, inversed it and applied blur to the rest of the image. This means that there is hardly any blur on the centre of the car's front end – the part closest to the camera – but with distance the level of blur increases.
Camera Nikon F5 **Lens** 20mm **Film** Fujichrome Velvia 50.

Kitty, Northumberland, England

I took this snapshot of my daughter just before she set off to sled down a steep sand dune near our home. She wasn't moving when the picture was taken, but by making a selection around her with the Lasso tool then reversing it and applying Motion Blur, it looks as if I have captured her in full flight! To make the effect even more realistic I adjusted the Angle setting in Motion Blur to match that of the dune.
Camera Nikon Coolpix 4300 digital compact with integral zoom lens.

Old Processes

As the digital revolution advances at an unstoppable rate, more and more traditionalists are delving into the history books of photography and using old processes from a century or more ago to create wonderful fine-art prints.

With that in mind, it was my initial intention, when planning this book, to include a short chapter on bringing together the old and the new by making large-format negatives with an inkjet printer then using them as the basis of old processes. It then occurred to me that the type of photographer reading this book is unlikely to want to start mixing up strange chemicals to create primitive photographic emulsions. Instead, therefore, I decided to look at ways of mimicking the characteristics of old processes digitally.

Here is what I came up with for cyanotype and gum printing.

WHAT YOU NEED

- A selection of colour or black-and-white images. If you want to output the images in print form, use some textured inkjet paper. You could also try uncoated art paper and handmade paper.

HOW IT'S DONE: METHOD 1 – CYANOTYPE

The English Astronomer and scientist Sir John Herschel developed the cyanotype process in 1842, using ammonium ferric citrate and potassium ferricyanide. These chemicals are mixed with water and used to coat the paper, which is then contact-printed with a negative and exposed to daylight. It is a simple process, and one that is still used by some fine-art photographers – but it is even easier in Photoshop.

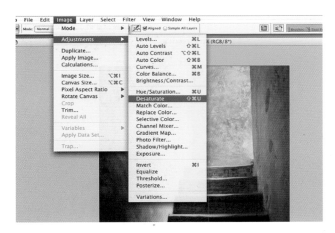

Step 1 In this case I converted an original colour image to black and white using Image>Adjustments>Desaturate. I then added a rough black border using the technique outlined on pages 14–15. As the real cyanotype process involves hand-coating paper with an emulsion, you could also use a border like the one described for liquid emulsion effects on pages 100–1.

Step 2 Cyanotype prints have two main characteristics. First, they are a rich blue colour – hence the name – and second, most examples are relatively low in contrast and consequently have a soft, subdued feel. I felt my image already possessed the latter quality but needed the blue tone.

Step 3 To create the right kind of blue tone, go to Image>Adjustments>Curves and select the Red channel. Click on the curve itself then in the Input box enter a figure of around 100 and in the Output box a figure of around 40. Now click on the curve again and enter an Input of around 190 and an Output of 195. The blue tone will now almost be there.

Step 4 Still in Curves, select the Blue channel and click on the curve. Enter around 190 in the Input box and 200 in Output. Click on the same curve again and enter 90 in both the Input and Output boxes. You won't notice a huge change, but the mid-tones will be bluer and the highlights will appear creamier.

Stairs in the Ben Youseff Medersa, Marrakech, Morocco
This was a chance shot, taken in low light by pressing my camera against the side of a doorway and shooting on 1/2sec at f/2.8. I wasn't sure if it would be sharp, but I loved the light on the stairs and as tripods weren't allowed inside the Medersa, I had no option but to handhold. The colour original works well, but the pseudo-cyanotype (below) is much more atmospheric and really brings the image to life.
Camera Nikon F90x **Lens** 28mm **Film** Fujichrome Velvia 100F.

Step 5 Now select the Green channel, click on the curve and enter 190 in Input and 195 in Output, then click on the curve again and enter 95 in Input and 85 in Output. This should give you a final tone that is pretty much what you are after, but if not you can always tweak it using Image>Adjustments>Hue/Saturation.

Step 6 Cyanotypes are often made on art paper with a textured surface. The final stage, therefore, is to add texture. Here I used Filter>Texture> Texturizer, choosing Sandstone as my texture and setting Scaling at 82% and Relief at 5.

Old Processes

METHOD 2 – GUM PRINTS

Traditional gum prints are even easier to make than cyanotypes. For this method of printing, just one chemical – potassium dichromate – is dissolved in water. A small amount of the solution is then added to a mixture of watercolour paint and glue, which is used to coat handmade paper. As with most old processes, a negative is then put in contact with the coated paper and exposed to daylight or UV light.

Step 1 Desaturate the original colour image then add a thick, black border by increasing the canvas size by 1cm/³/₈in in each direction and using black as the extension colour.

Step 3 Add sepia tone to the image using Curves (see pages 148–9), followed by texture using Filter>Texture>Texturizer, to make it look as if it has been printed on handmade paper.

Step 2 Using a Pastel Medium Tip brush from the Dry Media Brush list and the Clone Stamp tool, soften the inside edge of the black border (see pages 14–15).

Step 4 Finally, adjust Levels and Curves to make the image appear flatter and to further mimic the effect of fairly crude, hand-coated paper.

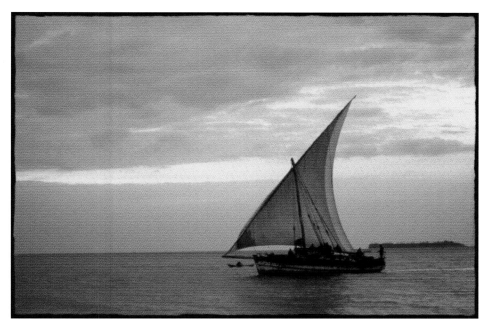

A Dhow off Stone Town, Zanzibar
My first attempt at a digital gum print!
The subject matter in this image is
well suited to this method – Arabian
dhows have been working the seas
for centuries.
Camera Nikon F5 **Lens** 80–200mm
Film Fujichrome Velvia 50.

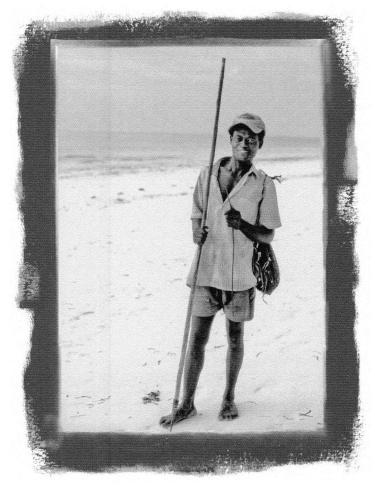

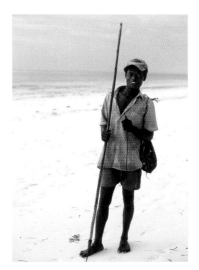

Spear Fisherman, Bweju, Zanzibar
This image works well. The low contrast
and the ragged border give a realistic
impression of what hand-coated paper looks
like. The tone was added by clicking on the
Colorize box in the Hue/Saturation window
and the texture added in the same way as
for the image of the dhow.
Camera Nikon F9 **Lens** 50mm
Film Fujichrome Velvia 100F.

Panoramas

Panoramic photography has seen a high rise in popularity in recent years. This is thanks partly to the launch of the Hasselblad XPan camera, a dual-format camera that allows both 24 x 36mm and 24 x 65mm images to be captured on 35mm film, and also to the availability of software packages that allow a series of digitized images to be stitched together to create panoramas.

I have been involved in panoramic photography for almost a decade, using both the XPan and the much bigger Fuji GX617 system to create panoramic images in-camera. I even wrote a book on the subject in 2004 (*Lee Frost's Panoramic Photography*, published by David & Charles).

Creating digital panoramas is far more versatile than using panoramic cameras because you can vary the angle of coverage, and if you use a digital SLR you can work with a much wider lens range. Stitching images together is also straightforward, thanks to the latest software, so with a little practice you will soon be producing breathtaking panoramas.

WHAT YOU NEED

- A series of photographs that can be stitched together digitally and the software that will allow you to do it (see panel below).

EQUIPMENT FOR PANORAMAS AND HOW TO USE IT

Ideally, the pictures you take should be shot with a digital camera so you can download them straight to your computer. It is also possible to take the pictures using a film camera then to scan the negatives or slides. Most high street processing labs also offer a service, in addition to having your film developed and printed, where you can have all the images scanned to CD. This saves you the bother of having to scan them yourself.

Whichever option you choose, the key to success is consistency. All the images should be as close to each other in terms of exposure and colour balance as possible, otherwise you will see the joins. Here are a few tips to help you make successful panoramas:

- Avoid using ultra-wide lenses, as the distortion they create may be difficult to hide. Lenses from 28mm are easier to use.
- Use your camera in manual exposure mode, or activate the exposure lock if there is one, so each frame is given the same exposure.
- If light levels vary widely across the frame, take a meter reading from an area that falls roughly midway between the lightest and darkest parts of the scene, then use the same exposure for all the shots in the sequence to ensure consistency.
- Overlap each image by 20–40 per cent so that they are easy to merge. If you don't provide a big enough overlap the software may struggle to merge the images successfully. At the same time, don't overlap them too much – any more than 50 per cent may cause problems.
- Before you start taking pictures, have a quick practice run and decide how much of the scene you want to include and where you want the sequence to begin. This latter factor is particularly important for full 360-degree panoramas.

Perhaps the most important aspect of digital panoramic photography is making sure the camera is perfectly level. If you shoot the sequence handheld, the chances of keeping the camera square throughout the sequence are slim, so you are better off mounting it on a tripod.

When you set up the tripod, use the spirit levels that are built into it as a guide. Don't follow spirit levels on the tripod head, however: they just tell you if the head itself is level when the tripod itself may not be, as you will discover as soon as you start to swing the camera through an arc. If your tripod doesn't have a spirit level built in, one option is to remove the head and place a spirit level on the flat surface of the tripod where the base sits, level it, then put the head back on and level the head. This can take a little while to get right, but it will be well worth the effort. The other option is to buy a special levelling base for your tripod that uses a ball-and-socket arrangement and a bull's-eye bubble so you can level the camera even when your tripod is set on uneven ground. Examples include the Manfrotto 554 Levelling Column and the Gitzo 1321 Levelling Base.

However, these levelling accessories do not account for the fact that as you rotate the camera to take the next shot in a sequence, that shot will be slightly out of line from the previous one due to parallax error. This happens because the camera is rotated around a point beneath the body, whereas for perfect alignment you need to rotate it from a point beneath the lens known as the 'nodal point'. This isn't crucial, as stitching software is very good at automatically adjusting each image to give a seamless join, but if you are really serious about stitching images you may consider investing in a special nodal point bracket, such as the VR-System from Novoflex or the QTVR Plus from Manfrotto.

This illustration shows why using the nodal point of the lens as your pivot point avoids parallax error, and why using the tripod socket as the pivot point causes it.

HOW IT'S DONE: METHOD 1 – USING PHOTOSHOP'S PHOTOMERGE

For this first example of digital stitching I took the easy
option and used Photomerge in Photoshop CS2. I say 'easy
option', because if the sequence you shoot is done correctly,
Photomerge will blend the images at the click of your mouse
and produce a stunning panorama. However, to see what it is
capable of, I broke all the rules outlined in the box opposite by
shooting a sequence of pictures handheld, instead of using a
tripod. I also left my camera switched to aperture priority mode
rather than manual, so each time I changed the camera's
position, the exposure changed. I took the pictures on colour
print film then scanned the 6 x 4in enprints into my computer
to stitch them. Not a good start, but let's see what happened.

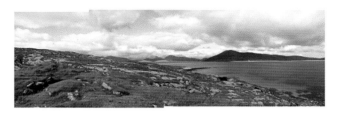

Step 5 First the images in the folder open one at a time,
then Photomerge starts to stitch them together as you watch.
If there is a problem a warning window appears to tell you
that not all images can be joined – this is usually due to
inconsistencies between images.

Step 1 Scan all the prints to the same output size and
resolution using a flatbed scanner and place them in a folder
on the computer's desktop.

Step 2 Open
Photomerge –
File>Automate>
Photomerge – and in the
dialogue box that opens
select Folder and click
on Browse.

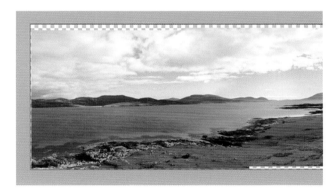

Step 6 More often than not, there will be some uneven
overlap between images. This can be minimized by levelling the
camera properly before shooting, but if the camera is handheld
there is no way you can keep it level each time you move to
take the next shot. However, the edges of the final panorama
can be cropped so this isn't a problem.

Step 3 A second
dialogue box appears,
allowing you to select
the folder you want
Photomerge to access.
Click on the folder, then
on Choose.

SOFTWARE FOR STITCHING

There are numerous software packages available that are
specifically designed to create panoramas – PhotoVista,
Picture Publisher, PanaVue Image Assembler and RealViz
Stitcher are popular examples. If you have a digital camera
you may also find that it came packaged with some
stitching software. The Photomerge option available in
Photoshop Elements and CS works in the same way
as stitching software. Failing this, you can merge the
images yourself using Photoshop.

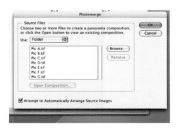

Step 4 The images in
the selected folder are
loaded into Photomerge.
Click OK and the
computer gets to work.

Panoramas

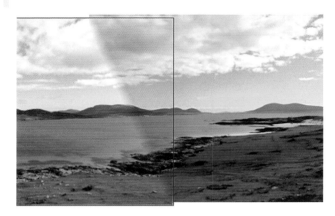

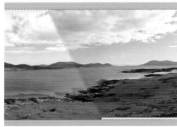

Step 8 To merge the images more successfully, I made a selection around the darker area using the Lasso tool then opened Levels and lightened it slightly. I then made further, smaller selections and adjusted colour balance using Image>Adjustments> Color Balance, so the green in particular was as closely matched as possible.

Step 7 If Photomerge can't join all the images automatically, you are given the option of dragging them into the window manually. I had to do that here because one image was noticeably darker than the next, because I had been shooting with the exposure set to aperture priority. If you put the effort in earlier and get the pictures right in the first place, you won't face such problems, but even if they do arise they can usually be sorted out.

Step 9 Once the images have been merged you may still be able to see joins in some areas, such as the sky seen here where there is an obvious grey line. To get rid of joins use the Clone Stamp tool with a soft-edged brush.

Harris From Taransay, Scotland
The sequence of pictures for this panorama was shot during a family holiday on a remote and uninhabited Scottish island called Taransay. One afternoon, my son and I went for a walk up a hill not far from where we were staying and the view over to the islands of Harris and Lewis was amazing. Without any preplanning, I quickly shot seven frames, handheld, overlapping each by about 30 per cent and covering an angle of around 200 degrees. Photomerge managed to join them pretty well, but to make the final image convincing I spent around 25 minutes getting rid of any obvious joins. The end result isn't perfect, but it really captures the glory of that view.
Camera Nikon F90x **Lens** 28mm **Film** Kodak Portra 160NC.

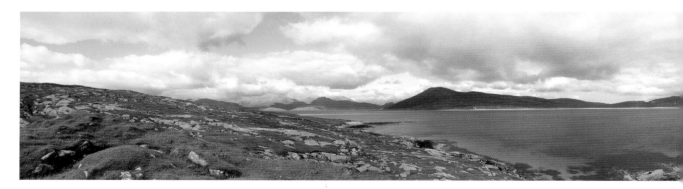

METHOD 2 – STITCHING IMAGES BY HAND

If you don't have Photomerge or any other stitching software, don't worry. It is fairly straightforward to do the job by hand using Layers in Photoshop. Here's how.

Step 1 Number each image in the sequence, starting from the left. Here I had six shots so they were numbered 1–6. This makes it easier to identify which image comes next in the sequence.

Step 2 Open the files in Photoshop and make sure they are all the same size. Because mine were shot using a digital camera they were identical in size and resolution.

Step 3 Open the first image (Pic 1), make a copy of it, then extend the canvas so it is a little deeper than you need, but a lot longer. To calculate how long, multiply the length of Pic 1 by the number of images in the sequence. This will actually be longer than you need because the images will overlap, but any excess can be cropped later. Note the position of the anchor point.

Step 4 Click on the Move tool then drag and drop the source images, in order, into the new document or extended canvas you have created as shown below. You can now close down the source images as you no longer need them.

Step 5 Go to the Layers palette and make the layer containing the second of your images active by clicking on it. Reduce the Opacity of this layer to 50% in order to make the alignment of the two images easier. Make the layers above the layer you are working on invisible by clicking on the eye icons next to them in the Layers palette.

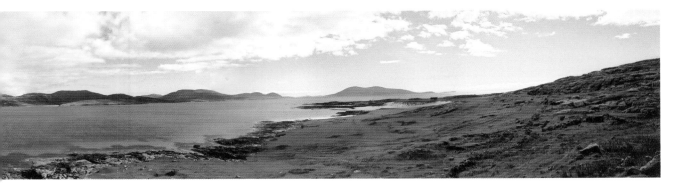

Panoramas

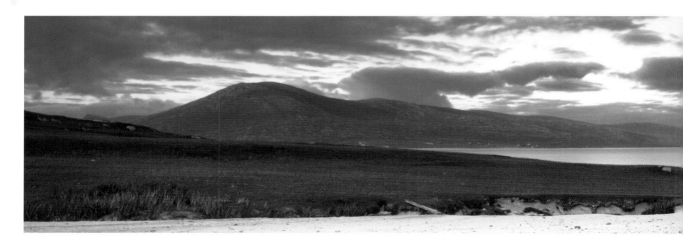

Step 6 Select the Move tool and roughly align the two images. When you are close to alignment, you can use the arrow keys on the keyboard to nudge the image one pixel at a time. Don't worry if there is some slight ghosting, this is probably due to distortion in the lens that was used to take the original pictures. To get rid of it, use the Transform tools and apply them to all or a part of a layer to achieve better alignment. When you are happy with the alignment, lock the appropriate layer so that it won't be knocked out of line if you use the Move tool again. Also set Opacity back to 100%.

Step 7 The next stage is to add layer masks and paint on the masks to reveal and blend with a lower overlapping image. In this example, I added layer masks to layers 2 and 3 using the Add Layer Mask icon at the bottom of the layers palette.

Taransay, Scotland
Here is the result – a seamless blend of six images. Merging them was fairly easy because the joins could be lost in the clouds, grass and beach. Only the sea contained areas of even tone. I shot the original pictures on colour negative, but this time I let the processing lab scan them for me.
Camera Nikon F90x **Lens** 50mm **Film** Kodak Portra 160 NC.

Step 8 Identify a join between two overlapping images, then select a soft-edged brush. Make sure your foreground colour is set to black and that the layer mask is active by clicking on it. Paint on to the layer mask to reveal the layer beneath, trying to make a join that is invisible. You can also vary the Opacity of the brush in the layers palette from solid black (100%) through grey to pure white (0%), making it easy to blend areas where there are abrupt changes of tone.

Step 9 Use the Zoom tool and the Pan tool to magnify and move around your blends until you are completely happy with the end results. The final step in the blending process is to crop off any untidy edges and unwanted canvas using the Crop tool.

Woodland Walk, Alnwick, Northumberland
This is a full 360-degree panorama, created by taking 18 individual photographs with a digital compact then joining them in Photoshop's Photomerge. To determine the correct exposure I pointed the camera towards the area in the centre of the panorama where light levels were even. The camera was set to 1/60sec at f/2.8, I locked this using the exposure lock so all the other frames were exposed the same.

The brighter areas are slightly burned out and the shady areas are a little dark, but that is what you would expect. Other than a little cropping at the top and bottom I did nothing to the final image, which shows that if you get your camera level and overlap each image sufficiently, the software will do the rest for you.
Camera Nikon Coolpix 4300 with integral zoom.

Photo First Aid

No matter how much experience you have as a photographer, mistakes can still be made that result in a potentially great shot being spoiled. Exposure error tends to be the main culprit. A fleeting opportunity presents itself and, without thinking, you fire the shutter, not realizing that your camera is set to manual exposure mode or that it is going to be fooled by tricky lighting.

Bracketing exposures is the most foolproof way to avoid errors. When you are working under pressure and trying to catch a crucial moment, however, you don't always have the chance to take several shots at different exposures, so you need to make sure you get it right the first time.

Negative film has always been very forgiving when it comes to exposure error because a negative that is too light or too dark can be rescued at the printing stage. Slide film doesn't offer the same leeway and as experienced photographers tend to use slide film, the need to get it right is great.

Fortunately, in this digital age, all may not be lost if you do make a mistake with slide film because, within reason, you can recover your images.

Underexposure is always preferable to overexposure because if you haven't actually recorded the detail on the film in the first place, it can't be retrieved. With overexposure, the usual outcome is that the highlights 'burn out', which means they record as pure white. In this case, no matter how skilled you are with Photoshop, you can't recover lost detail. If an image is underexposed, however, there is usually detail even in the darkest areas that can be recovered.

WHAT YOU NEED

- A selection of underexposed or overexposed images.

HOW IT'S DONE: METHOD 1 – RESCUING AN UNDEREXPOSED SHOT

I thought these octopuses drying in the sun made an eye-catching subject, so I moved in close to capture them against the light. Unfortunately, the background was so bright that it fooled my camera's metering system into causing underexposure. This happened because the metering is designed to record everything as a mid-tone. As the scene was bright, it underexposed it so it came out as a mid-tone.

I wanted the octopuses to be correctly exposed and the background a little burned out, which shouldn't be too difficult, though there are several options available in Photoshop.

Step 1 First I tried adjusting the image in Curves by making a Curves adjustment layer – Layer>New Adjustment Layer>Curves. This opens the Curves dialogue box. To pin-point specific tones on the RGB curve, hold the Option key down and click on a part of the image. Doing this will put a point on the curve where the tone you have selected lies. In this case I wanted to lighten the selected tone so I pulled

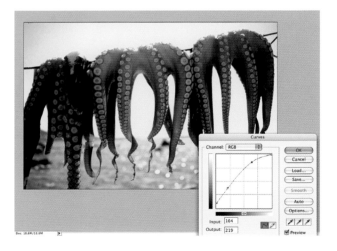

the curve a little higher and to the left. I then repeated this procedure in the shadows and highlights. The result is a brighter, crisper image – more like what I had in mind when I took the original.

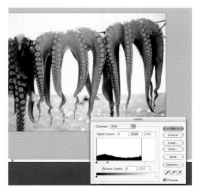

Step 2 Using Levels can also rescue an image. In this example I made a Levels adjustment layer so that I could discard any changes without affecting the original image. I then adjusted the mid-tones and highlight points in the Levels dialogue box until I was happy with the effect, though it is not quite as successful as making a Curves adjustment. I also found that colour saturation increased and it was necessary to tone things down in Hue/Saturation.

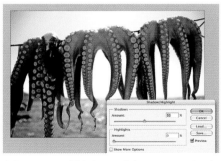

Step 3 Users of Photoshop CS and CS2 have another option – the Shadow/Highlight tool found under Image>Adjustments. This is a quick way to make the shadows or highlights lighter or darker. In this case the default setting of shadows at 50% and highlights at 0%, which was applied to the image when I opened the tool, was pretty much OK; although, again, colour saturation had to be reduced after adjusting image density.

The original

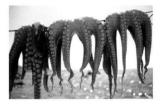

Curves adjustment

Levels adjustment

Shadow/Highlight adjustment

Mykonos Town, Mykonos, Greek Islands
This comparison shows how an underexposed photograph can be rescued using three different methods– Curves, Levels and Shadow/Highlight. Of the three, I prefer the Curves method as it allowed me to adjust the density of specific areas of the image to achieve a more pleasing tonal range. With Curves and Shadow/Highlight I found that the shadow areas were darker than desired. **Camera** Nikon F90x **Lens** 28mm **Film** Fujichrome Velvia 50.

SNOW JOKE

Underexposure is more likely to occur when the tones in a scene are very light. Snow-covered landscapes are perhaps the most common example of this scenario, closely followed by whitewashed buildings. When this happens your camera tries to record the white as a mid-tone (grey) so it underexposes the whole photograph. Luckily, such a mistake is easy to rectify in Photoshop.

Go to Image>Adjustments>Levels. In the Levels dialogue box you will see three triangle markers under the histogram for the image. The triangle on the right allows you to lighten the highlights. For images where the whites are underexposed, pull the highlight marker to the left until it is under the first peak in the histogram. This should restore the whites to all their pristine glory. Click OK when you are happy with what you see.

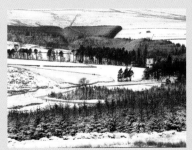

Weardale, County Durham, England
It took just one quick adjustment of the highlight marker in Levels to go from a drab, underexposed image to one that is perfect. **Camera** Pentax 67 **Lens** 300mm **Film** Fujichrome Velvia 50.

Photo First Aid

METHOD 2 – RESCUING AN OVEREXPOSED SHOT

A camera meter may be fooled into causing overexposure if the subject or scene you are photographing is made up of predominantly dark tones, such as a close-up of a black cat's face or a black door that fills the frame, or if your main subject is small in the frame and against a much darker background. Once again, the camera sets an exposure to try to record the scene as a mid-tone, which is what it has been designed to do, so it gives too much exposure to lighten the dark areas. This is exactly the opposite of what happens if you shoot a snow scene.

In reality, it will rarely be the subject matter that causes the problem. You are more likely to overexpose because you forgot to cancel a + setting in the camera's exposure compensation, or because you were shooting in manual mode and went from photographing a darker subject to a lighter one without changing the exposure. Whatever the reason, if it happens you will need to try to rescue the image. I find the best way to do this is by adjusting Curves, as follows:

Step 1 Make a Curves adjustment layer. To do this, open the Layers palette using Windows>Layer then click on the Adjustment Layer icon at the bottom of the palette and choose Curves. Alternatively, use Layer>New Adjustment Layer>Curves. By making adjustments on a layer you don't permanently change the original image (unless you flatten the layers) so it is much safer than working on the original. You can

also re-open the adjustment layer at any point and adjust the changes you have made.

Step 2 To adjust a specific tone in the image, click on it while pressing down the Option key and a marker will appear on the curve that corresponds to that tone. In this case I selected an area of sky near the statue. You can see that it falls pretty much in the middle of the curve, so that makes it a mid-tone.

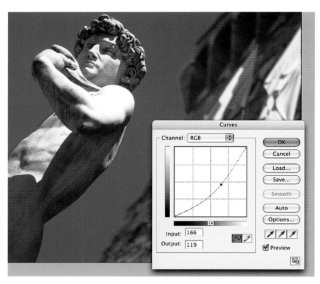

Step 3 To darken down the image I pulled the curve down as shown. The further you pull down the darker the image becomes, but don't overdo it. You can repeat this at any number of points on the curve, though in this case adjusting just the sky tone brought the other tones in the image in line and produced a perfectly exposed result.

Statue of David, Florence, Italy
I was busy chatting when I composed this shot and forgot to adjust the exposure, resulting in gross overexposure. However, by scanning the original slide, I was able to rescue it quite easily in Photoshop.
Camera Pentax 67 **Lens** 165mm **Filter** Polarizer **Film** Fujichrome Velvia 50.

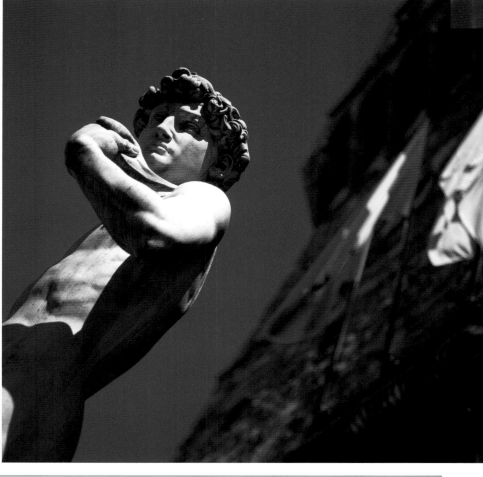

BE CREATIVE

What does 'correct' exposure mean exactly? To me it's a very personal matter, and sometimes, what's considered technically correct may be boring, while an image that is technically too light or too dark may actually be far more interesting. So, don't be afraid to experiment with exposure and use 'error' to your advantage. Highlights don't have to contain detail and in some cases, complete burn-out can work in your favour. Similarly, shadows can be deep black with no visible detail if that's what you want.

Bath Toys
The original image here is slightly underexposed, but not much. When I came to correct it in Photoshop, however, I decided to overcompensate and made bigger adjustments to the highlight and mid-tones levels than I really needed, so the whites burned out and the yellows were on the verge of doing the same. I found this gave the image a contemporary high-key look.
Camera Nikon F90x **Lens** 105mm macro **Film** Fujichrome Velvia 50.

Photoshop Filters

Back in the early 1980s Cokin Filters were all the rage. You could buy filters that multiplied your subject by 7, added a rainbow to landscapes, turned the sky purple, made static subjects look as if they were breaking the sound barrier – the list went on and on. Like many enthusiasts, I loved them all, and went on to create lots of, well, pretty awful photographs!

Many of the effects seemed great in theory, but in reality they were just gimmicks. After you had used a filter once or twice, there was a severe danger of overkill if you ever used it again. Far too many photographers used the more unusual filters as an easy way of trying to make a bad picture look good, something you simply can't do.

The same can be said of Photoshop and similar image manipulation packages. An image can be totally transformed at the click of a mouse or the press of a button. Sadly, though, that transformation isn't always for the better. It is very tempting to add filter effects for the sake of it; consequently the appeal of the final image is based solely on what you have done to it, rather than what is in it.

The key is to choose effects carefully. It's great fun to try different ones out, but apply only them if they actually enhance the original photograph. To give you an idea of what is possible, here are some examples of effective Photoshop filters that look good when used with the right image.

WHAT YOU NEED

■ A selection of colour of black-and-white images. I used only colour images here, and applied filters that work well with colour.

HOW IT'S DONE: METHOD 1 – DIFFUSE GLOW

This is a great filter to use on backlit images as it adds an atmospheric glow. It can also be used to help create an infrared effect in black-and-white photographs. To use it, go to Filter>Distort>Diffuse Glow. There are three controls available that allow you to vary the effect and a large preview image so that you can see what happens when any of the sliders are adjusted.

Near Buckland-in-the-Moor, Dartmoor, England
I chose this woodland scene because I knew the effect would work well on it. After applying the Diffused Glow filter, I selected Image>Adjustments>Hue/Saturation. Moving the Hue slider a little to the left made the autumnal foliage much redder, rather like using a red enhancing filter. I also increased the saturation.
Camera Horseman Woodman 5 x 4in **Lens** 90mm **Filter** Polarizer **Film** Fujichrome Velvia 50.

Kitty on the Beach, Alnmouth, Northumberland
Looking through some family snapshots taken with a Nikon Coolpix digital compact, I came across this light-hearted shot of my daughter Kitty. The original is OK, but it needed something more to give it a creative lift. Diffuse Glow again came to the rescue by burning out the background to create a halo effect around Kitty's hair and also adding a lighter, high-key feel to the image.
Camera Nikon Coolpix 3400 digital compact with integral zoom.

METHOD 2 – EXTRUDE

It is tools like this that show just how clever Photoshop is. Extrude – Filter>Stylize>Extrude – is almost verging on the ridiculous and it took me a while to find an image to suit the effect. That said, Photoshop was created for designers rather than photographers and in imaginative hands this filter offers bags of potential.

Venice Carnival, Italy
I tried Extrude on a number of images and, though I really like the effect, I did wonder if I would ever put it to good use. Finally, I found a photograph that suited it. Initially I applied Extrude to the whole image, using 14 and 14 for size and depth. However, I found it worked better if I didn't apply it to the whole image. Using the Marquee tool I selected the model's face, then went to Select>Inverse, so I could work on everything but the face, and applied the Extrude filter again.
Camera Nikon F5 **Lens** 80–200mm zoom **Film** Fujichrome Velvia 100F.

Photoshop Filters

METHOD 3 – POSTER EDGES

This filter can be found in the Artistic menu – go to
Filter>Artistic>Poster Edges. When the dialogue box appears,
use the three sliders to vary the effect and to check progress
on the preview screen. It is a fun filter to use, but it only works
on simple, graphic images – at least that is my opinion.

Imerovigli, Santorini, Greece
I like the way the shapes have been
enhanced by the Poster Edges filter in
this simple image, making it appear
more like a piece of graphic art than
a photograph. The settings I used
were 4, 4 and 2.
Camera Nikon F90x **Lens** 28mm **Filter**
Polarizer **Film** Fujichrome Velvia 50.

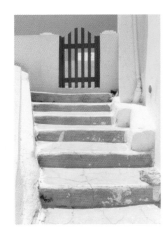

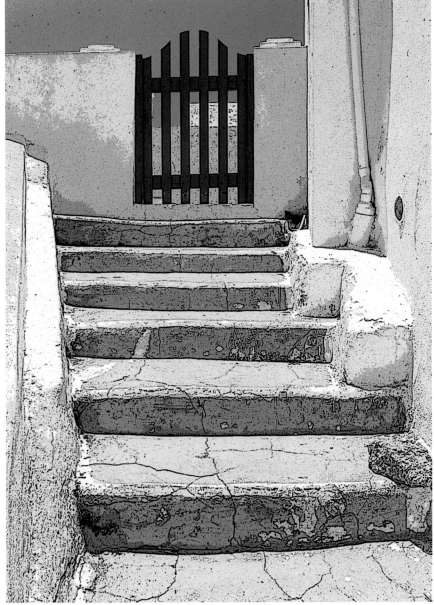

METHOD 4 – DISTORT

If you go to Filter>Distort, you will find various distorting filters. Different ones work on different images, but in all cases you need to start off with an image that will still be identifiable once the filter has been applied. Portraits work really well. You can distort your subject's face and turn a simple snapshot into a humorous caricature – it's great fun and bound to raise a smile. Any simple, graphic image will also suit the treatment, as you can see with this set of images.

In each case, you have simple controls available that allow you to vary the level of distortion to suit the image. More than one distortion filter can also be applied to the same image, if you are feeling really adventurous, or you can keep re-applying the same filter to make the effect more extreme. For example, I applied the Pinch filter four times to get the effect shown here. Liquify is more complicated – I used this filter to help re-create Polaroid emulsion lifts (see pages 62–5), but it works well as a stand-alone effect. I used a brush size of 300 pixels to pull and push the image around and to distort it, but you can select a larger or smaller brush than this.

Lloyds Building, London
Here is what the original image looked like before I applied the various distortion filters. As you can see, they make quite a difference.
Camera Nikon F90x **Lens** 50mm
Film Fujichrome Velvia 50.

Pinch

Shear

Spherize

Twirl

Liquify

Restoring Old Photographs

A year or so ago, my father discovered a box of old photographs of his mother's family that had been hidden away in a cupboard. He asked me if I would reprint some of them so that he could give copies to other members of the family. Without having seen the photographs I agreed, but when they arrived I realized that most of them were going to require some expensive restoration work before I could reprint them. As well as stains, blemishes and creases, some of the prints had tears in them and most were also faded due to their age.

In the days before Photoshop became available, repairing this kind of damage on old photographs required great skill with both paintbrush and airbrush and took many hours. Nowadays, just about anyone with a basic understanding of Photoshop tools can do it with and achieve professional-looking results in a matter of minutes.

HOW IT'S DONE

Restoring old photographs mainly involves using the Clone Stamp tool or Healing brush to get rid of scratches, tears and blemishes. Both these tools allow you to copy pixels from an undamaged area and paste them over the damage. With so many different brush types and sizes you can deal with everything from the smallest dust spot to the largest scratch or tear. The key to success, however, is patience, and if you take your time the transformation can be amazing.

To demonstrate, I chose one of the old photographs belonging to my father. As you can see from the original it was in a pretty bad way, but that soon changed.

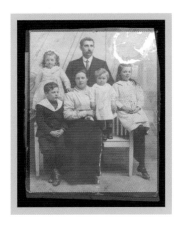

Step 1 Scan the original print at 300dpi using a flatbed scanner, then copy the master file. I cropped this image to get rid of the uneven edges that had been caused when the print was cut from a scrapbook.

Step 2 Most old photographs are sepia-toned, as this one was. However, it is easier to work on images in black and white, so get rid of the tone using Image>Adjustments>Desaturate and re-tone the image later when the repair work has been completed.

Step 3 The original print may have faded quite badly so to give the image a bit more sparkle and life you can adjust Levels – Image>Adjustments>Levels. This boosts contrast, making the blacks deeper and the highlights crisper.

Step 4 In this photograph, the first area I decided to repair was the long crease that runs from the top of the print to the bottom. This was particularly evident in the woman's black skirt and the face of the child standing on the bench. To do this I selected the Clone Stamp tool and used a soft brush with a diameter of 35 pixels to begin with.

Step 5 To use the Clone Stamp tool all you do is move the cursor to an area where the image colour/tone is similar to the part you want to repair then Alt-

click on it. Moving the cursor over the area to be repaired you then click the mouse and it will paste the copied pixels on to it. For lines such as the crease shown here you can click and drag the mouse so it does a continual repair.

Step 6 Every few minutes it is a good idea to reduce the size of the image on your screen, so you can check progress. Here, you can see a difference already, with the crease on the woman's skirt gone.

Step 7 The next area I worked on was the girl's shoe, which had some fine cracks showing through as white. I used the same soft brush, but reduced its diameter to 5 pixels in this area.

Step 8 Scrolling to the bottom left corner of the image, I then retouched some cracks, creases and marks. Repairs like that are easy to deal with. Having got rid of the white marks on the boots with a small brush,

I increased its diameter to 50 pixels, copied an undamaged area of the floor using the Clone Stamp tool and pasted the pixels over the damage. For larger areas you can also use the Marquee tool. Drag it over the area you want to copy then go to Edit>Copy, drag the tool over the damaged area and go to Edit>Paste.

Step 9 The only way to make a good repair job is to take your time. I spent about 40 minutes on this image, moving from one area to another, retouching any damage. I paid particular attention to faces, as blemishes on these stand out, and although I didn't expect to get everything perfect I made sure I dealt with all glaring marks.

Step 10 The top part of the print was especially bad and on the top right corner a large area had been torn away then stuck back down. Unfortunately, the repair was crude

Restoring Old Photographs

to say the least and there were some areas that were missing completely from the image, with only the white backing being visible. Although it looked bad, sorting it out was easy. I used a soft brush at 30 pixels to cover the cracks and marks with pixels from a clean part of the background. I also got rid of some of the ropes and generally tidied everything up.

Step 11 In the badly damaged top left corner there were traces of a building that had been painted on to the studio backdrop. I copied this, making a selection with the Marquee tool, then pasted it twice into empty space in the top right of the image. Quick tidying up with the Clone Stamp tool made it look as if the building went all the way to the top of the picture. I also used the Clone Stamp tool to remove the remains of the steps you can see to the right of the man.

Step 12 To replace the missing hair of the girl to the right of the group, I used a small brush (5 pixels) to copy different areas. By click-dragging the mouse I was able to draw in the

tones to create the right shape on the top of her head, rather than just pasting blobs of tone on to the area.

Step 13 I couldn't get the right eye of the boy on the bench quite right using the Clone Stamp tool, so instead I made a selection around his left eye with the

Marquee tool, copied it – Edit>Copy – drew another selection around his right eye, then using Edit>Paste, I dropped the copy of the left eye on to the image. Because his face wasn't particularly sharp I didn't need to flip this selection as it looked fine as it was.

Step 14 When the retouching is complete, you may want to sharpen-up the image a little using Filter>Sharpen>Unsharp Mask. The key with this filter is not to oversharpen, otherwise the results look unnatural. Also, if part of an image is unsharp because it is out of focus or blurred due to movement, you can't actually make it look sharp.

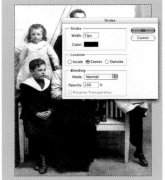

Step 15 Add a keyline to define the edge of the image using Edit>Transform>Stroke. Here, I selected a black line 3 pixels wide.

Step 16 To reinstate the image tone you can use the quick method described on page 150. Go to Image>Adjustments> Hue/Saturation, click the Colorize box, then adjust the Hue and Saturation sliders. The settings shown in the screengrab left are the ones I used to produce the tone in the final print.

Step 17 Finally, to help show off the image, increase the canvas size – Image>Canvas Size – by 2cm (¾in) in height and width and choose white as the extension colour.

132

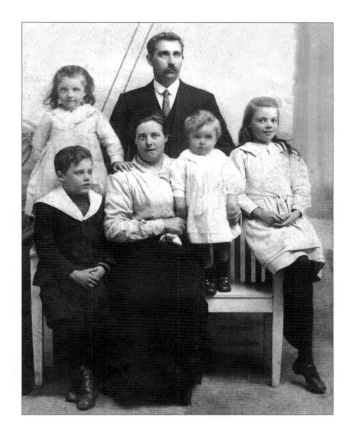

The Archer Ancestors
If you compare the original with the final, retouched image you can see that Photoshop is capable of repairing pretty much anything. Only missing body parts create a problem, but professional retouchers can even get around that by copying from different parts of the print — or even different prints — and cleverly blending them in so that no one can see the joins.

Here is another example of an old photograph that I have retouched using Photoshop.

Simple Lenses

In recent years, 'toy' cameras, such as the Holga, have developed a cult following among fine-art photographers – see www.toycameras.com if you are not convinced!

These cameras are crudely made, frequently leak light and there is little or no exposure control. Optical quality, as you can imagine, is poor. Often there is just a small sharp spot in the centre of the frame, while the rest of the image is blurred beyond recognition. Despite their flaws – or perhaps because of them – toy cameras are great fun to use, and the prints that result have a wonderful feel to them.

The downside, however, is finding time to print the negatives, so as an alternative I decided to devise a way of mimicking the effect digitally.

WHAT YOU NEED

- A selection of colour or black-and-white images.

HOW IT'S DONE

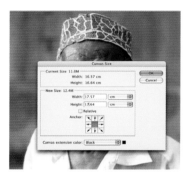

Step 1 If the original image is rectangular, crop it to a square – most toy cameras produce 6 x 6cm images on 120 film. Extend the canvas size using Image>Canvas Size. Increase the image dimensions by 1–2cm (⅜–¾in) in height and width. Choose black as the extension colour to create a black border.

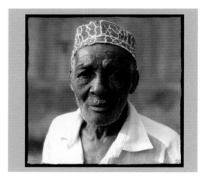

Step 3 Work all the way around the inside edge of the black border so that the edge is made uneven, as shown. Don't worry if there are signs that you have used the Clone Stamp tool as this will soon be lost.

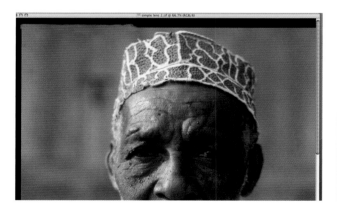

Step 2 Click on the Clone Stamp tool. From the Brushes dropdown menu, select Dry Media Brushes and click on Pastel Medium Tip brush. Use the Clone Stamp tool to soften the sharp inside edge of the black border (see pages 14–15).

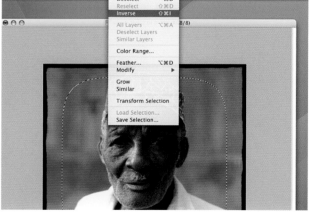

Step 4 Using the Marquee tool, click and drag over the central area of the image then go to Select>Inverse so that everything outside the selected central area can be worked on. Set a feathering of 25 pixels to create a soft edge.

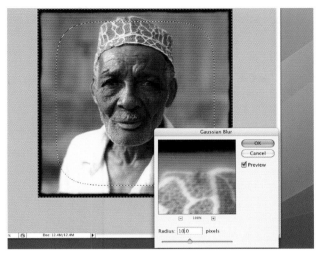

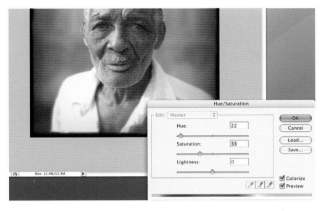

Step 5 To soften the edges and corners of the image, so that they appear out of focus, go to Filter>Blur>Gaussian Blur. Here I set a Radius value of 10.0 pixels.

Step 8 Adjust the toning by going to Image>Adjustments> Hue/Saturation and clicking the Colorize box. Adjust the Hue and Saturation sliders.

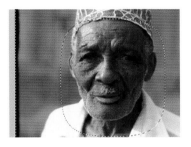

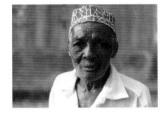

Old Man, Stone Town, Zanzibar
The effect of blurring and vignetting the picture edges does a good job of mimicking the Holga, while the square format suits the composition of the portrait.
Camera Nikon F5 **Lens** 50mm
Film Fujichrome Velvia 100F.

Step 6 To create your sharp area or 'sweet spot' in the centre of the image, follow steps 4 and 5, but make the central selection smaller and use a lower Radius setting in Gaussian Blur of around 6.0 pixels.

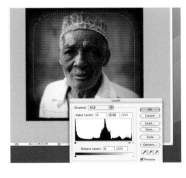

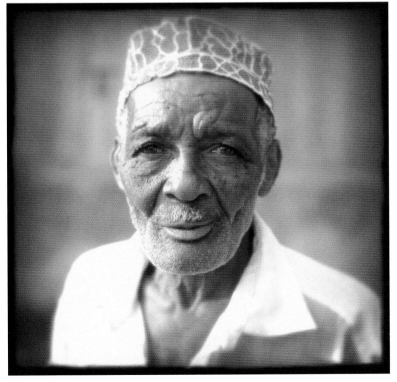

Step 7 Make a final selection with the Marquee tool towards the outer edges of the image. Go to Select>Inverse, then open Levels and darken the outer edges of the image to create a vignette effect.

Soft-Focus Effects

Using soft-focus filters to add mood and atmosphere to photographs is a technique I've been using for years. It works well on a wide range of subjects, from still-life and portraits to nudes and landscapes, in both colour and black and white. There are lots of different filters available, each creating a slightly different effect.

The only problem with adding soft focus when a photograph is actually taken is that you are then stuck with the image in soft focus only, unless you also shoot an unfiltered version at the same time. By adding soft focus digitally, however, you can experiment with an almost endless range of effects, from delicate diffusion to a dramatic, dreamy glow. You can then view the results before you commit, and you will always have an unfiltered version of the image as a back-up.

WHAT YOU NEED

- A selection of black-and-white or colour images. Soft focus destroys fine detail so stick to simple images that don't rely on fine details for their success and also those that would benefit from a touch of soft focus.

HOW IT'S DONE

There are many ways to create soft-focus effects in Photoshop, and much fun can be had from playing around with the various Blur filters on offer. For the best results, make a duplicate layer of the original image so you can discard the effect if you don't like it. You can also use blending modes and the Opacity/Fill sliders to vary the effect.

Step 1 Make a duplicate layer of your chosen image by selecting Layer>Duplicate Layer or using the New Layer icon in the Layers palette.

Lucignano d'Asso, Tuscany, Italy
The original, unfiltered, photograph for comparison with the diffused versions.
Camera Pentax 67 **Lens** 165mm **Film** Fujichrome Velvia 50.

GAUSSIAN BLUR AND BLEND MODES

My favourite soft-focus filter is Gaussian Blur – it is easy and quick to use and also highly versatile when combined with blending modes. The following sequence of images shows just a few of the effects it is capable of.

Step 2 Making sure this layer is highlighted, go to Filter>Blur>Gaussian Blur. In the pop-up window that appears you will see a preview and a Radius slider. The further to the right you drag the slider, the more blurred the image becomes. In this case, I set a value of 5.0 pixels.

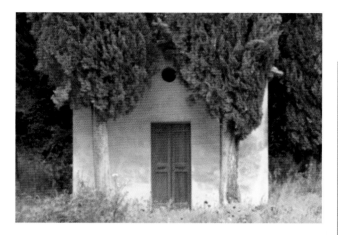

This is how the image looks when Gaussian Blur is added with the Radius slider set at 5.0 pixels.

Step 3 The effect created by Gaussian Blur alone doesn't look that good as the image is just blurred. However, if you combine the blurred layer with the original, sharp layer, the effect is much more attractive, Here, I simply changed the blending mode of the duplicate layer from Normal to Darken.

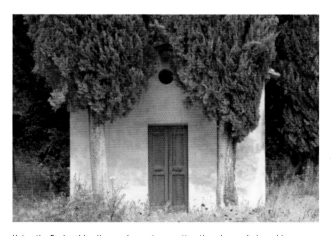

Using the Darken blending mode creates an attractive glow and also adds a delicate black-and-white mask.

SURFACE BLUR

Photoshop CS boasts even more Blur filters, all of which are worth trying. I particularly like the Surface Blur filter as it creates an effect similar to breathing on your camera lens, but with much greater control over the final result. To produce this image I selected Filter>Blur>Surface Blur and in the pop-up window set Radius to 30 and Threshold to 70 pixels. The layers were then blended in Normal mode and the Opacity slider was set to 60%.

Riad Enija, Marrakech, Morocco
It was the vivid pink sofa that caught my eye as I walked through a courtyard of the Riad. The colours leapt out against the neutral background and the sofa had been carefully positioned for maximum design impact, creating a ready-made composition. Adding a soft-focus glow softens the hard lines and gives the picture extra mood.
Camera Nikon F90x **Lens** 28mm **Film** Fujichrome Sensia II 100.

Soft-Focus Effects

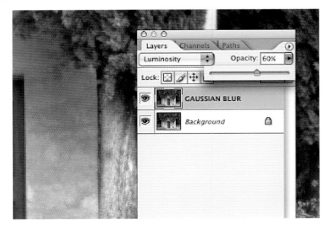

Step 4 This time I chose Luminosity blending mode. Initially, I saw little change in the appearance of the image, but by reducing Opacity to 60%, some sharpness from the original image started to show through.

Luminosity blending mode creates a similar effect to soft-focus filters used on a camera lens.

Step 5 I decided that this image could stand more diffusion without too much loss of detail, so I set Gaussian Blur on the duplicate layer at a Radius of 9.0 pixels then used Normal blending mode to combine the two layers and set Opacity at 60%.

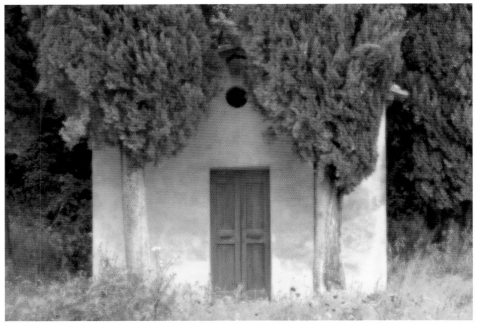

Increasing the level of Gaussian Blur adds a dreamy glow to the image. This is my favourite of the sequence.

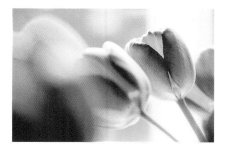

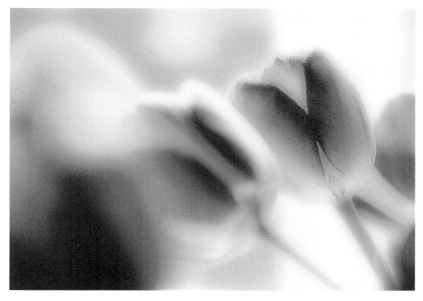

Tulips Against the Kitchen Window
Backlit subjects are ideal for soft-focus effects because the 'halo' that is created is more obvious. In this case, I set Gaussian Blur to a value of 9.0 on the duplicated layer, blended the layers using Luminosity mode, and set Opacity at 80% and Fill at 80% to create the effect I wanted.
Camera Nikon F90x **Lens** 105mm Macro
Film Fujichrome Sensia 400 rated at ISO1600 and pushed two stops.

DREAMY DOUBLE EXPOSURE

If you go to the Filter dropdown menu in Photoshop and select the Other section at the bottom, one of the options in that list is Maximum. I decided to experiment with this, which is when I discovered another quick and effective way to create soft focus.

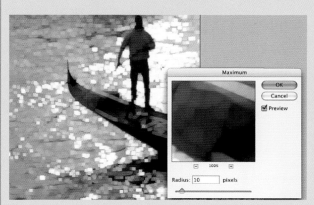

As usual, make a duplicate layer of your original. Next, go to Filter>Other>Maximum and experiment with different settings of the Radius slider. For this image, a Radius of 10 pixels produced a good effect. All I did then was blend the layers

in Normal blend mode and adjust Opacity until I was happy with the on-screen image. The final effect is similar to making two exposures of the same subject on a single frame of film – one sharply focused and one defocused – so the defocused image creates a halo around the sharp one.

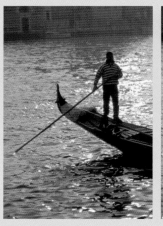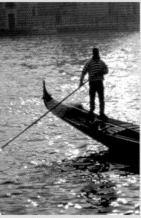

Gondolier, Venice, Italy
The Maximum filter can produce an interesting soft-focus effect, though if you push it too far the final image will appear out of focus.
Camera Nikon F90x **Lens** 80–200mm **Film** Fujichrome Velvia 50.

139

Solarization

Also known as the 'Sabatier effect', solarization in a traditional wet darkroom is created by exposing a print or film to light during development so it becomes partially fogged. This causes the undeveloped areas of the print to go dark, other tones to be reversed so you get a part negative effect, and the creation of fine lines – known as 'Mackie lines' – at the borders between the light and dark areas.

Solarization was discovered by mistake by in the 1920s, when a light was turned on the darkroom while a print was still in the developer. The pioneering American photographer, Man Ray was one of the first to use the technique in his work. These days, creating solarized effects using Photoshop is a much more straightforward technique, and gives far greater control over the appearance of the final image.

Detail is lost by solarization so it is best to stick to simple images that have bold shapes and strong lines.

HOW IT'S DONE: METHOD 1 – USING THE SOLARIZE FILTER

Photoshop allows you to do so much at just the click of a mouse. Although this is not always the best way to work, it certainly makes life easier when you first start to experiment with digital imaging techniques.

In the case of solarization, you can sample the effect in seconds simply by opening your chosen image, then selecting Filter>Stylize>Solarize. No controls will be offered to you, instead Photoshop automatically solarizes the image.

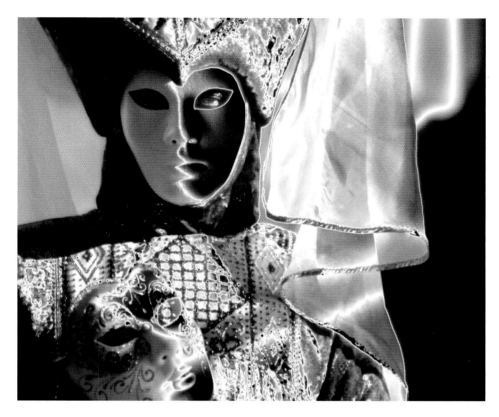

Carnivale, Venice, Italy
Depending on the type of image you start out with (see the original photograph opposite), using the Solarize filter may produce just what you want. If not, you can always tweak the result using Levels or Channel Mixer, as I did here.
Camera Nikon F5 **Lens** 80–200mm **Film** Ilford FP4 Plus.

Old Bottles
This set of pictures shows how you can produce interesting solarized effects in colour and in black and white. Both solarized versions of the original were created using the Solarize filter in Photoshop, with some final adjustment of Levels. For the black-and-white version, the original colour image was first converted to mono. If you don't like the colours of a solarized colour image, simply select Image>Adjustments>Hue/Saturation and adjust the Hue slider to change the colours.
Camera Olympus OM4-Ti **Lens** 50mm **Film** Fujichrome RDP100.

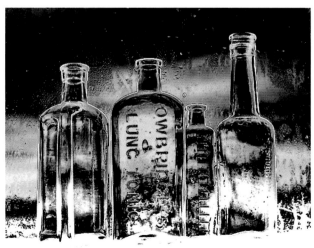

Solarization

METHOD 2 – USING CURVES

The Solarize filter does have its limitations because there are no variables available for you to play with. However, there is another way – if you use Curves to create solarization effects you will have more control over the final image. Here is how it is done.

Houses of Parliament, London
The original image was shot in colour, but I felt that it would also work well in black and white.
Camera Pentax 67 **Lens** 200mm **Film** Fujichrome Velvia 50.

Step 2 Take the bottom left point of the curve and drag it to the top of the box so the image goes white. Next, click on the centre of the line and pull the curve down. This has the effect of reversing the tones of the image so it appears in negative – notice how the silhouetted statue appears white.

Step 1 Open your selected RGB image, select Window> Layers to open the Layers palette then click on the New Adjustment Layer icon and select Curves. This opens up the Curves dialogue box as shown.

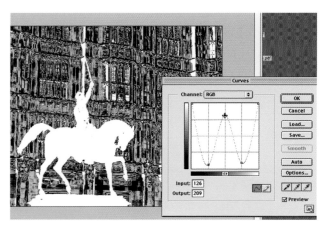

Step 3 Now drag the curve down on the left and right of the centre point, then pull the centre point back upward so the curve looks like the letter 'W'. This should give you a reasonable solarized effect, though you can adjust the curve further to fine-tune the image, and make further adjustments in Levels if necessary.

142

The small image below shows how the final solarized image looked. The effect works well, but I wasn't sure about the statue being white, so I decided to reverse the tones using Layer>New Adjustment Layer>Invert. This turned the negative tones in the image to positive.

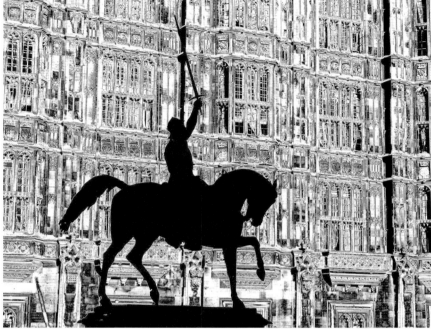

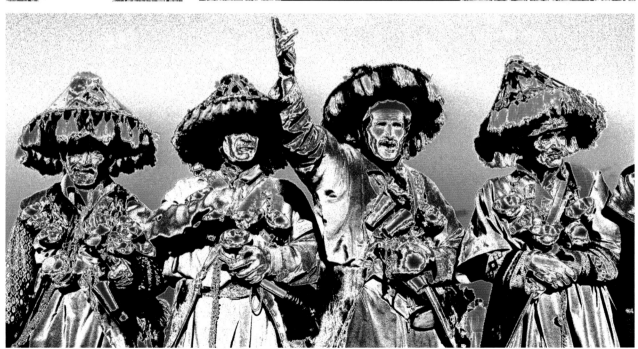

Watersellers, Marrakech, Morocco
This image started life as quite a contrasty black-and-white print, but I felt that solarization would simplify it further and add impact. I used Method 2 to transform it.
Camera Hasselblad XPan **Lens** 45mm **Film** Ilford HP5 Plus.

Textured Images

I have always been a great fan of painterly images. Over the years I have experimented with numerous techniques that have allowed me to produce pictures that walk the boundary between photography and painting.

The easiest method is to shoot fast films and use their coarse grain structure to impart a pointillist feel. In the darkroom you can take this further by printing through different materials, such as greaseproof paper or a scratched plastic sheet. You can also make texture screens by photographing textured surfaces on black-and-white film, then sandwiching the negative with your image and printing them both together, so the texture bleeds through.

In the digital darkroom, however, you have an even greater choice. Not only can you try out different textures to see which one works best, but you can also control exactly how much influence the texture has. Here are some examples I have prepared to give you an idea of what is possible with Photoshop.

WHAT YOU NEED

- A selection of colour or black-and-white images that would benefit from the addition of texture. Also some texture images – you could take photographs of surfaces such as concrete or stone or scan textured materials, such as greaseproof paper.

HOW IT'S DONE: METHOD 1 – CREATING A TEXTURE SCREEN

For this first example I wanted to add the texture of greaseproof paper to a black-and-white image. It is a technique I have used many times in my conventional darkroom and it involves laying the greaseproof paper over a sheet of printing paper on the enlarger's baseboard, then exposing the negative through it. Achieving a similar effect in Photoshop is even simpler.

Step 1 Cut a piece of greaseproof paper – in this case it measured 15 x 12cm (6 x 4¾in) – and scan it at high resolution (300ppi) using a flatbed scanner. This will give you a dull, grey image, as shown here. You can make changes to this image before you use it, such as increasing contrast by adjusting Levels, but I chose to leave it as it was. If you don't have a flatbed scanner you can photograph the greaseproof paper using a digital camera then download the image into your computer.

Step 2 Open your chosen image, then open the texture image so you can see both on your monitor. I opted for this nude study as the model's body forms a strong shape that will still be obvious when the texture is added. The original black-and-white print had been exposed through a soft-focus filter to diffuse the image and make it more atmospheric. I scanned the print and added a subtle blue tone.

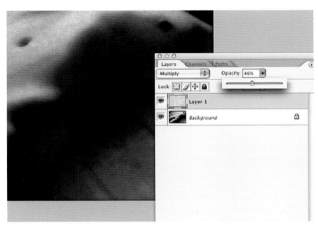

Step 3 Click on the texture image then click on the Move tool in the Photoshop toolbox. Drag the texture image over the main image and release. If the texture image is smaller than the main image, go to Edit>Transform>Scale and increase its size so it is at least the same size as the main image. If it is already larger than the main image you can leave it as it is.

Step 4 Go to Window>Layers and open the Layers palette. You will see the main image and the texture image as two separate layers. Click on the layer for the texture image then change the blending mode from Normal to one of the other options. The usual mode for this kind of job is Multiply, but try some of the others – you may prefer the results they give. Soft Light and Color Blend are two that work well. Whichever blending mode you do choose, you will almost certainly need to reduce the Opacity of the texture layer so that it doesn't overpower the main image. Drop it down to 30–40% using the slider, then take it from there. You may also want to adjust Levels a little if the tones of the image aren't quite right.

Original

Nude Study
You can see the effect the texture image has had on the original from these two examples. For the first one I used Multiply as the Blend Mode and set Opacity quite low (30%) so the texture is subtle. For the second I used Color Burn as the blend mode and a higher Opacity (40%) to give a darker and more sombre effect.
Camera Nikon F90x **Lens** 28mm **Film** Fuji Neopan 1600.

Multiple blending mode

Color Burn blending mode

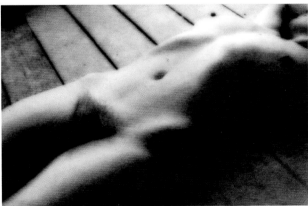

Textured Images

De La Warr Pavilion, Sussex, England
To add the texture to this lith print I again scanned a sheet of greaseproof paper, but before doing that I screwed it into a ball and flattened so it was full of fine creases. I then adjusted Levels to make the image more contrasty and show up the creases. This created a more obvious texture or pattern, which was revealed by changing the layer's blending mode from Normal to Soft Light and adjusting Opacity. Once I was happy with the effect, I decided to add a black film rebate border using the method outlined on pages 14–15.
Camera Nikon F5 **Lens** 20mm **Film** Ilford FP4 Plus.

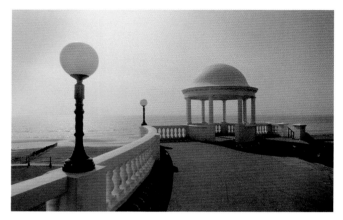

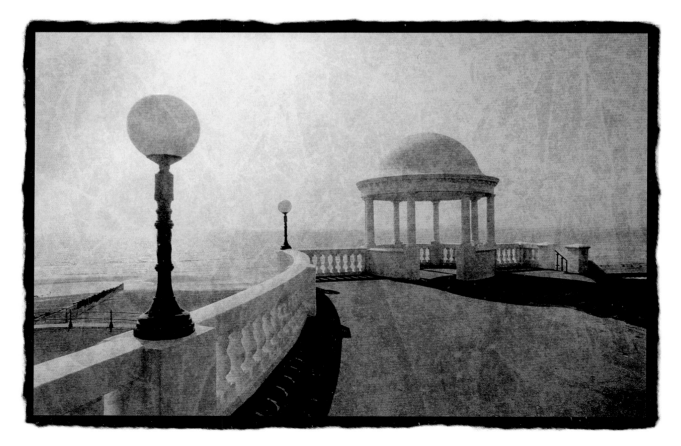

METHOD 2 – USING A PHOTOGRAPH TO ADD TEXTURE

Instead of creating a texture screen, try looking through your photo archive to see if you can find any existing images that could do the same job. In this example I came across a picture taken several years ago at a glass recycling plant of an enormous pile of broken glass and decided it might work. I scanned it in then proceeded as follows.

Step 1 Open the chosen texture image, copy it and, if necessary, crop it. In this case I cropped out an area where the broken glass formed an interesting pattern. There was one distracting item in the top right of the image, but I soon got rid of that using the Clone Stamp tool.

Step 2 To stop the colour of the texture image showing through, before doing anything else you should desaturate it using Image>Adjustments> Desaturate.

Step 3 Now open the image you want to add the texture to, then, with both images side by side on the desktop, use the Move tool to drag the texture image over the main image. Adjust its size using Edit>Transform>Scale and apply the change, then in Layers change the blending mode of the texture image to Soft Light and adjust the Opacity.

Alphabet Letters
Here is the area cropped from the glass recycling shot, the original alphabet picture and the result of merging the two in Layers. I also increased colour saturation in the final image to make it more eye-catching and adjusted the highlight level to make the white background starker. Although I didn't set out with this in mind, I can't help but think those plastic alphabet letters now look like sugar-coated sweets. **Camera** Nikon F90x **Lens** 105mm macro **Film** Fujichrome Sensia II 100.

Toning Prints

Toning is an important part of black-and-white photography. It allows you to change the mood of a print by adding an overall colour (or more than one colour if required) to the image.

The most popular toner is sepia. Photographs from Victorian times were often sepia-toned, so it is ideal for adding a historical and aged feel to prints. Blue, copper and green are also commonly used, as are selenium and gold – the latter two being favoured more for their archival properties.

Traditional photographic prints are toned using chemical kits, a process that is messy, time-consuming and, in some cases, expensive. But, like so many other photographic techniques, the effects of toning can also be created digitally and with a much higher degree of control over the final result.

Digital toning also allows you to achieve effects that could never be created chemically, simply by tweaking a few controls in Photoshop. Mistakes can also be quickly and easily reversed, which is more than can be said for chemical toning, and you can work on an image until you have the effect you are looking for.

WHAT YOU NEED

- A desaturated RGB image – don't convert it to greyscale as this removes all colour information and prevents toning.

HOW IT'S DONE: METHOD 1 – USING CURVES

The easiest way to tone an image is by using Curves in Photoshop so, having opened your image file, go to the Layer menu and select Layer>New Adjustment Layer>Curves, so that any toning affects only the layer and not the main image.

Next, go to the dropdown Channel box, where it will say RGB, and you'll see that you can select Red, Green or Blue. Adjusting these individual curves allows you to create different toning effects.

Sepia toning: select the Blue channel and drag the curve down and to the right a little. The image now will look yellow/green, so next select the Green channel and drag the curve to the right into the magenta side. The image will now appear brown in colour. Finally, select the Red channel and drag the

curve a little to the left into the red to produce a nice sepia tone. The curve can be dragged from the centre, as shown above, or you can tag it at certain points so you are adjusting the colour only in the highlights, mid-tones or shadows. This is a handy technique when multiple toning (see pages 151–3).

Copper toning: repeat the steps for sepia toning, but simply push the Red curve further into red to create the effect.

Blue toning: select the Blue channel in Curves, then drag the curve to the left into the blue area – the more you pull the curve, the bluer the tone. Remember, In each case you can adjust the depth of colour using Image>Adjustments>Hue/Saturation then tweaking the Saturation slider.

Trinidad, Cuba
Here is the original, untoned black-and-white photograph, which I saved in RGB. **Camera** Nikon F5 **Lens** 80–200mm zoom **Film** Ilford HP5 Plus.

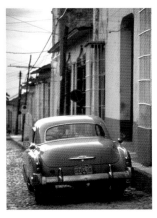

Sepia toning produces an attractive, warm image colour that suits this old-fashioned scene perfectly.

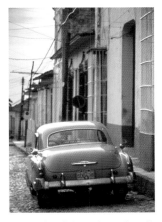

The cold feel of blue toning works well with the right shot and you can make the colour very subtle.

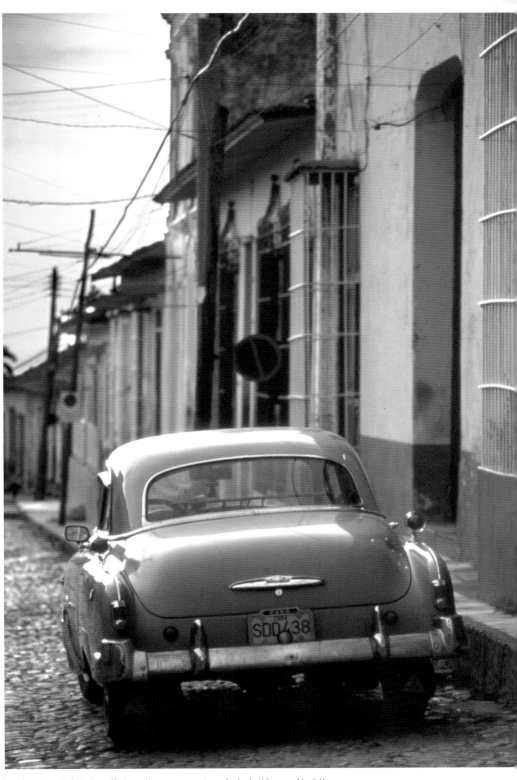

I prefer quite subtle toning effects as they are more atmospheric. In this case, I took the sepia-toned image and simply reduced the depth of colour using the Saturation slider in Photoshop – Image>Adjustments>Hue/Saturation.

Toning

METHOD 2 – USING HUE/SATURATION

A quick and easy way to tone a black-and-white image is to select Image>Adjustments>Hue/Saturation. When the dialogue box appears, click on the Colorize window. You can then

simply adjust the Hue and Saturation sliders until you are happy with the effect. Adjusting Hue changes the actual colour of the image, while adjusting Saturation makes that colour stronger or weaker. The photographs here show how you can produce a wide range of different effects, as strong or as subtle as you like.

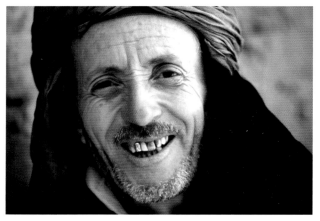

Guardian of Ait Benhaddou, Morocco
Here is the original untoned black-and-white image I chose to work on. Below are variations of it with the Hue and Saturation set at different levels.
Camera Nikon F5 **Lens** 80–200mm zoom **Film** Ilford HP5 Plus.

Hue – 40
Saturation – 20

Hue – 0
Saturation – 40

Hue – 30
Saturation – 65

Hue – 20
Saturation – 20

Hue – 200
Saturation – 25

Hue – 100
Saturation – 15

METHOD 3 – SPLIT TONING

As well as toning a black-and-white image with a single colour, such as sepia, it is also possible to use more than one toner on the same print. This is usually referred to as split toning.

In a conventional darkroom, the key to split toning is using toners that affect different parts of the image, so they work with rather than against each other.

For example, sepia toner affects the highlights first then the mid-tones and finally the shadows, while blue toner affects the shadows first and the highlights last. So, if you sepia tone a print for 20–30 per cent of the recommended time, only the highlights and lighter mid-tones will take on the sepia colouring while the shadows are left totally unaffected. If the same print is then washed thoroughly and partially blue toned, the shadows will take on a cold blue cast that contrasts nicely with the sepia highlights, while the mid-tones come out a blue/green colour.

Achieving this type of effect digitally is very easy because you can 'peg' the highlights or shadows of an image so that only certain parts of it are affected. Also, because there is no chemical process taking place, you can combine a much wider range of colours – in the darkroom you are limited by the small range of chemical toners available and how they affect the photographic image.

Here is how to create a sepia/blue split.

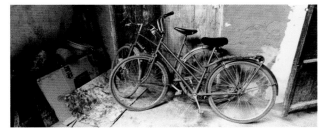

Old Bikes, Marrakech, Morocco
Here is the original, untoned black-and-white photograph.
Camera Hasselblad XPan **Lens** 45mm **Film** Ilford HP5 Plus.

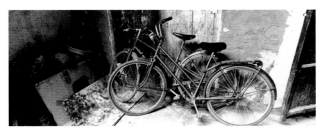

Here is how the image looked after completing Step 1 – note how only the highlights and lighter midtones have taken on the warm sepia tone. Turn the page to see the final image.

Step 1 Open your image in Photoshop, then select Image>Adjustments>Curves. In the Curves dialogue box, go to the Channel window and select the Blue channel. Before adjusting the channel, peg the shadows and darker mid-tones by clicking on the curve to lock it in position. When you've done that, follow the instruction on page 148 to create a sepia tone.

Step 2 When you are happy with the partial sepia tone in the highlights and mid-tones (remember that you can adjust the level of tone using Hue/Saturation if necessary) select the Blue channel. Next, peg the highlights and darker mid-tones by clicking on the curve, as shown, then pull the shadow part of the curve to the left, so the shadows take on a blue tone.

Toning

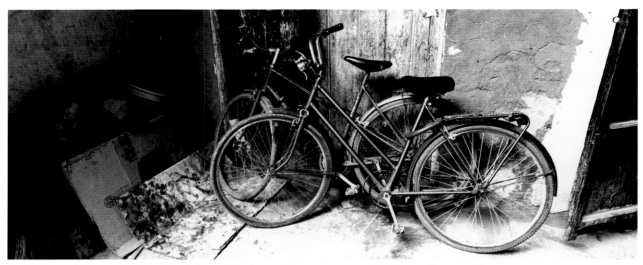

The final image exhibits sepia highlights, blue shadows and blue/green mid-tones. I purposely made the tones quite strong so the effect is obvious, but it is possible to achieve much more subtle effects. The beauty of digital split toning is that mistakes can always be rectified, whereas with chemical toning if you mess up at any stage, a high-quality print ends up in the bin.

METHOD 4 – USING COLOUR BALANCE

A quicker and easier way of split toning black-and-white photographs is to adjust Color Balance in Adjustment layers for the highlights and shadows. Here is how I created the split sepia/blue picture of the rhino.

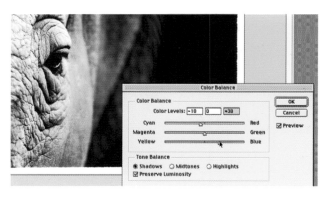

Step 1 Open your chosen image and the Layers palette. Click on the New Adjustment Layer icon at the bottom of the Layers palette and select Color Balance. A dialogue box will open. In the Tone Balance section of the box, click on Shadows then move the Yellow/Blue slider to the right and the Cyan/Red slider to the left to tone the shadows blue. Click OK, then in the Layers palette double-click the Adjustment Layer icon and rename it 'Shadows'.

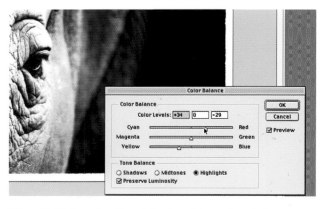

Step 2 Click on the New Adjustment Layer icon in the Layer palette and select Color Balance again. This time, click on Highlights in the Tone Balance section of the Color Balance dialogue box and move the Yellow/Blue slider to the left and the Cyan/Red slider to the right in order to add a sepia tone to the highlights.

That's all there is to it. You can play with blending modes to adjust the way the sepia and blue tones merge, but it is not essential. What you may want to do, however, is to select Image>Adjustments>Hue/Saturation and reduce saturation a little if the tones are too intense.

Rhino, Edinburgh Zoo
The image on the right shows what the original, untoned black-and-white photograph looked like. The version below was split toned in sepia and blue, using Layers and Color Balance. This is more controllable than the Curves method, and also faster.
Camera Nikon F5 **Lens** 80–200mm zoom **Film** Ilford HP5 Plus.

Zoom Effects

Photographers mainly use zoom lenses for convenience – two zooms can replace six or more prime (fixed focal length) lenses. There is also a handy trick that can be done with zoom lenses. By adjusting focal length while an exposure is being made, obviously at a slow shutter speed, you can record your subject as an explosion of colourful streaks and produce images that are full of action and impact.

Getting the effect right takes practice, and can be rather hit-and-miss because the pace at which you zoom

the lens through its focal length range, and the smoothness of the zooming action, have a big influence on how the final image looks.

Luckily, you can create convincing zoomed images using a simple Photoshop filter. In fact, to be honest I never bother doing it conventionally any more – the digital alternative is more controllable, much more predictable and far easier. It also gives you the option to pick and choose from images you already have in your computer that may suit the technique.

HOW IT'S DONE

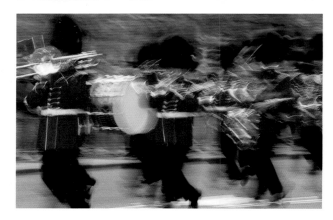

Step 1 I had panned the camera to add movement, but I felt that more could be done with this image – and I knew that whatever I did to it those vibrant red tunics would still stand out and identify the subject.

Step 2 Go to Filter>Blur> Radial Blur. In the dialogue box that opens you will see two options under Blur Method – Spin or Zoom. Select Zoom. There is also a slider that allows you to vary the degree of blur applied. Start off with a low level and see what happens. Here, I set it to 20.

Step 3 You don't have to apply the zooming effect to the whole image. In this case, having tried applying it to everything, I decided to isolate an area in the centre of the picture and to zoom everything else. To do this I used the Marquee tool to make a selection, with Feathering set to 100 pixels to ensure no join was visible. I then used Select>Inverse to reverse the selection and applied the filter for a second time to everything except the central area. This gives a more realistic zooming effect because when you use a zoom lens there is usually an area in the centre of the picture that isn't as distorted as the rest of the image.

**Changing of the Guard,
London, England**
You can see what a difference the
Radial Blur filter has made to this
photograph. It was already quite a
strong image, thanks to the panning
when I originally took it, but the
additional zooming effect makes it
even better – I almost feel dizzy just
looking at it, with all those colourful
streaks rushing towards the camera.
Camera Nikon F90x **Lens** 80–200mm
zoom **Film** Fujichrome Velvia 50.

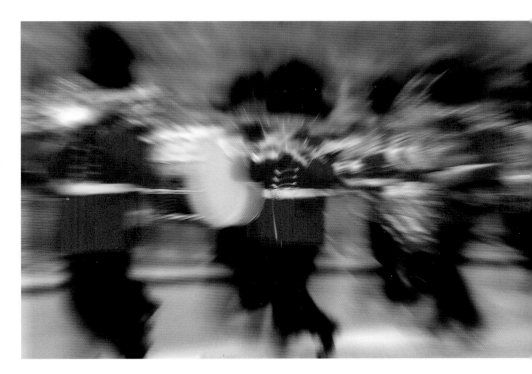

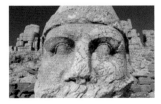

**Head on Mount Nemrut,
Cappadochia, Turkey**
This huge stone head of an ancient
king was carved many centuries
ago and still sits on the summit of
a mountain in Turkey. I think it looks
quite spooky so I intentionally went
in really close to create a powerful
portrait. Adding a zoomed effect
has made it even more striking.
As before, I applied only a small
amount of Radial Blur (5.0) to the
whole image before selecting the
central area containing the eyes and
nose, inverting the selection, then
applying a great amount of Blur (25)
to the rest of the image.
Camera Nikon F90x **Lens** 28mm **Filter**
Polarizer **Film** Fujichrome Velvia 50.

Glossary

The advent of digital imaging has introduced a whole new language of words and phrases that make perfect sense to the experts but can baffle beginners. So, if you're confused by some of the words and phrases you've encountered in this book, take a look below and you'll find an explanation of what they mean.

Action A sequence of adjustments in Photoshop that are recorded so they can be applied automatically to more than one image, thus saving time.

Adjustment layer A layer in an image that can be edited and changes the appearance of layers under it.

Aliasing Jagged edges in a digital image that are caused by the square shape of pixels – seen in extreme enlargement on straight lines and curves.

Application Software designed to make a computer perform a specific job. Photoshop is an image-editing application, for example.

Artifacts Flaws in a digital image that degrade image quality. They are common in images that have been heavily compressed.

Background printing A computer's ability to output a print or document while the user continues to work in the same or a different application.

Batch processing Applying the same series of adjustments or commands to a set of images to save time. Common when processing images from a digital camera or preparing images for a website.

Bit The smallest unit of binary data. Eight bits make a byte.

Bit depth The number of bits of colour data in each pixel of a digital image – such as 8-bit or 16-bit. Also often referred to as colour depth.

Bitmap image An image where the pixels are arranged in a grid like a chessboard. When viewed at pixel size or smaller the image has continuous tone – like a photograph.

Blending mode A setting in Photoshop that allows you to merge two layers so the pixels in one layer affect the pixels in layers beneath. Different blending modes create different effects.

Blown out Term used to describe parts of an image – usually the highlights where no detail is recorded. Usually caused by overexposure.

Byte Eight bits form one byte in binary numbering. Bytes are a unit used in computers to express memory and size of data.

Calibration The process of adjusting monitors, scanners and printers so they all work consistently together.

Card reader A device that connects to your computer and has a small slot that accepts memory cards so you can download digital images – like a small disk drive.

CCD Charge-Coupled Device – the array of sensors in a digital camera and scanner that turns light into an electronic signal and records images in digital form.

CDR Recordable compact discs that store digital data such as image files or music. The data is 'burned' on to the disc using a computer's CD writer. CDR is a cheap way of storing data – each disc holds up to 850MB of data.

CDRW Rewritable compact discs – same as CDR but you can re-use a CDRW many times whereas CDR can only be burned once.

Channel The colours in a digital image. RGB image files have three channels – red, green and blue.

Cloning The process of copying pixels in one part of an image and pasting them on to another part of the image. Commonly used to hide blemishes such as dust spots and scratches or to cover unwanted elements such as telegraph wires.

CMYK image A four-colour image mode used in litho printing or, for example, magazines. The images consist of cyan (C), magenta (M), yellow (Y) and black (K) layers.

Colour management The process of ensuring devices such as monitors, scanners and printers are calibrated to ensure that a printed image looks the same as the image on the monitor.

Compression A means of reducing the size of an image file by using computer algorithms to create colour 'recipes' for groups of pixels without reducing the actual pixel size of the image. A lossy format does this by discarding data.

Contrast The range of tones in an image from highlights to shadows. A high-contrast image has a wider tonal range than a low-contrast image.

CPU Central Processing Unit – a computer's 'engine', which runs the calculations required to modify an image.

Curves A Photoshop tool that allows you to adjust the colour, contrast and brightness of an image in individual colour channels (red, green and blue) or all channels together.

CRT Cathode Ray Tube – conventional design of computer monitor, like a TV screen.

Custom profile A profile created so that optimum print quality can be achieved when using a specific printer, ink and paper combination. This is created by conducting tests to find the printer's optimum driver settings for the chosen ink/paper.

Default The standard settings used by an application until they are changed by the user.

Descreening The process of removing the pattern created by litho printing from a document or photograph – such as a page from a book – during scanning.

Dialogue box A window or box that appears on screen when using an application that allows you to change settings.

Dithering A way of simulating colours and tones using only a few colours. Inkjet printers do this by arranging tiny dots of colour in different patterns to create more than 16 million different colours.

DIMM Dual Inline Memory Modules – chips that can be installed in your computer to increase the amount of RAM available. See RAM.

Digital zoom A technique used by a digital camera to make your subject appear bigger, but instead of magnifying the subject optically, it merely enlarges part of the image.

Download Moving data from one device to another – such as transferring images from a digital camera to a computer or other storage device.

Dye sublimation A type of printing that uses ribbons impregnated with CMYK dyes to create a colour photograph one layer at a time. The small printers you can connect direct to a digital camera are often of this design.

DPI Dots Per Inch – when scanning an image, DPI refers to the number of pixels recorded per inch and is more correctly referred to as PPI (Pixels Per Inch). When printing, DPI refers to the number of ink droplets per inch deposited on the printing paper. The higher the number, the better the image quality.

Duotone An image mode that uses two colour channels and allows you to apply a tone to an image.

Driver Software that a computer uses to operate an external device such as a scanner or printer.

Dynamic range The brightness range you can capture using a digital sensing device such as a scanner – the higher it is, the better the quality. Photographic film also has a dynamic range.

Feathering Making the edges of a selection softer so that joins aren't visible – such as when combining elements from two or more images or applying Photoshop filter effects to parts of an image.

File extension The letters at the end of a file name that tell you and computer applications what the file format is – such as Image.jpg or Image.tif.

FireWire A fast system of data transfer used by many devices such as scanners, printers and portable hard disks. It reduces the time it takes to transfer images from your computer to the device – or vice-versa.

Gamma A means of measuring and expressing the contrast in a photographic image, be it digital, film or print.

Gigabyte (GB) One thousand megabytes (MB) or one million bytes. Used most commonly to express the capacity of a storage device such as a computer hard disk – a 60GB hard disk is able to store 60,000 megabytes of data.

Greyscale An image that contains grey tones as well as black and white. There are 256 steps from pure white to pure black.

Halftone An image created from a dot screen of different sizes to simulate tone and colour. Newspapers are printed using halftone images.

Highlight The brightest part of an image.

Histogram A graph that shows the tonal range of a digital image from the shadows through to the highlights.

ICC International Colour Consortium – formed by major manufacturers to standardize colours.

ICC Profile A measure of a printer's or scanner's colour characteristics, used to ensure consistency and optimum quality.

Inkjet A type of printer that creates an image or document by squirting tiny dots of ink onto different media.

ISO International Standards Organization – system used to express the sensitivity of film or a digital camera's sensor. The lower the number – such as ISO50 – the less sensitive it is and the more exposure is required to record an image.

Interpolation A system of adding new pixels to an image by copying others nearby so that output sizes can be increased without losing image quality – interpolation is used when making giant prints and posters, for example.

JPEG A file format that reduces/compresses file size by removing unused colour data but doesn't change the pixel dimensions of the image. Different levels of JPEG quality are possible.

Kilobyte (K or KB) One thousand (actually 1024) bytes of digital information.

Layered image An image created in Photoshop that consists of more than one layer, with each layer contributing something to the appearance of the final image – such as a filter effect.

Layer opacity The strength or transparency of an image layer in Photoshop – it can be adjusted from 0–100 per cent to control how much of the layer beneath is visible.

Levels Tools in Photoshop that allow you to adjust image brightness and contrast.

Lith A traditional printing technique where printing paper is grossly overexposed then underdeveloped in weak lith developer to produce high-contrast prints with attractive image colour.

Lossy A file format that compresses an image by losing information, unlike a lossless format such as TIFF. JPEG is the most common lossy format.

Marquee A Photoshop tool that lets you select part of an image.

Masking Selecting part of an image and blocking it off so that it is not affected by changes you make to the rest of the image.

Glossary

Megapixel One million pixels. The more megapixels a digital camera has, the higher its resolution and therefore the higher the image quality.

Megabyte (MB) One thousand kilobytes (1024 to be precise) of digital information. A common unit of measurement used to express the size of a digital file and also computer memory.

Metamerism Black-and-white prints can take on a colour cast when viewed in different lighting conditions – green in daylight and magenta in tungsten light. This is known as metamerism.

Mid-tone The average tones in an image – a mid-tone in a black-and-white photograph is a mid-grey tone.

Noise Random pixels on a digital image. Usually created when a digital camera is set to a high ISO and used in low light. Brightly coloured pixels are created in the shadow areas so they stand out.

Pantone The internationally recognized system of describing colour to ensure consistency. Used in the printing industry, and also by graphic designers when specifying colour to printers.

Paste Placing part of a copied image over another image, or one image over another. In Photoshop this tends to be done using Layers.

Peripherals Devices that are connected to your computer such as scanners, printers, CD/DVD writers and so on.

Photoshop The world's most popular image-editing software, produced by Adobe for Mac and Windows.

Pigment ink A type of ink used in inkjet printers that has better archival properties than dye-based inks and tends to be used for exhibition, fine-art and limited edition prints.

Pixel Formed from the words 'picture element'. The unit upon which digitized images are based, like a single tile in a mosaic. The more pixels an image has, the higher its resolution and quality.

Plug-in A program that will work alongside an application from a different manufacturer. There are many Photoshop plug-ins, for example.

Quadtone An image consisting of four different colour channels – black-and-white prints can be toned using this image mode.

RAM Random Access Memory – the primary part of your computer's memory in which program instructions and data are stored for use by the central processing unit (CPU). The larger the RAM, the faster the computer can work.

RAW A file format used by some of the more sophisticated digital cameras, which allows you to record every detail the camera takes. If you shoot in RAW the image you end up with has to be processed before you can edit it.

Resolution The amount of detail in a digital image, stated in terms of the number of pixels per inch or, in the case of prints, dots per inch. The higher the number, the higher the resolution and the better the image quality.

RGB image mode Red, Green and Blue – the three colour channels used in colour images. Each channel has 256 steps and all colours in an image are created by mixing them in various combinations.

RIP Raster Image Processor – used by many digital printers to enable large prints to be made and also to manage the print workflow. Image print is a popular RIP.

Sabatier effect The partial reversal of tones in a photographic image if it is exposed to light during development – this effect can be created in Photoshop.

Selection Isolating part of an image with a tool such as the Marquee or the Lasso, so you can work on it without affecting other parts of the image.

Scratch disk Part of a computer's hard disk, which acts as a RAM overflow while you're working on an image. External drives can also be used as scratch disks.

Shadow The darkest part of an image.

Sharpening Increasing the contrast between pixels so an image looks sharper.

Split toning Toning a black-and-white image with more than one colour – such as sepia in the highlights and blue in the shadows.

Thumbnail A small version of an image that takes up little memory and is quick to open – used for referencing and filing purposes.

TIFF Tagged Image Format File – the most popular file format for digital images as it allows high resolution, is compatible with most operating systems and applications and is also lossless so no data is lost when you copy a TIFF file.

Toning Adding a colour to a black-and-white image.

Tritone An image that comprises three different colour channels – compared to a duotone which has two.

TWAIN A universal software standard that allows applications such as Photoshop to acquire images from a digital camera or scanner. Stands for Toolkit Without An Interesting Name!

Unsharp Mask (USM) A sophisticated sharpening filter that works by combining a slightly soft negative version of an image with the positive original – hence the confusing name.

USB Universal Serial Bus – a type of connector that allow you to link various devices to your computer and achieve fast data transfer.

White balance A setting on digital cameras that allows you to adjust colour temperature to suit different lighting situations and avoid colour casts.

Windows The world's most widely used operating system for PC (personal computers), created by Microsoft.

Index

Photoshop Toolbox

Throughout this book I have I have made probably hundreds of references to the toolbox in Photoshop and the many tools it contains. These are the mainstay of any digital photographer – you can't do much without them. Initially, you may be confused by the range available, how to locate them and, most important of all, how to use them to your advantage. To help you overcome these hurdles, here is a complete Photoshop toolbox. Depending on which version of Photoshop you have, there may be some tools here you don't have, or you may have tools that don't appear here. If in doubt, open Photoshop then go to Help>Photoshop Help, where you'll find explanations of what every tool does and how to access it.

A – Selection tools
• Rectangular Marquee (M)
Elliptical Marquee (M)
Single Column Marquee (M)
Single Row Marquee (M)
• Move (V)
• Lasso (L)
Polygonal Lasso (L)
Magnetic Lasso (L)
• Magic Wand (W)

B – Crop and slice tools
• Crop (C)
• Slice (K)
Slice Select

C – Retouching tools
• Spot Healing Brush (J)
Healing Brush (J)
Patch (J)
Red Eye (J)
• Clone Stamp (S)
Pattern Stamp (S)
• Eraser (E)
Background Eraser (E)
Magic Eraser (E)

• Blur (R)
Sharpen (R)
Smudge (R)
• Dodge (O)
Burn (O)
Sponge (O)

D – Painting tools
• Brush (B)
Pencil (B)
Color Replacement (B)
• History Brush (Y)
Art History Brush (Y)
• Gradient (G)
Paint Bucket (G)

E – Drawing and type tools
• Path Selection (A)
Direct Selection (A)
• Pen (P)
Freeform Pen (P)
Add Anchor Point (P)
Delete Anchor Point (P)
Convert Anchor Point (P)
• Horizontal Type (T)

Vertical Type (T)
Horizontal Type Mask (T)
Vertical Type Mask (T)
• Rectangle (U)
Rounded Rectangle (U)
Ellipse (U)
Polygon (U)
Line (U)
Custom Shape (U)

F – Annotation, measuring and navigation tools
• Notes (N)
Audio Annotation (N)
• Eyedropper (I)
Color Sampler (I)
Measure (I)
• Hand (H)
• Zoom (Z)

• indicates default tool
* keyboard shortcuts appear in brackets

To select a tool do one of the following:

- Click the tool's icon. If the icon has a small triangle at its lower right corner, hold down the mouse button to view the hidden tools. Then click the tool you want to select.
- Press the tool's keyboard shortcut. The keyboard shortcut is displayed in its tool tip. For example you can select the Move tool by pressing the V key. To cycle through hidden tools, hold down Shift and press the tool's shortcut key.

Selecting tools: **A**. Toolbox **B**. Active tool **C**. Hidden tools **D**. Tool name **E**. Tool shortcut **F**. Hidden tool triangle